THE DESIGN METHOD

A PHILOSOPHY AND PROCESS FOR
FUNCTIONAL VISUAL COMMUNICATION

ERIC KARJALUOTO

New Riders

VOICES THAT MATTER™

THE DESIGN METHOD

A Philosophy and Process for Functional Visual Communication

Eric Karjaluoto

New Riders
www.newriders.com
To report errors, please send a note to errata@peachpit.com.

New Riders is an imprint of Peachpit, a division of Pearson Education.

Acquisitions Editor: Nikki Echler McDonald
Production Editor: Becky Winter
Development Editor: Anne Marie Walker
Proofreader: Bethany Stough
Indexer: James Minkin
Design: smashLAB

ISBN-13: 978-0-321-92884-9
ISBN-10: 0-321-92884-9

9 8 7 6 5 4 3 2 1

Printed and bound in the United States of America.

For Mom and Dad—from whom I learned practicality, order, and decency.

"Required reading for all students of design, Karjaluoto's straight-talking *Method* aptly advances designers beyond artistic *makers* to constructive facilitators that *make things happen.*"
—ROBIN ALYSE DOYLE, MANAGING EDITOR, *COMMUNICATION ARTS*

"As a successful designer and design commentator, Eric Karjaluoto combines his twin passions to great effect in *The Design Method.* By turns wise, witty, and opinionated, the book acts as a thoughtful and practical guide to doing effective brand, communication, and graphic design. While not all designers will embrace Karjaluoto's method, all have something to learn from it."
—PETER GIFFEN, EDITOR, *APPLIED ARTS MAGAZINE*

"Everyone likes to complain about design, but almost no one is leading, teaching, and talking about how to do it better. Thanks, Eric, for giving us a book we can share with those that need it—us!"
—SETH GODIN, AUTHOR OF *THE ICARUS DECEPTION*

"Eric: I know you were only 10 years old at the time, but if you'd published this in 1984 I might have avoided some of the lessons I had to learn the really, really hard way. This is solid thinking, clearly articulated. You done good!"
—DAVE MASON, PRINCIPAL / STRATEGY DIRECTOR, MULTIPLE INC.

"Eric Karjaluoto doesn't think this book is for everyone, and boy is he wrong. This book is for every designer on the planet. *The Design Method* is proof positive that it is possible to make timeless, beautiful design that actually succeeds in the marketplace. If you've ever had your work rejected by a client (and who hasn't), this book is for you."
—DEBBIE MILLMAN, PRESIDENT DESIGN, STERLING BRANDS

"Eric Karjaluoto has a wonderful way of writing about design, which is engaging, conversational, and understandable. While this book is helpful for anyone interested in design, it is also a pleasure to read."
—PAULA SCHER, PARTNER, PENTAGRAM

"For the first eight years of my design career I learned from my mentor. For the next eight, I learned from my mistakes. *The Design Method* short circuits both with practical advice and proven wisdom. Karjaluoto's casual style and personal perspective make for an engaging, non-nonsense read. There are times when you'll want to put this book down—but only to make the changes it recommends."
—CHRISTOPHER SIMMONS, PRINCIPAL / CREATIVE DIRECTOR, MINE

"Designers often get confused with artists. Designers, however, are not paid to communicate their issues but to solve other people's problems. We are professionals and we have clients. For them we visualize ideas, processes, messages, and products. Working within constraints means that we cannot wait for that moment of divine inspiration. It means employing methods to keep us on track by making our thought process transparent to our clients and our peers. When kids ask me for the three most important things to do, I tell them: 1) Learn; 2) Learn; 3) Learn. And in that order. Start by reading this book."
—ERIK SPIEKERMANN, PARTNER, EDENSPIEKERMANN

"Eric Karjaluoto's book, *The Design Method*, is the essential handbook that should come with every career in design. This exceptionally practical reference, based on real world experiences in problem solving, will inform and enlighten everyone from beginning students to seasoned practitioners."
—MYLES TANAKA, DEPARTMENT CHAIR, THE ART INSTITUTE OF NEW YORK CITY

"Being a staunch believer that design is not about being artsy or a vehicle for self-expression and is, instead, an objective, rational, laborious process based on listening to a client and translating that into a tangible, accessible solution, I found *The Design Method* the exact kind of prescription the design industry needs.
—ARMIN VIT, CO-FOUNDER, UNDERCONSIDERATION

CONTENTS

ix Preface

xi Introduction

1 Debunking the Creative Myths

15 Creating Purposeful Design

33 Achieving Order Through Systems

59 Introducing The Design Method

73 Gaining Understanding: The Discovery Stage

97 Determining Course: The Planning Stage

125 Working with Ideas: The Creative Stage

149 Making Design Real: The Application Stage

173 Presenting Work to Clients

189 Bringing Order to Your Practice

211 Suggested Reading

215 Acknowledgments

217 Index

Design writing can be difficult to put into use. When I started out, I found this frustrating. I didn't need design books filled with heady academic discourse; I just wanted to learn better ways of working. Although theoretical discussions can be fun, they often have little bearing on your daily practice and can be a distraction.

Real designers aren't chewing on their glasses and pontificating on the "nature of design"; instead, they're solving problems, improving experiences, and helping people communicate. They work for paying clients on projects that ship. Some may dream of luxurious environments, speaking events, and adoring fans; nevertheless, the actual gig is usually far more ordinary—in my mind, it's a lot like working with 2x4s and table saws.

I wrote this book because I believe deeply in design that both fulfills a function and avoids getting jammed up by passing trends. I see design as a process that produces appropriate outputs. This runs quite contrary to what many wish design could be. They struggle because of their misunderstandings, making interesting work that fails to perform as it should. This book clarifies the way you make—and think about—design.

The book is opinionated, and some readers won't like it. They'd prefer to see design as an explorative pursuit and would like this book to be more accommodating of personal style. They may argue that instead of one approach I should provide several and allow the designer to choose. If you feel this way, I ask you to return this book to the shelf. You'll find many other books that define common design principles, outline problem-solving methods, and speak in a general fashion. Although there's a lot to be learned in those books, they take a very different approach than *The Design Method*.

You might not agree with what you read here, find my approach rigid, or think it suffers by not highlighting other perspectives, but

you'd miss the point. Designers trade in ideas, esthetics, and solutions: things difficult to quantify and even harder to make procedural. This means you must work extra hard to bring order to the work you do.

Throughout the following pages, you'll find my best recommendations for creating sensible design. I'll show you a way to approach your design work that is replicable. In this book, you'll learn how to position yourself as a professional and lead your clients through a defined, intelligible, and rewarding experience. By following this advice, you'll produce stronger design and achieve greater satisfaction in your work. My sole purpose for writing this book is to better equip you to be an effective designer.

Thanks for reading, and let's get to it!

Eric Karjaluoto

INTRODUCTION

Nearly fifteen years ago a good friend and I started a design company called smashLAB. We began with so much enthusiasm that we failed to properly consider all we had going against us: We worked in a small town; had no clients, prospects, or real experience; and worse yet, the economy was in a slump. While trying to navigate the many varied opinions about what designers should aspire to, we were forced to develop our design capabilities and run a viable business. Although this was tough, we persisted. Over the years, I've been sharing the lessons we've learned on *ideasonideas.com* and have recently started a new personal blog at *erickarjaluoto.com*.

Everything in this book is derived from the experiences we've had at smashLAB. We work on diverse projects, and our customers tell us we offer them good design that does as promised. It wasn't easy getting to this stage: There have been stressful days, long nights, and oh so many sacrificed hair follicles. (In the time since our company started, all my hair has migrated south of my ears.) What I want you to know is that I've been where you are and have struggled through the same challenges that stymie you. I know this work is tough, and I appreciate how difficult it is to produce good design while also managing the daily requirements of a business—regardless of whether you're working as a freelancer or running a studio.

This book isn't for everyone. Those in product, fashion, or interior design may find that the principles are sound but don't quite translate to their distinct disciplines. That's OK. I wrote *The Design Method* for brand, communication, and graphic designers who do work for clients. To make it more useful for you, I provide many examples and tips. These bits of advice will get you through the tricky spots you might encounter—such as when a client discounts a design approach without having even heard your rationale for it.

Although many designers will find answers as a result of reading

this book, a few groups may gain more from it than others. For example, if you do freelance work or run a design studio, you'll get suggestions that will unequivocally improve how you work—even if you've been at it for some time already. Additionally, this book provides a tidal wave of common sense for design students still infatuated with an idea of what their future careers will be like. After reading this book you'll avoid some painful lessons many of your peers will suffer through the hard way.

This book starts from an ideological standpoint. Chapter 1 debunks some common myths about design, such as luck, inspiration, and personal expression. Chapter 2 proposes what design should be: a purposeful pursuit that concentrates on making functional, appropriate solutions. Chapter 3 concludes this part of the book with a look at systems thinking and explores how this viewpoint underlies all good design, enabling you to provide better service to your clients. All of the ideas and arguments presented in the first three chapters aim to set you up to take action.

In the next few chapters, the discussion becomes more applied in that I describe a way to make design happen. Chapter 4 introduces The Design Method and explains how you can use this approach to gain understanding, craft a plan, develop ideas, and then apply them. I elaborate on each of these points in Chapters 5–8, which explore the key stages of the Method: *Discovery*, *Planning*, *Creative*, and *Application*. In this part of the book, I also detail how to work through each stage of the Method. These chapters on process provide examples of the techniques we at smashLAB use to work through The Design Method. They include ways of asking questions and probing for insight along with tools like personas and content inventories. These examples will give you a sense of what to consider as you prepare your own documents and tools. In addition, real experiences we've had at smashLAB are presented so you can incorporate this knowledge into your own daily practice.

Also in Chapters 5–8 I explain how the Method can be applied to many different projects, ranging from simple items like brochures and posters to more complex undertakings like corporate identities, websites, and applications. (This isn't a book about interaction design, but I've touched upon this discipline generally.) Although The Design Method can be applied to many kinds of projects, it's best suited to

complex, ill-defined visual communication problems. For smaller projects, you'll ratchet back the suggested approaches, but the general principles will still hold true.

Chapters 9 and 10 address presentation methods and explain how you can apply systemic procedures in your studio. The way you present and document design—and interact with your clients—can make the difference between your ideas living or dying. Similarly, to practice design in an orderly fashion, your studio must be geared to work in a certain way, so some essential considerations are discussed as well.

Throughout this book I talk a great deal about clients. They are, after all, the reason you're able to practice your craft. However, the interactions between designers and clients can be challenging. By examining these dynamics at various stages of The Design Method, you'll set yourself up to collaborate more effectively and deliver a positive, fruitful experience for your customers.

Like the Method itself, this book follows a particular order. Even if you're in a rush, I encourage you to work through the book linearly. Jumping randomly between chapters will weaken your overall sense of how to apply The Design Method in your own practice. As you continue through the book, you'll see that the initial suggestions fit with all of the working methods proposed. By linking theory with practice, the concepts and procedures described gain fidelity and enable you to put The Design Method to good use.

Debunking the Creative Myths

Designers create inappropriate designs more often than they should. They do so by confusing their vocation with art and entertaining notions of luck, inspiration, and personal expression. Let's examine some common design myths.

Understanding the Myths

Design isn't complicated. It's about making things. The range of items designers make—from objects and messages to actions and constructs—results in design seeming ambiguous and troublesome to define. No wonder there are so many opinions, beliefs, and myths surrounding design—and some at odds with producing work efficiently. These misapprehensions prevent you from creating good design.

Do you need evidence of these myths? Just take a look at the work designers put in their portfolios. Even when the visuals are beautiful, the design can be broken. Some designers apply a single house style to every client project (be it an energy drink or a funeral home); others create interfaces that defy convention and are impossible to make sense of; still others create gorgeous visuals that fail to align with the brands they represent.

Once certain ideas about design are lodged in your mind, they're almost impossible to eliminate. They conflict with the role you've signed on for, weaken you as a practitioner, and damage the industry. It's not enough to question these notions; you need to extinguish them.

In this chapter, I'll identify 11 common myths and how they weaken you. By recognizing what gets in your way, you can push these notions aside and focus on the aspects of your work that matter.

Myth: Design Is Art's Cousin

One myth confuses two similar pursuits as the same. Walk through any bookstore and you'll find the Design section sandwiched among all the art books. (The Business section may be on a whole other floor, even though it has more to do with design than art typically does.) This says something. You've been fooled into seeing design as art, but these disciplines are different.

It's understandable that you confuse these two vocations as being the same. Art and design both deal with perception—often visual—but they are incongruous. Everyone might agree that art is explorative. Whether it's Duchamps pushing the boundaries of taste, Tarantino reshaping the narrative, or Christo reframing public space, all art explores what might be possible.

Imagine some designed products: a poster advertising yoga lessons, an insurance renewal form, or the assembly instructions for a toy. Do you care how innovative an approach the designer took? Of course not! Each of these designed items fulfills a functional requirement. The visual treatments applied lend support and shouldn't distract from the content.

Don't get me wrong: Novel approaches can lead to good design implementations. It's just that exploration isn't design's principal concern. Whether a designed object is innovative, unexpected, or interesting may bear little consequence. *It just needs to work.* Design and art have little to do with one another. You must look at each independently and stop measuring them in the same ways.

On the left is a representation of art; on the right is a representation of design. Although these pursuits sometimes overlap, they are—for the most part—distinct disciplines.

Myth: Originality Exists

One of the most persistent design myths surrounds originality: Consider billions of people with the same motivations, following the same basic patterns, consuming the same media. In spite of this sameness, people fantasize that each person is capable of—nay, entitled to—original thought. Right.

It's difficult to say how often genius thoughts happen. My hunch is

that most people would be lucky to have one in a lifetime. Expecting them daily—or banking your career on them—seems unwise. Despite the odds, you see new and delightful innovations emerge on a daily basis. What can you learn from this? Perhaps that originality is elusive and doesn't matter.

When you look back at earlier times, you get the sense that a few people made the big leaps. But do you ever wonder if you and others are too quick to assign credit to individuals? Humans are remix artists, taking from one another and building collectively, and designers do this as much as anyone. You assess, construct, and run variations— none of this occurs in a vacuum.

Originality exists only when you have your blinders on. Put differently, your "original" idea probably isn't as original as you think it to be. That's OK. Although few people want to be repetitive or derivative, creating truly original work is inconsequential. The pursuit of that goal is too great a mountain to climb—and an unnecessary one.

Instead, you should try to understand your clients' problems. Listen, observe, and think about what they face. Come to know your clients and the situation so well that you can make a sound call on a suitable approach. And don't wander so far from your subject that you miss the opportunities right in front of you. You'll learn new methods for tapping into information about your clients and what affects them in Chapter 5, "Gaining Understanding: The Discovery Stage." For now, try to end your fascination with creating "original" approaches.

Myth: Different Is Good

You should never put your focus on creating something unfamiliar. In many cases, design that is different is anything but good. The principal concern you must bring to any design solution is whether it is suitable to the task at hand. How much it varies from convention is another discussion. Designers sometimes get distracted and try to push projects into unorthodox places. This is a mistake that results in inappropriate design that fails to serve the client's needs.

Defending your work by saying it's different is a carryover from the art world. The fine arts sometimes need to champion unconventional work, given how people occasionally don't appreciate

the new. For example, society failed to recognize geniuses like Van Gogh; this failure made people wary of dismissing what they don't yet understand. But design doesn't need to break barriers. It's an applied practice, and its users are more concerned with whether or not it does what it promises.

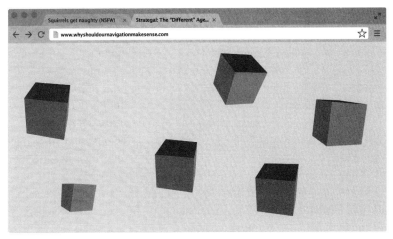

Designers of early websites were very keen to make "neat" interfaces. I find this one entertaining; it requires you to move your mouse above each cube to find out which page it links to. Different? Yes. Intelligible? Hardly.

There can be a place for unique approaches. A less-common approach for a youth-focused magazine or a whimsical identity for a bike company would make sense. If the audience digs the esthetic, let your freak flag fly. Just keep in mind that using unexpected approaches isn't always suitable. When an investment bank wants to run edgy ads, the marketing team and designers should ask whether doing so makes any sense.

New designers often want to shatter the approaches devised by their predecessors and rebuild them in fresh, new ways. This impulse can be long lasting, even as you grow "wiser." It spawns phrases like, "I want to push the boundaries of design." However, unique approaches should arise naturally, not be forced on a project.

Although the desire to make your mark is relatable, you need to remember that designers are like tailors. Your aim should be to amplify the characteristics of the brand, organization, product, or initiative you're working to represent. Aiming for something different

disconnects you from what the client needs. Instead of trying to understand the situation, you'll find yourself looking for inspiration.

Myth: You Must Seek Inspiration

What do inspiration and the Easter Bunny have in common? There's little proof of their existence. You may disagree, noting that you've been inspired many times. However, you might have actually experienced a kind of flow that comes from being deeply in the moment—the feeling that every move is the right one and you're creating effortlessly.

I, for one, have never sat waiting for an idea, witnessed the skies part, and had a lightning bolt zap me with inspiration. My hunch is that you haven't either—unless you consumed a mind-altering substance.

The problem with inspiration is that it's random, which leads you to focus your hope on outside influences you can't rely on. These stimuli aren't under your control, available on tap, or always relevant to the work at hand. Thinking you can find ideas elsewhere leaves you flipping through magazines and browsing the web, hoping you'll stumble on a magic cure.

You would do better by bringing your exploration closer and considering your client, users, obstacles, assignment, and landscape. In doing so, you reduce the risk of going astray, because you situate yourself in the right environment from the very beginning of the project.

Myth: Brilliance Matters

Praise is gratifying: Parents tell you that you've made them proud; instructors see promise in your work; bosses say you've exceeded their expectations. The biochemical rush of admiration, acclaim, and approval makes you go to great lengths to get another hit. No wonder you try to reach so much higher than necessary.

Wanting to do great work isn't a bad quality. It's just that the search for greatness in design may conflict with what's appropriate. A conflict arises because bold ideas are exciting, and simple ones are less so. Good, lasting design, however, tends to fall into the latter camp.

INSPIRATION

I love getting hit by inspiration; it's such an "electrifying" feeling. (Pity about all the burn marks on the noggin', though.)

You need to decide how much ego plays into your work. Do you want to feel smart, or do you want to solve the current problem? When you want to make a groundbreaking design, you set the bar almost unattainably high, which leads you to dismiss viable options because they seem too obvious. This mindset becomes mentally constipating; soon, no idea is good enough.

When you're motivated to solve the problem, it doesn't matter where the spark or solution originates. It doesn't matter how simple, obvious, or familiar it may be. All that matters is whether it works. This is the attitude you should aim for, because it creates a healthier working dynamic. It sets you up to cooperate with others, solicit feedback, and bounce ideas around because you aren't playing the part of the lone genius.

Keep in mind that your clients don't ask you for brilliance. For them, good enough may be their only requirement. Creating suitable design is hard work. Easing the pressure you put on yourself can free up your mind to sketch, play, and experiment—just what you need to do to solve the problem.

The impulse to make your way into smarty-pants design books may be more of an impediment than an opportunity.

Myth: Design Is a Lifestyle

Although those in business may be changing their perceptions about design, designers sometimes hinder these advances. Some designers do this by adhering to a (literal and figurative) dress code. They carefully select their clothing, using it to illustrate their cultural literacy. They sneer at anyone who doesn't use a Mac. They try to avoid any tasks they deem to be "beneath" them.

Few vocations are as concerned with appearances as design. Maybe this relates to when you choose a career path: Few young people yearn to spend their days in a cubicle farm. Working with interesting people, who make neat stuff, seems compelling by comparison. I can see how the logic works. Design is more secure than other creative acts, like juggling and fire eating. So, design becomes the perfect "in-betweeny" option: creative freedom coupled with a steady paycheck. It's like having your cake and eating it too—*but it's not.*

Much of the work in design schools—such as precious book designs, lofty social projects, and highly personal exercises—illustrates the belief that design should be fun. After leaving school, these new designers face a rude awakening: They are met with having to design boring reports, menus, charts, forms, banner ads, e-mail newsletters, and other banal items—which will have to be done in hours, not over the course of a semester.

In spite of the aspirational messages you encounter, you need to remember that design is a job, not a way of life. You can find enjoyment in solving design puzzles and seeing your solutions in use. These humble pleasures are as good as it gets. The life of a designer is otherwise more ordinary than the recruitment brochure suggests.

Myth: Personal Voice Is Key

Your time on this planet is short, and you want to make it count. Whether it's notoriety, professional advancement, or wanting to create meaningful work, you have goals. As understandable as these motivations are, they can distract you. The need for personal fulfillment sets up a conflict. It forces the designer to fulfill a personal mission *or* serve the client. This can pit designers against their patrons.

Technology accelerates the cult of personality in the design industry. Designers who used to be behind-the-scenes players can now craft personas of their own. Although marketing is important, becoming a brand unto yourself comes at a cost. To be identifiable, you must establish a recognizable personal style, which sets you up to do one sort of work indefinitely—like baking the same cake day in and out. Having a "look" will limit your range and encourage repetitive work that may not adapt to the current job.

Designers are facilitators, not products or brands unto themselves. You are a backstage worker. When you do your job well, you become transparent. Your work has to stand alone without any explanation or props. It's not that you can't bring your insights to this work; you just have to put your client's objectives ahead of your ego.

Myth: Designers Are Smarter than Their Clients

Clients can make confusing decisions when it comes to design. This shouldn't surprise you; the populace receives little education relating to how images work. As design's importance grows, an increasing number of people are pulled into these settings and forced to make unfamiliar choices. They do the best with the knowledge they have, which isn't always enough. You shouldn't allow this lack of design familiarity to justify your own sense of superiority.

Client decisions or suggestions can frustrate designers who aren't keen to slow down, answer questions, and address obstacles. Regardless of their dedication to their craft, many designers tend to bellyache when they're frustrated. Letting off steam can be healthy, but you'll do yourself a disservice by allowing these rants to color how you act.

Designers need to stay cognizant of how tourist-like their role is. Whereas a few specialize in one industry, most move from one gig to the next. You are a visitor who achieves enough general understanding to get the job done. But don't make the mistake of thinking you're a local.

You hold domain knowledge that can transfer from one engagement to the next. However, you can't fully navigate the customs, anomalies, and details of each industry you're brought into. It's the way you share your respective knowledge that makes for workable design solutions. The best client/designer relationships are straightforward

interactions between equals who acknowledge what each party brings to the table.

Myth: Designers Are the Audience

"I like" are two very dangerous words in design regardless of who speaks them. From the design professional, this phrase is even less acceptable. You need to be able to separate yourself from the work you're doing, even when you're emotionally invested, and keep in mind that you are not the audience.

You need to suppress your subjective responses. The work you do isn't for you or your client. It's for those who actually use it: customers, visitors, and users. Sure, your clients are paying for this work, but their real interests lie in how people interpret it and act as a result of it. Your focus needs to be on the end users or audience, even though you may share little in common with this group. It's unwise for you, the person who creates the work, to believe that your sensibilities will match that of others.

Fortunately, you have ways to work around such obstacles. First, you have the ability to empathize: You can put yourself in the position

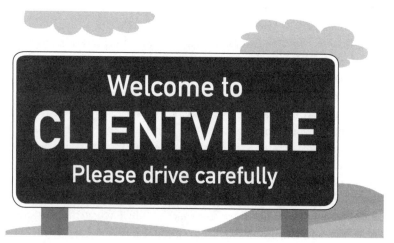

Designers are guests in their clients' homes. As such, you'd be wise to behave nicely—and acknowledge your lack of local understanding.

of the users and try to understand their situation and requirements. This may involve visiting their shop and seeing what they do. Or, it might require you to purchase the service offered and learn how it works. If you can think, behave, and experience as they do, you're better able to understand what impacts and motivates them. (I'll talk about this in more detail in Chapter 6, "Determining Course: The Planning Stage.")

Second, you can test solutions, explore which variations work best for your audience, and ask probing questions to gain a more informed sense of whether your approaches are effective or not. This information may lead you to make changes to the design you wouldn't have otherwise. For instance, you might set the type in a website larger than you personally like because all the users squinted during testing.

Myth: Awards Count

The words "award-winning studio" no longer mean much. Given the proliferation of advertising and design shows, anyone who wants an award can now "win" one. Award show organizers appear to be doing a brisk business. To increase participation and entries, they crank out new categories every year.

Most designers I know acknowledge what nonsense these awards are. But that doesn't stop many from going after them. Awards can be a useful publicity tool and a way to celebrate work you're proud of. Given their ubiquity, the value of these awards has become questionable. Sadly, this won't stop many from treating them as validation of their work's effectiveness.

Ego leads you astray in design, feeds your appetite for awards, and inhibits good work. You see this in delightful ad campaigns that win big at award shows but produce minimal results for those who paid for them. Just think of CP+B's highly celebrated work for Burger King. Always playful and unexpected, it was the darling of award shows. Some loved the ads, but sales didn't reflect this. In fact, AdAge.com reports that while these ads ran, market share fell from 15.6 percent to 14.2 percent. During the same period, McDonald's ran less "innovative" ads but grew sales. Don't fall into this trap! Hijacking a project to build your own portfolio is unethical.

No designer should start any project contemplating how he or she can use it to gain adulation or publicity. Doing so compromises a project from the start and breaches the trust your clients place in you. Completed work is different. If you have a finished design that is suitable for a competition, there's nothing wrong with entering this work.

Winning an award is self-gratifying; satisfying your client is better. *Accomplish both and you'll have achieved a notable coup.* Go after the occasional award if you have time and money to spare. Just don't kid yourself into believing that an award matters that much.

For the record, if you want to get new business, taking prospective clients out for lunch may be more effective than chasing awards.

You want a trophy to celebrate your achievements? Why not join your local 4H club or bowling league, or attend a fishing derby? They'll give you a trophy!

Myth: Creative People Needn't Play by the Rules

Designers beg to be seen as professionals and then get fussy when they're asked to play by the rules and do what's commonplace for others. Albeit a generalization, designers seem to feel entitled to work that is fun and unconstrained. It's hard to imagine those in accounting having similar expectations from their work.

You might not enjoy every requirement you're forced to conform to in the workplace. It's a good bet that even accountants balk at certain duties from time to time. But you just might have to stomach these formalities if you want a place at the table where the big decisions are made. Being open to collaboration and suppressing your personal desires is part of the deal when you're involved in larger creative projects.

You need to work twice as hard to overcome the stereotypes surrounding the design industry. Regardless of your actions, biases do exist. Some people are predisposed to thinking of designers as emotional and fitful. To eradicate these prejudiced attitudes, you need to arrive early to meetings, articulate strategy well, speak to objectives over style, document your decisions, and serve as a voice of reason.

You don't need to be other than who you are. Just don't let your presentation and approach get in the way of what you want to accomplish. You don't want your clients to be distracted by your cool shoes when you're concentrating on putting a good plan together. The same applies to your PowerPoint deck. Do you want them to remember your slick transitions or the approaches you came up with?

Myths Have a Price

Some designers treat the practice of design in a slipshod fashion. They confuse their vocation with making art, seeking outside inspiration, and treating notions of originality and personal voice as key concerns. These habits and myths impair how you work and result in shoddy design.

This book contains commonsense thinking that you should implicitly know. The problem is that designers dislike repetitive processes, want to approach creative projects in a romantic fashion, and don't act as decisively as the job demands. To build good design and advance your career, you need to break these bad behaviors and find smarter ways of working.

You'll learn how to make these changes in *The Design Method*. This book is a treatise for practical objectives and methods, and a reminder to hold firm to such disciplined thinking.

Up Next

With these creative myths discredited, you're better equipped to see design for what it is: a problem solving process that helps facilitate desired outcomes. In the next chapter I'll delve further into what design is and what you should aspire to as a designer.

Creating Purposeful Design

As a professional designer, you sidestep myths about creativity. You focus on achieving order, making functional work, and delivering appropriate solutions. Instead of worrying about what your design looks like, you analyze what it does.

A Utilitarian Pursuit

A design career is like that of a plumber. Sure, you work with ideas, beliefs, and perception common to artists, but your work is different from other creative pursuits. For the most part, you, like a plumber, are asked to diagnose and resolve applied problems. Imagine that water is dripping from your ceiling. Your plumber may have a deep passion for exploration and bold new approaches, but that isn't the reason you hired him. You just need him to find the problem, and fix it.

Design involves exploration, but it's structured. Design has a starting point, trajectory, and many prospective routes. Let's say you want to create an app to help staff collaborate. You have a loose idea of what you'd like the technology to do but are unsure of the most suitable approach. So, you meet with management and staff, and observe how they interact. Most likely, you ask what they need to do and what pain points (e.g., lost files, duplicated contact information, inconsistent processes) they face. This research refines your direction. Your path is still not fully defined, but it is clearer and will be more so as you continue working on the project.

Most creative pursuits are difficult to judge because there are few definitive ways to measure creativity. (How do you describe a sculpture

One of the places where I eat lunch has dreadfully designed salt & pepper shakers. Instead of the design helping me identify which shaker is which, the visuals just add noise.

as "good" if you don't understand what the artist hoped to elicit?) However, design can be measured: You can put your design into use, examine patterns and results, and determine whether the desired outcome has been achieved. Tapping website analytics, sales figures, user feedback, social media measurement, and other data will help indicate whether you've hit the mark or not.

Creative pursuits often involve navigating uncharted territory in hopes of stumbling upon new discoveries. You, as a designer, commit to a far more methodical practice. Yours is a life of research, planning, intuition, testing, measurement, and iteration. Creativity bears few limitations, but design works within restraints. You must define objectives, and then lay out a course of action to guide solutions that are measured by their utility.

Form Follows Function

Do you want to spark a heated discussion among other designers? If so, ask whether design is about form or function. Once the noise dies down, most will agree that it's a combination of the two. Although this is a safe answer, it presents the two considerations as equals and belies the fact that in design form is a subset of function. Design that doesn't fulfill objectives—in spite of how beautiful it is—fails. However, ugly but functional pieces will still find use. The best design works as intended and is presented appropriately.

Due to personal bias, you may first think of form when referencing design. Most designers give too much credence to what they see, even when appearance isn't the most important aspect of the design. You'd achieve more effective work by concentrating on how the item you are designing will be used. Just look at the beautiful objects in your house. Many go unused in favor of those that work better: Heirloom tea sets are forgotten on high shelves, whereas microwave-friendly "World's Best Dad" mugs are used daily. Linen pants that require dry cleaning get half the wear of easy-to-wash jeans. Your DSLR camera gathers dust because it's heavy and cumbersome, whereas the camera in your smartphone is always with you.

Function is a characteristic of many items you use on a daily basis but rarely do you give it a second thought. A fork helps to deliver food

to your mouth; a desk provides a surface to work on; a mouse helps you navigate the digital space. Purpose is in everything a designer makes: A mobile app helps you complete a task; an ad campaign grows a company; a book cover piques a reader's curiosity; a video creates an emotional connection; a corporate identity system assures buyers that a brand is credible.

An attractive presentation in your design is pleasing but is not always necessary to ensure that your design will work as it needs to. Users will tolerate a deficient form, as long as it works better than other available options. Just consider beta versions of software. Users forgive primitive appearances to benefit from utility. Craigslist, for example, has become ubiquitous, even though its user experience is crude. Yes, it could be designed in a much better fashion; however, its lack of design isn't as big of a deal as you might expect.

Restrain Yourself

The role you've taken on requires suspension of your personal emotion. Impulses, in particular, need to be checked. They can cloud your better judgment and compromise what you are working to achieve. Think about some of the bad choices you've made while shopping. Buying clothing that looks great—and perhaps different—is fun. But this excitement fades when you take these items home and realize that they don't meet your needs. I own all kinds of garments that looked great on the mannequin but just didn't work with the other clothes I own. (These eventually find their way to the donation bin in near-new condition.)

As a designer, you make the same impulse mistake when you leap to visuals too quickly. Your client states a problem, and you want to fix it. The client complains about limited brand awareness, and you immediately start sketching logo variations. This reaction is understandable but premature. Restrain yourself and first work to understand the bigger situation. Their real problem may be a lack of purpose, conflicting ideas within the organization, or the result of a saturated marketplace. Until you know your client's circumstances inside and out, and have a plan to rectify the problems, you have no business thinking about visual implementation.

Ultimately, I'm advising you to exercise impulse control and avoid reckless shortcuts. I'll admit it: Over the years, I've gotten carried away more than I should have. Mostly, this has happened when I found some new visual approach that I wanted to try out. I'd then start imagining ways to shoehorn this look into a project—even if it didn't necessarily fit. Most times, I was able to recompose myself and do the right thing: Save the "neat" idea for my sketchbook and instead solve the client's problems.

You'll make better decisions in your design work by first considering function. Before making a single call on a color, typeface, or visual motif, ask *what do I need this to do?* In doing so, you're more likely to employ treatments that are appropriate to the project—and in retrospect seem obvious. A good measure of whether your solution works is in how well you can explain your approach to your client and have them agree that your logic is sensible.

Everyone loves the creative part of designing an item, when they get to pull out their tools and make what they've been hired to create. Leaping into the visual design stage without first determining function can compromise your entire effort. Resolve the function question first, and then move on to more esthetic decisions.

Look for Problems

Design isn't about creativity; it's about problems. Fashioning a new form without purpose is play, which is fun but often pointless. Instead, consider the situation and ask your clients—and their audience—what doesn't work. Doing so will help you create better design.

Most designers try to avoid problems, but by doing so they miss out on opportunities. It is in your best interest to take the opposite approach. The important part of your design process starts with the broken parts, such as obstacles your clients are grappling with, points of frustration for their customers, and misconceptions in the marketplace. For new organizations, these pain points may relate to establishing a position, obtaining some market share, or identifying competitors' weaknesses that they can leverage. Figure out what the critical issues are and address them in your plan and design solution. Doing so may be all the design you need to do.

Consider Drew Houston, a student at MIT who was continually forgetting his USB flash drive. He wanted a better way to access his files, so he looked for a technology to solve his problem. Unfortunately, what he found were awkward and buggy tools, so he made his own: Dropbox serves a few needs, but mostly, the service provides an easy way to share and access your digital files. By late 2012, the service boasted over 100 million users.

Working with problems is straightforward. You just have to isolate them, understand them, and then make plans to solve them. Notice how these points become almost clinical? The reason is that design isn't centered on being novel or different; instead, it prompts you to determine what's broken or insufficient and then forces you to find a way to address these shortcomings. This is all you need to do. But don't kid yourself; it's plenty.

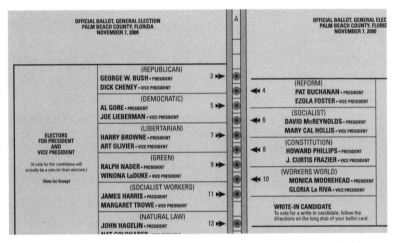

The course of history changed because of the confusing design used in the "butterfly ballot." Good designers need to remedy problems like these and make function clearer to users.

Own the Role

Designers sometimes fail to define what they do. You may believe that your role is quite clear, but it can quickly become murky. There are many kinds of designers, variations between disciplines, and notions surrounding what makes for good design. Admittedly, even I become tongue-tied when asked to explain my work (more about this shortly).

Design training presents a number of career possibilities for you. Industry trends, moral imperatives (such as social or environmentally driven design), and lifestyle choices add to the goals you might aspire to. This multitude of options can result in conflicting aims. On a daily basis, clients ask you to concentrate on a single objective but later change their minds. Grappling with so many objectives can leave you feeling overwhelmed and unsure of which directive to pursue.

Although many factors influence you, your role is simple: You facilitate outcomes. You might build a website, ad campaign, or other design collateral to meet your clients' requirements. Alternately, they may need you to devise a less tangible solution: maybe a naming system or a social media strategy. The form in which you deliver your work doesn't matter. What you do isn't what you make; rather, being a designer relates to what you can make happen. Your client needs that brochure to bring her new customers more than she needs it to be a beautiful design specimen.

The samples in your portfolio are souvenirs. They can be proof of what you've done, and you may even become known for these examples. But they aren't the most important part of your profession. They're representative of ephemera that helped clients get closer to their goals. A better measure of how good a designer you are is found in your ability to facilitate a constructive process and produce work that meets your client's needs. (You can get a sense for whether you're achieving good designer status by the number of past or current clients who'd recommend you to their colleagues.)

Often, designers are perceived as having a freewheeling role, but it's more practical than most realize. Your function is to solve problems. The important part isn't in achieving recognition or developing a personal style; it's in finding solutions to real-world puzzles. You collect pieces, examine them, and then organize them until they fit. This isn't a terrible way to spend your days: But it isn't like you're working on the set of *PeeWee's Playhouse*, either. (Even if your mom and dad imagine that your job is that wild and crazy.)

Your role forces you to shift readily from big-picture matters to the most detailed implementation points. One moment you'll have to ask strategic questions, try to understand your audience, and play hunches on what approaches might work in a particular situation; the next, you'll need to address specific implementation questions, such as

whether elements in a design should be placed 10 pixels apart or 15. This vacillation makes your job more difficult. Even if you're excited by a direction and have invested a good amount of time in it, you need to remain analytical. Should your chosen approach not work, you'll have to abandon what you've built and test other routes. This can be tough, because it forces you to backtrack, do extra work, and might even reduce your billable efficiency; nevertheless, it's what you signed up for.

Eschew Ambiguity

Design is easier to define when it is tangible: a teapot that doesn't leak, a ballot that allows you to vote for the person you intended, or a pen that feels good in your hand. Product designers face many challenges, but at least they have an object to show at the end of their projects.

In communication design, the end deliverable isn't as obvious. Sometimes you'll be tasked with creating a wordmark, presentation, or catalog. At other times, you'll have to devise a less-expected solution, such as a position, a way of thinking, or a "look and feel." Think, for example, of the direction Kastner & Partners provided when it helped launch Red Bull. The agency hardly altered the visual treatments of Red Bull's predecessor: a beverage called Krating Daeng. Instead, the brand was positioned around vitalizing the body and mind, coining the phrase, "Red Bull Gives You Wings." Since then, the beverage has turned into an iconic brand that seemingly "owns" extreme sports.

Technology has changed the world and has led to new outputs and platforms, which have made design even more ambiguous. Although a client may have a specific deliverable in mind, you also need to question whether more effective alternatives exist by employing abductive reasoning: observing a situation and then generating likely hypotheses. The remarkable aspect of what designers do is that they probe beneath the surface of clients' problems to make insightful discoveries. For example, Red Bull didn't need a logo so much as it needed something to stand for. The marketing approach Johannes Kastner helped shape *is* Red Bull—arguably more so than what is in the can. Even though many dislike the flavor of the beverage, in 2012, the brand generated 4.25 billion Euros in revenue.

The observations and approaches you provide to your clients can

enable them to better service their users, change how their brands are perceived, and have a notable impact on their balance sheets. In any case, the variable nature of deliverables in your work makes your business more difficult to run. You'll have to ask potential clients to commit to a contract in which the plan may be undefined. Sure, some will come to you with a specific requirement, such as creating a logo, an app, or a brochure. Others might have a need but not yet know quite how to address it.

A similarly undefined project is underway at our agency. A tourism organization is building a new visitor center. Its people have a plan in place for the interior design of the space; they also want to make digital tools part of the visitor experience. The organization has a sense of what it could do but doesn't know which devices, technologies, and features to employ. Before we can provide a price or list of deliverables for the integration of digital tools in this center, there has to be a plan. So, we're helping this client sort out the best way to meet the needs of visitors and the counselors who help tourists plan their stay. After determining needs and potential solutions, pricing and delivery details can then be filled in.

Projects with such nebulous ends often evolve as they progress. As you build out the plan, you'll learn that some of your approaches won't work or need to be modified. This is the real value you afford: You help clients figure out what needs to be done, create a plan, and then make course corrections when obstacles—or better alternatives—arise.

The variable nature of the projects you're tasked with makes it even more important to adhere to a consistent design process. You might not know exactly what you'll deliver, but you can control the methods you'll use. I liken the planning and creative stages in design to walking in a world without form. Having guide rails relating to end goals and how to go about meeting them helps you make sense of this unfamiliar space. A clear sense of direction, coupled with a well-structured process, mitigates the ambiguity many designers struggle with.

Create Order

Design is a process that leads to an outcome. During this process you engage in a few key activities. The primary one is to create order, which

may involve establishing organizational structure among a family of brands, determining the sequence of content in an exhibition, or organizing the conventions within an interactive device. As a result of this process, the end user or audience should find greater ease in using the artifact you have designed.

People seek order and use the cues they find to make sense of context. For example, signs and symbols help visitors find their way in a new location. A well-designed interface provides familiar tools to help users understand what they can do. Users know that a circle or rectangle with an x in it will close a window or terminate a process; they also understand that a grayed-out text field is inaccessible. Similarly, many game environments teach players new actions as each level progresses, so they know how to maneuver in the environment.

The world you live in is increasingly a designed one: The App Store contains more than a million titles, there are over a half-billion active websites on the Internet, and tens of thousands of grassroots projects have been funded through Kickstarter. The proliferation of technology, coupled with the decentralization of distribution channels, has dramatically increased the number of design experiences users have to navigate. Whether they respond positively or negatively to these designs indicates whether you, the designer, have managed to create sufficient order.

Designed items are supposed to make lives better, but their sheer number can have the opposite effect. How often do you find yourself at an automated gas pump asking, "Why is this so confusing?" Challenges like this one are compounded by misinformation found in advertisements. Audiences not only have to determine an object's purpose and use, they also need to sort out whether the claims made by the seller are accurate. It is your job to affect these situations by creating order and reducing friction for users.

You do this in part by providing cues users recognize. When messages are important, users expect that the text will be made larger, boldface, or set in uppercase. Restroom symbols, coupled with arrows, direct those with "urgent" needs to the appropriate facility. Interactive elements are raised to indicate to users that they can be clicked or pressed. Road surface markings generate noise when crossed to warn drivers that they have violated lane restrictions.

Cues don't require new learning; instead, users should be able

Let's make a deal. You and I stop trying to make neat stuff, and just do our best to avoid producing design that's as confounding as this. What do you say?

to process them intuitively. Some of the ways you do this might seem invisible to users, but that doesn't make them any less relevant. Typographic hierarchy (using the size of type to connote importance) allows readers to scan content faster. Changing an established pattern indicates that users need to pay attention to something: The Return/Enter key is an example; it is larger than the alphanumeric characters on your keyboard. Similarly, the shape and textures used on your television's remote control indicate which way it should be held—convenient cues when it's dark and you can only feel it.

To create order, you must first establish structure by defining rules, taxonomies, and underlying systems that help users make sense of what they encounter. Designed items require audiences to identify the conventions in use, interpret their meanings, and then remember these characteristics. Once you've established conventions in a design system, changing any of them can confuse the user. This is the reason people get angry when Facebook's designers try to make changes for the better. In spite of how good these design improvements may be, people don't like to relearn behaviors. Even the grouping and

proximity of items to one another convey information about whether the items are related or not: When website menus contain item names and photos that are spaced too far apart, I get very frustrated and hope that I've ordered the right thing.

When designed well, indicators and cues guide the user; however, the absence of such order produces inconsistent messages that frustrate people. These mixed messages are everywhere: Consider the red exit signs you see in buildings. The word promises a path to safety, but the color red means "stop" or signals danger. In some places this treatment has been replaced by a green pictogram of a man slowly running out of a space. This solution has two advantages: It is intelligible to those who don't speak the local language, and green is commonly associated with "go" and "correct."

Users are often met by contradictory design messages: OK and Cancel buttons that swap locations in a modal window, interface buttons that change behavior depending on the setting, and doors with pull handles that you need to push to open. Some people won't be able to identify these inconsistencies and lack of order; they'll just find the experience confusing and unpleasant. Make the creation of order key in the design you produce; users will appreciate it.

Make Design that Works

Of the many goals you can aspire to as a designer, the most important one is to make design that works. A poster for a concert should convey key information, attract the right audience, and generate excitement. A passport application has to make the collection of accurate data

Although both signs seem like reasonable approaches, which one do you expect will make the most sense to someone who doesn't speak English?

simple for the applicant and those who process the document. A blog needs to make content easy to browse, read, and possibly act upon in some fashion. Design seems like it's about ideas, but it's actually about facilitating actions.

Designers like to treat all ideas as equal and subjective—particularly when it comes to creative pursuits. This is fine when you're making expressive works but less appropriate when you need to fulfill a purpose. For example, consider art movies, like Andy Warhol's *Sleep*, that have no plot. (You'd think they could have fit in a storyline given that it is nearly six hours long.) Even if you're shaking your head at the notion, others will vehemently argue its relevance. It's hard to imagine anyone making as passionate an argument for the design of a beautiful new drinking glass that can't hold liquid.

You need to be mindful of real uses, particularly given how compelling it can be to add unnecessary treatments to a design. Yes, you can make the browser window shake, but does this frill result in a better user experience? Sure, a holographic image can be printed on a business card, but does this gimmick help recipients read the contact information? Of course, you can add a skeuomorph (an ornament that makes a design resemble another material) and have your web application look like many others, but does this treatment improve how users interact with your software? If an addition to a design doesn't help achieve the end goal, try to remove this element. In most instances, doing so will result in better design.

Modern technologies present so many options that it's difficult to know which ones matter. In order to get anything done and achieve a successful result, you need to edit or remove any nonessential elements. Editing provides a substantial opportunity for designers. Instead of introducing added features, functions, motifs, or content, figure out what you can simplify or eliminate. A perfect example is a text editor called iA Writer. It's a joy to write with because its designers removed many features, affording the writer a clean page with no distracting extras. As a designer, you need to keep in mind that what you perceive as enhancements may in fact be superfluous—and that editing them out can result in better design solutions.

In spite of the frivolity sometimes associated with design, you'll be more effective when you exercise restraint. As a designer, you have an obligation to create design that seems obvious, behaves as expected,

and is free of redundancy. Ultimately, you just need to make design that works. This may seem overly simple, but it's not. If you can make design that does what it's supposed to, you'll be more successful than many of your peers.

Achieve Suitability

A good design solution should fit the client like a well-tailored suit: It puts the emphasis on the wearer (user), not the garment (design). Many designers think they are measured by how novel their ideas are and how playfully they style their work, but their perspective is inaccurate. Random, strange, or unexpected approaches in your work aren't necessarily innovative. The design solutions that actually improve lives, create advancements, or benefit the planet can be quite plain. Thoughtful packaging, for example, doesn't seem exciting but can make for easier shipping while lowering costs and minimizing environmental impact. Alternatively, talking cars seemed like a neat idea but soon proved to be an irritating gimmick. Don't confuse unusual solutions for innovative design.

Consider the first websites. Many suffered from treatments that fought the medium. They incorporated technological-seeming visuals, such as flashing lights, glowing lines, angular typefaces, and inhuman themes. These esthetics were powerful devices used in films like *The Matrix*, but when applied to website interfaces, the style didn't work. Within a few years, these awkward gimmicks disappeared and were replaced by more suitable designs. Search engines no longer resembled digital magazines and instead were redesigned around the search field. Onscreen type stopped looking like it was made for a print setting and instead became web friendly and scalable. Overly designed software gave way to applications that eliminated extraneous features and elements—and considered function first.

The point isn't to make different design but rather to find the most appropriate form for what you're presenting. You may design work that challenges convention, but such results should develop out of necessity instead of being forced.

Microsoft spent decades imitating products of other companies. It added transparencies, metallic textures, and reflections that did

nothing to improve the graphical user interface (GUI). Finally, Microsoft's design team made a bold move: It stripped away all the decoration in a new design language called Metro (now Modern UI). It concentrated on clarity, informative tiles, large type, intuitive gestures, and smooth animations—among a number of other fitting treatments. Although past approaches were derivative and cobbled together, this new approach felt responsive and concentrated on a more logical presentation of data.

Taking such a sensible design approach afforded Microsoft a powerful asset that had previously been missing—an identity of its own. The design industry and press lauded those in Redmond for their newfound design sobriety. The system became central to the Windows Phone and Windows 8, and crept into Microsoft's advertisements and other marketing. Even staunch Mac users had to admit that this system resulted in an experience that was surprisingly good—almost like Microsoft had out-Appled, Apple.

Lasting advances don't occur frequently; therefore, the search for them shouldn't be central to your efforts. Such leaps aren't a result of trying to be "innovative"; instead, they reflect an honest effort to recognize a need and solve the problem. Contemplate why the item in question doesn't perform and determine what you could do to make it work. By doing so, the result will be a suitable design, which is the kind that gets used most—and longest.

Uncover Possibility

The magic in design often comes down to identifying what others didn't. You can uncover opportunity when you understand the situation, consider the audience, and examine usage patterns. You're more apt to see what others have missed when you are able to grasp the circumstances you are designing for.

Consider the game-changing "Got Milk?" campaign. In the mid-90s, milk sales in California were on the decline. So, the California Milk Processor Board asked ad agency Goodby Silverstein and Partners (GS&P) for help. Until then, milk advertising was aimed at new customers, but the agency wanted to instead appeal to existing milk drinkers. It knew milk was a complement to sticky foods like

peanut butter sandwiches, but it didn't realize how strongly people felt about the beverage.

Researchers learned that when people needed milk to wash down something gooey or dry and had run out of it, they got upset—and even felt "deprived." This informed the advertisements, which showed people in extreme need of milk, unable to satiate this need. This scene, coupled with the phrase, "Got Milk?" became a cultural icon. It generated over 90 percent awareness in the United States, increased sales, and was licensed to milk processors across the nation.

Clients sometimes ask you to design items they don't actually need because they confuse deliverables and outcomes. For instance, if clients want to increase sales, they might ask for a new website, thinking that will make the difference. However, the desire to boost sales and the requested deliverable may not correlate. Many websites created just for this purpose don't generate any new business. It's your responsibility to point out when approaches and expectations are misaligned. You should also propose other ways to meet your client's objectives.

You can't limit clients to a predetermined deliverable—particularly when another might better meet their needs. As such, you have to divorce yourself from what clients have asked you to make and what you'd like to create, and instead consider what best solves their problem. A client who wants a new website might actually just need to hire more frontline staff; the company that asks you for an ad campaign might instead need to improve how its product functions; a

Canadian banknotes use raised dots to indicate the denomination of each bill. What a wonderful design element for the estimated 1 million (plus) Canadians who are vision impaired.

group that wants you to design a custom application might be better served with off-the-shelf software that's less expensive and better supported.

Design's value can be exponentially greater than the time and money initially invested. A design innovation can impact how an organization functions or interacts with its customers, or how the brand is positioned. To afford your clients the greatest value, you have to work in a diagnostic fashion. When you think critically and seek out more viable possibilities for clients, your role is elevated to that of a trusted advisor. (You'll learn more about strategy in Chapter 6, "Determining Course: The Planning Stage.") Smart clients will come to appreciate that your level of counsel wouldn't be achieved if they worked with others who just followed their marching orders. Your value isn't limited to the designs you create; it's in facilitating a process that can lead your clients to fruitful, and profitable, insights.

Design Is Everywhere

A hair stylist once asked me what I did. She was unfamiliar with the term "designer," and I struggled to explain it. My pause may have been due to the broad nature of the practice. It isn't some new trend; it's something humans have always done. At one point, design was limited to the creation of tools and shelter. Later, design centered on products, communication, and presentation. In the digital age, it has become further reaching by shaping the way people interact with one another, perform tasks, and even represent themselves. You reconnect with friends on social networks, meet potential mates on dating websites, and get new projects by presenting your thoughts on blogs and your work in online creative showcases.

I looked around the salon hoping to find something representative of the type of design I practiced. Unfortunately, I found little other than ridiculous posters showing new hairstyles. So, I turned to the tools she used: combs, brushes, hair dryers, and clips. I explained that someone designed all the implements she needed to do her job. Other designed items were just out of view—for example, the website that helped me find the shop, the booking system used to schedule my trim, the payment terminal that processed the transaction, and the

loyalty card she hoped would bring me back. The list continued: the organization of the lobby, the publications intended to distract bored spouses, the way I was greeted—all were designed.

For commercial organizations, good design can increase opportunities to build a brand, improve workflow, and generate sales. But design isn't limited to these corporate endeavors. A charity uses design to better access and engage donors. A community uses design to offer constituents more and better opportunities. A school uses design to provide instruction that suits its students' needs. The key to design is found in purpose. Never trick yourself into thinking you make things; instead, remember that you help make things happen.

Up Next

Purposeful design is made, in large part, by applying systems thinking to your work. In the next chapter, I'll explain how this big-picture approach lends cohesiveness to your design solutions. You'll also find some examples of what happens when systems are absent from design.

Achieving Order Through Systems

As a professional designer, you have to apply systems thinking to your process and practice. This approach will help you make decisions, sharpen your focus, and enable you to give your clients better service.

Thinking in Systems

Systems thinking is a way of looking at how things influence one another and work together. It informs a large part of The Design Method. Instead of fixating on a single designed item, this perspective requires you to look at how all of the variables fit together to impact the whole. Doing so helps you create more robust, adaptable, and appropriate design by removing the gaps that tend to appear when items are built in isolation and later forced into working together.

The systems highlighted in this chapter are present in much of what you do, and they often overlap. They allow you to establish a cohesive design ecosystem. Systems are not only for your clients and the way you frame your design process, but they also relate to how you organize jobs, manage your files, and document changes. By establishing order, you can create stronger presentations and take a role in producing a design that has a bigger impact. All the visuals that you create for a project, and perhaps client, are part of a system of interrelated parts. Later in the book (Chapter 10, "Bringing Order to Your Practice") I'll provide examples on how to use systemic approaches in your daily operations.

Systems are important to your process and the reason you need to connect every design decision you make. In doing so, you step back from acting solely as a craftsperson and apply broader insight to the work you do. Once you incorporate systems into your work and witness the clarity that ensues, you'll find it difficult to not apply this kind of thinking to all of your design projects. Systems thinking lends structure to situations that can be wickedly unclear.

Design Gets Messy

When you make design, you face many conflicting opinions, directives, and expectations. If you just made what you were told, design would probably seem pretty easy: a logo with a truck, rainbow, and ballerina? *No problem!* A website with a sparkly background and a gyrating Elvis doll riding a pickle? *Hell yes!* But you are not that kind of designer. You make design that creates real value for your clients, improves the user's experience, and can be held up as an example of

clear-headed thinking and suitable application. Making design that accomplishes all of these results isn't without challenges.

Organizations often engage designers in a way that gets messy: Clients want quick fixes, even when they are grappling with deep-rooted problems. Remedying these issues may require them to first reconsider their vision, business plan, or marketing strategy. Their expectations surrounding a new design can also be unrealistic. (I'm often asked to make a video that will "go viral.") People tend to see design as a one-time deal with a start and end instead of a process that requires an ongoing dialogue. These points illustrate how disconnected ideas about design are from actuality and how they add complications for the designer.

Design that fails often does so because the right questions weren't asked. For example, this dialog performs many functions, but doesn't make the user's options seem intuitive.

Most don't have a good grasp of what design is, which also adds to the confusion. It is seen as a superficial add-on—like a layer of varnish being applied after the real work is done. This is the reason prospective clients are so bewildered by the cost of design services. They've figured

that they've already sorted out the big stuff—surely it can't cost that much to "jazz it up a little" and "add some pop." As frustrating as such comments can be, there's a reason for this mindset.

People are busy, and those who run organizations are even more so. Between cash flow, marketing, human resources, and the other issues that demand their attention, there's little time left for reading books and case studies on design. These may be the reasons organizations sometimes leave branding, design, and customer experience in the "deal with later" pile. It's a little like tossing all of your receipts in a box and only opening it at tax time. The consequences of not setting up systems in advance generate chaos; you'll have a greater number of issues to sort through, make sense of, and address later—most likely when you're in a rush.

The same people who make disciplined fiscal decisions fail to apply such rigor to design matters, in spite of the very real impact design can have on their company's bottom line. When they don't consider what the design is intended to achieve, the decisions they make surrounding design can become erratic, cavalier, and emotional. They cast aside design and only deal with it when it's absolutely needed, which sets them up for unnecessary future panic when they need to get a project done, despite the outcome. They then look at how their competitors present themselves and try to out-do one another instead of asking what their customers need most. This lack of purpose eventually makes them lose focus and leads to impulsive choices and damaging results. Without adequate time to think about the implications of each choice, decisions are made in haste. Design elements fail to link together, forcing a number of other elements to seem created by happenstance. Items start to overlap in function, and messages compete with one another, confusing the customer and making the brand seem cheap or poorly defined. Those who fail to bake design into their plan set themselves up for all kinds of future pain.

Brand design studios often have to deal with a litany of sloppy choices that later impede an organization's growth. Although some of these careless decisions may not seem like issues a designer needs to address, it's what I spend a large part of my time helping organizations resolve. (Most times, this is long overdue and comes at a time when it's expensive and awkward to make changes.) Founders often name their companies in haste without considering potential acquisitions,

directional changes, or relationships between sister brands. Similarly, they get excited about making elaborate and ornate logos but neglect to consider whether their "neat" logos will work in all settings. Website designs become a tug-of-war between departments that want the top spot but fail to understand usage patterns and user needs. When advertising opportunities arise, companies realize they don't know what to say or how to say it, so they create one-off ads in a rush without linking to long-term goals and objectives. And the list goes on. These real obstacles are the results of organizations that failed to think about their design, marketing, and other brand elements as part of an overarching system.

As a designer, you have to think about how approaches work together as part of a design system. This perspective allows you to make the design process manageable and set organizations up for easier and more profitable decisions in the future. Clients are not the ones who will guide the design process; they aren't familiar with the methods you practice. Instead, it's your responsibility to lead them through this process and facilitate a dialogue that moves them in the right direction. You need to sort out which issues matter most to your clients and their audience. You also have to push back on your clients' decisions when you see them getting in the way of their goals. By considering the long-term implications of the choices you make today, you produce design that works for years to come.

Reckless Decisions Come at a Price

You might be tempted to take a more casual approach to design and reason that all questions will eventually sort themselves out. This is a mistake—and can prove an expensive one at that. Lots of designed elements work in the absence of an all-encompassing design system— or at least they may seem to. An impromptu social media campaign, for example, might receive a number of likes and be deemed a success. But put such a campaign into the context of the overall brand, and this success may be less sure. The campaign might fail to reach the right audience, or it may send a message that conflicts with the brand's promise. Your clients will lose business if their offering doesn't align with their audience's expectations. Worse yet, some ideas, once set

in your audience's minds, are impossible to remove. Once a brand is deemed cheap, it will take substantial time, effort, and expense to change this perspective.

Whenever brand elements—or the individual pieces in a design system—fail to relate, the message and ideas you're working to convey fall apart. As a result, the communication you've designed confuses the target audience. It can also introduce doubt that can kill a brand. Consider the following purchase: A few years back I bought an unfamiliar brand of scotch. The packaging was lovely, so I was excited to taste it. After removing the seal, I found an unexpected plastic cap in place of a cork. Although this may sound like a very small point and hardly worth mentioning, nevertheless, this one out-of-place detail was enough to shake my faith in the product. Without that cork, in my mind the scotch seemed like a cheap brand, and that's an awful notion to associate with this kind of indulgence. I don't remember the taste of that drink; I just know that I've never considered buying it again.

Decisions made without careful consideration start to blur the overall purpose of the design exercise in progress. This blurriness is contagious because it clouds every subsequent decision you'll have to face. It makes the project frustrating for your clients. And it will leave their customers unsure of what they are supposed to think, do, or believe. The costs associated with reckless choices aren't trivial.

Decisions made without considering the whole can result in irreconcilable conflicts. In such situations, you'll have to discard your work and backtrack. Odds are you estimate projects at a fixed price, meaning that the cost for this extra work is your responsibility. But it's far worse for your clients. Imagine what it costs organizations to replace their stationery, uniforms, building signage, and fleet vehicle graphics when they realize that their identity doesn't convey the desired message. (Those who save money by using a $99 logo service are punished heavily when it comes time to repair this blunder.) This isn't the only cost, though. Just consider the sales lost and opportunities missed because a presentation doesn't instill confidence in the intended audience.

Audiences get a sense of an organization from its touchpoints, which include customer service, websites, reports, word of mouth, and so on. Inconsistent design makes a brand appear weak and introduces doubt instead of reassuring prospective customers or users that an

organization is credible and deserves their trust. More important, inconsistency can hamper the growth of the company by interrupting the brand's story, creating friction between the company and its customers, and driving the audience to consider other options.

In the absence of systems, each design decision has to be treated as a new one. This lack of planning creates a kind of Wild West in which key messages, brand values, and design standards are treated as independent elements that don't have to reconcile. By the time these points are properly considered by the brand stewards (the CEO, marketing people, or even you), it may be too late to integrate them into a cohesive and ordered design system. As a result, making design changes becomes costly and time-consuming, and involves a never-ending attempt at trying to shuffle items until they correlate.

Take the time to examine groups that have created substantial design; you'll find that they set their direction carefully at the outset. They did so through the creation of a system that helped guide their future design decisions. These systems evolve as the times and needs change. But the progression is logical, not a reckless reaction to competitors' actions, popular styles, or trends in the marketplace.

Trends Are Your Enemy

Many young designers' portfolios have been weakened by trends. Believe me; I've met several of them. They want to seem current and explore fun visual motifs, which leads them to imitate what's popular or soon to be all the rage. This mistake not only makes their work seem derivative and dates their portfolio, but results in deficient work for those who hire them.

Style is a distinctive set of treatments that groups a work within a category. Every design utilizes a style, which may be ornate, playful, or severe in nature. Or, it may reflect a shared association, leveraging a number of elements that evoke a certain time or sensibility. Alternately, the style may be an unfamiliar design that you've fashioned to meet the needs of a particular client. For example, the absence of visual treatments would create a minimal style; a mishmash of approaches might result in an eclectic or post-modern style.

It's impossible to create design free of style, and I don't propose

that you try. Instead, you must be incredibly mindful of how seductive and dangerous style can be. Many inexperienced designers simply find a style to copy and apply these treatments to the work they're producing, which doesn't result in functional design. By reproducing a successful design, you become the design equivalent of a cover band that replicates the work of others. Most often, this is evident in young designers' portfolios that invariably have one sample that mimics Russian Constructivist posters. (Oh, how clever.)

It's understandable that you find trends compelling, but it's a real drag to look back and realize that you were lured into the same pointless fads as everyone else.

The problem with style is that it taps into a whole series of preexisting emotions and associations. If you choose to leverage style, you must do so judiciously and ensure that it doesn't overpower bigger decisions and the approaches you need to take. However, your greatest concern should be popular styles: Because they surround you, you become less able to properly identify them. This leads many to follow these trends without even knowing that they're doing so.

Trends promise an immediate reward. You get to utilize a new look and gain praise for your ability to do so. Clients often respond enthusiastically to these treatments, because they seem fresh and exciting. But ultimately, this novelty becomes ineffective because trends short-circuit any kind of systems thinking, thereby limiting your ability to create functional design.

Trends are the enemy of design and offer nominal lasting value. In the 90s, countless corporations added swooshes to their logos. More recently, trends have been seen in "hipster branding," which applies

a contrived mix-and-match approach to any brand, even when it's completely inappropriate. It lets the notion of "cool" supersede what actually works in a design. Design is rooted in the essence of the object or brand, whereas trends are a paper-thin veneer. My Braun coffee grinder is no more or less appropriate than it was when I bought it 20 years ago. On the other hand, my oversized, five-year-old sunglasses are embarrassing to wear.

Good design transcends popular culture and lasts for years. It lends itself to subtle refinement over time and bypasses popular styles that might suck in and hoodwink weaker brands. Trends are temporal and cannot achieve utility and resilience. Trends are skinny jeans, leg-warmers, and tribal t-shirts. Design is a simple black dress that works as well today as it did decades ago. Design is the New York City subway signage system, which was proposed back in 1966 and has been gradually refined over the years. Design is the Ford emblem, Shell icon, and Twinings of London wordmark.

Well-planned design is flexible in that it allows for new implementations and becomes stronger through them. Pick up a MUJI t-shirt, and you're unlikely to think about it twice, given how plain it appears. Spend a moment in one of its shops, and you'll see how that garment is just one part of a greater vision—minimalistically designed, seemingly brand-less items that are created while trying to minimize waste. Whether in a pen, skirt, notebook, app, clock, or suitcase, MUJI products all fit together. For those who establish and follow a design system, a visual language can evolve and become increasingly obvious. It's a good bet that the designers at MUJI have an easier time designing new items because of this clarity. It's hard to imagine them asking, "So, should we put a unicorn on this shirt because irony is cool?"

Trends are not part of a bigger plan. They take new form with each passing season, and in fact, many who create them bank on their obsolescence. You aren't inclined to replace an item that works; however, trends force you back to the store out of fear that you'll look outdated. Once trends come to their end, they are only returned to for amusement and sentimental purposes.

Visual design is no less immune to trends. The Web has made this worse by allowing trends to proliferate so quickly: the Instagram look that has infected seemingly all photographs, micro-type that made spaces seem vast but was unreadable, and the OS X-inspired

jellybean buttons (circa 1999) that made the Web look like it was part of Willy Wonka's personal playland. Novices and professionals alike are susceptible to trends. It takes discipline to resist their magnetic pull. Your best antidote is to concentrate on your clients and their users' needs. Then put your effort into creating design systems (as you'll learn in Chapters 4–8) that can help you forgo trends altogether.

Many of the items MUJI produces aren't even imprinted with the company's logo; nevertheless, the clarity of its mission and visual systems means all of its items link together beautifully.

Systems Inform Design

The longer you work as a designer, the more you realize that all of your decisions need to be informed by larger design systems. Even something as seemingly simple as type selection must relate to what it needs to accomplish. For this reason, criticism of Comic Sans is highly misdirected. Vincent Connare built it not as a typeface for common use, but instead to better suit onscreen cartoon characters' speech bubbles than Times New Roman did. The typeface does exactly what it's supposed to. But it was never meant for menus, general correspondence, or serious announcements (like the Higgs Boson discovery). Blame those who use the font inappropriately— not the typeface. Design goes wrong because fine materials are used inappropriately when designers don't step back and consider how their choices affect the whole.

When you build items in isolation, it is difficult to make good design happen. Instead, you should create a design vision, experiment with variations, and determine how each piece in a design ecosystem links together. Thinking in systems forces you to examine relationships and better understand what you have to work with: the situation, client's needs, available funds, audience expectations and misunderstandings, and so on. I compare it to household finances: taking them on gives you power. Shirking these responsibilities leaves you moving blindly, unaware of the implications of your choices and apt to deeply regret your lack of planning.

Systems relate to how you work and the way your design functions. The steps you take during the planning stage impact the outcome. As you execute your plan, you make choices that build on each other to foster future additions and changes. This is most visible in corporate identity design. The hard work is in understanding the situation, determining a plan, and creating an overall visual approach. Once all the specifications are completed, producing additional elements is relatively straightforward. Any designer could create an appropriate pamphlet for the IKEA brand because its visual systems are so defined.

Each of your clients is different, and each faces unique challenges. You might not be able to change their personalities, backgrounds, or circumstances, but you can control how you create your design solutions. Applying systems—in the messages, interactions, content, or visuals you create—to your design process lends direction and objectivity to your work. In fact, these systems are often interrelated and build on one another. The strategy you develop informs the messages you establish; these messages determine the visual approaches to employ; these visual approaches inform the design choices you make—including the typefaces, layouts, colors, photographs, and sense of balance you create.

As you build design assets, a common denominator—or "design DNA"—emerges and grounds subsequent decisions: Recently, our agency helped a software provider clarify its position. Three words shaped the tone of all of its future design, marketing, and communications—*good, accessible,* and *wholesome.* These three simple words informed the playful illustrations and textures used in the company's design, the hyperbole-free approach in marketing collateral, and the friendly language that would shape its communications. From

the vision to the application, each piece worked together to produce a unified presentation.

As you establish systems in your design work, you'll start to realize how important it is for each part of a design solution to share the same DNA. You'll then apply it to all the elements in your design, from color and type to printing methods and voice (i.e., Is the piece of communication from a friend? a trusted advisor? an adversary?). Later, this underlying system will inform advertisements, staff manuals, interior design, annual reports, telephone greetings, and every other deliverable you create. A design system can develop organically, but this is rare. For the most part, you'll need to determine the ways you want your system to work and ensure that it resolves design questions.

You Face Many Questions

Design isn't so much about ideas as it is about answering questions. Who should you be speaking to with this designed item? What should you be saying? How should you make it look? What's the best way to measure its effectiveness? These are the principal questions and they consist of countless smaller ones. Should you use photographs or illustrations? If you use photographs, what should they contain? Is there a particular style you should employ? For the designer, these questions may seem endless.

Employing systems in your work helps reduce the number of questions you later face. Or, at very least, systems help you answer these questions more easily. The designer who forsakes systems chooses an arduous path. You might craft a beautiful design and be praised for doing so, but later you may be asked to adapt the design to another related use, only to find it difficult or impossible to do. As a result, your earlier win is less sweet. This lack of foresight places you in an uncomfortable position, but your clients are even worse off. Now, they must work with a messy assortment of disconnected design elements that might prevent them from achieving their goals.

Systems—visual, verbal, or organizational—establish syntax and common characteristics in your work. These guidelines help you understand what fits and what doesn't. You can compare these conventions to those you would use to create a character for a film:

IKEA's designers employ a number of consistent rules when producing assets. As a result, you could change the text to gibberish and most would still be able to identify the brand.

You'd want to know who the protagonist is, where she is from, what motivates her, and how she speaks and presents herself. This top-down creation of an entity allows you to create rules for how your character should behave. If she's a Parisian debutante in the early 1800s, she won't walk around in sweatpants and speak with a drawl. The more time you spend developing this character, the better you know what is and isn't appropriate for her. Eventually, these guidelines make answering questions easier. Should she drive a monster truck? *I don't think these trucks existed then.* Should she sport a mohawk? *Umm, I think not.* Should she date a space alien? *Wait a second—is this a Monty Python sketch?*

Sure, the movie character example may seem a little far-fetched. But it helps to illustrate just how easy it is to answer a question once you know the factors you're working with and where your designed creation lives (i.e., the context it works within). Defining the system that your design will work within isn't easy, but the alternative is far more difficult. You face an enormous number of choices during the course of a design project. These can't be dealt with concurrently. Instead, you have to address strategic ones first and leave implementation questions for later. This tactic will help you make sense of your options. For example, you can't properly choose an appropriate typeface if you don't know what tone the poster you're working on is supposed to evoke.

Choice is usually desirable, but in some situations it can be paralyzing. Young designers can get excited about a design and start sketching ideas without asking what the designed item needs to achieve. They immediately envision a great idea and quickly move their work to page layout software. Then they choose typefaces, toss in colors, and start flowing placeholder copy and photographs. But *it doesn't work*. Truth be told, the outcome looks like a display from a grade school science fair. So, how is this resolved? Change the typeface? Add more elements? Duplicate another style? Try a historic approach? Strip away the extraneous pieces? Change the format? A night of frustration—and little sleep—looms ahead for this freewheeling individual.

Systems are relevant because they reduce the number of choices you need to make. But the benefits don't end there. Systems lend clarity to what you do, help you make sense of which choices are most important, and allow you to move forward in a definite direction instead of facing multiple divergent options that only confuse you more. Through systems, you make better decisions and act faster, because you first come to know which route you need the project you're working on to take.

Determining Relationships in a Design System

Every designed item is the sum of the relationships within and surrounding it. When I look at a business card you created for a client, I infer certain messages and tone from how all of the pieces work together. It's not the type selection or the paper stock that tells me your client is credible, fun, or exciting; it's how these ingredients along with the color, form, balance, composition, and other supporting elements work together. As I gain exposure to the brand's other design collateral, I start to see each component as part of a larger presentation. Ads, uniforms, signage, the website, phone greetings, and customer experience all relate to one another and affect the user's impression.

Like a set of Russian nesting dolls, most designed solutions are part of something bigger. The smallest incarnations share a relationship with the largest. You wouldn't create one doll without considering the others. Starbucks, for example, has countless touchpoints,

Every part of a system needs to work with all the other parts. Therefore, crafting a workable system often requires you to limit variables and aim for simplicity.

ranging from digital to visual, tactile, savory, aromatic, and audible experiences. You walk past the store and instantly spot that familiar green Siren. You pull the door open to the smell of freshly brewed coffee and hear the hiss of the espresso machine frothing milk. You thumb over the new selection of beans packaged in bags that combine beautiful type and exotic patterns atop glossy and matte textures. You slide into a worn leather seat, feel the company's icon embossed on the mug, and sip your drink. The designers at Starbucks need to create not only suitable individual materials, but they must also consider how all of them work together to fulfill the company's brand promise and deliver an interconnected experience.

The way your design elements interrelate indicates how fitting your solution is. Relationships exist even when you think you're creating a one-off design. To illustrate my point, I'll use a personal example, because you might face similar challenges. Our agency needed to make a video about how we developed an iPad app. This small task soon presented a number of questions. Should we show a user's experience? Provide a listing of the app's key features? Highlight the visuals? Each possibility triggered more questions about what we should do: Does the video work in a particular space? If so, what should this be? Should we show real users, hire actors, or have a narrator walk viewers through the app?

We realized that we had to pull back and ask two predominant questions about the relationships this piece had in our agency's growth and marketing: What do we want to accomplish for our organization

with this video? And, how does this video fit within our identity and broader marketing efforts? We should have asked these questions earlier in the motion design process, but unfortunately, we too get sloppy sometimes.

Resolving these broader questions that related to our agency's marketing directives made our decisions easier. We determined that our purpose wasn't to promote the app but rather to showcase our interaction design services. The video also had to work with other videos we had made to market our agency, and complement our corporate identity and brand values.

As we examined all the related pieces, we realized that our videos had to be classified into groups. Small films about our studio and people were included in one group. Our agency reel would involve a more animated approach and be categorized on its own. And our work samples could be treated as plain examples of the end product.

Once we figured out the relationships between our business and design assets, we knew what to build—a simple visualization of the app in use. This saved us time and money, because we could avoid complex shoots and hiring actors. In the long term, we'd know how to treat similar pieces and could ensure that they'd work together.

When you determine how items within a design relate to one another, you establish a system. This provides an underlying framework for the project—or potentially even your client's entire brand. Although many designers are attracted to divergent approaches, they should instead make rules that help define how each piece fits within the whole. With these relationships in place, every subsequent decision is made easier.

Learning from Interaction Design

Interaction design shapes digital experiences, such as the use and function of websites and touch interfaces. Systems are central to the design of these interactive properties, whether they are used on mobile apps, websites, kiosks, or desktop software. You might even say systems are the basis of interaction design. There's a system in the way a user is allowed to navigate the setting. There's a system in the organization of content. And there's a system in how that content is presented on

a page or in the interface. These systems may work efficiently or be outright unintuitive, depending on how well they were considered, prototyped, tested, and refined.

Interaction systems are multifaceted design structures that allow users to make sense of unfamiliar spaces and new information. Regardless of their area of specialization, all designers should recognize and apply some of the techniques used in interaction design. Producing digital experiences that are easy, intuitive, and rewarding for users requires careful planning and appreciation of the way users will interpret the cues they encounter. Effective interaction design involves determining what strategic requirements and desired outcomes clients need. It also requires the designer to understand the expected users, edge cases (uncommon situations), and prospective scenarios for both of these groups.

The only initial concerns for you should be to determine the nature of the content displayed, suitable ways of organizing the material, and which metaphors you employ in the interactive property. A computer's graphical user interface (GUI) for example, uses a real-world desktop metaphor to help users make sense of information and functions. If you've ever used DOS (now I'm dating myself), you'll appreciate what a huge design advancement this was. Instead of needing to memorize

Most take for granted how powerful the desktop metaphor is for using a computer; however, even a simple representation of it makes the organization of data visible.

arcane codes and commands, users can—without much instruction—make sense of this metaphor as they can move items on the desktop, and organize folders and documents. They can also click onscreen symbols that visually represent physical items they're used to seeing in their workspace: like sheets of paper, printers, connecting cables, peripherals, and a trash can.

When you design items that people interact with, your job becomes more complex than when you design items that solely communicate a message. If you're preoccupied with the visuals for these projects, you'll put insufficient consideration into the underlying structures that help users understand what they can do. As a result, those who use the digital tools and properties you design will become frustrated and discouraged. Beyond identifying the interactive property's purpose and use, you must provide precise cues to aid users in understanding functions. It's not enough to just put buttons and text where they look good; you have to consider the way they are interpreted, how they adapt when areas need to expand, and whether they inhibit other actions from being completed—and these critical factors only scratch the surface.

Every interactive element affects how the user interprets the space, gains comfort, and ultimately becomes proficient in using it. My peeve lies in how badly clickable elements, like buttons and links, are sometimes treated. Many provide confusing visual instructions: Sometimes the text on a button is so low in contrast that it looks inactive. Other actions are grouped illogically and confuse me, because I can't find the feature I'm looking for without clicking randomly on every tab until I stumble upon it. Often, the visual treatment is inconsistent, which makes the entire experience maddening.

Currently, I'm experiencing this kind of aggravation with Microsoft Word on the Mac. It offers buttons and functions galore, but I still find them largely unintelligible. It gives me options in the top menu bar, a strip of shortcut buttons, and a set of tabs in the "ribbon," which is loaded with even more options. There are groupings, labels, and symbols—so many that they overwhelm and confuse me. Rarely can I find the proper tab containing the functions I require. This chaos, inconsistency, and mishmash of visual cues leaves me loathing the product. (I gather I'm not alone in feeling this way.)

Most users can't verbalize what makes a design unpleasant or

cumbersome. Nevertheless, these frustrating experiences impact the way people see a brand. Granted, determining minutia, like the location and form of buttons, can prove tedious. But the joy comes when a user remarks on how simple a technology is to use. Successful interaction systems receive this kind of praise. For instance, I've met a number of passionate photographers who love the handling of their Canon cameras. They praise the button locations and how they seem to just present the information they need access to—as though the camera knew what they were looking for. Unfortunately, I don't share this same enthusiasm; nevertheless, when I mention Nikon to these folks, they recoil, which must be indicative of something.

Several different design considerations and information systems need to link together to define a seamless user experience. How do users know they can click a word or picture to access more information? Is a link as intuitive on a touch device where there is no hover state? Can users find what they need, even if they are color blind? Is the link element visible on top of a photo, in a large body of text, or when background colors change? Do the same visual treatments that convey *you can click on me to get to this informatio*n translate to other navigation areas, or does the user need to learn something new in each setting?

Many designers ignore interface and interaction details. These aren't glamorous parts of your job, and clients don't always appreciate their importance. These seemingly mundane aspects of a project may not be captivating, but that doesn't make them any less important. Lots of designers think they're above creating site maps, content inventories, and user flow diagrams. They ignore thinking through all of these requirements and instead try to make slick-looking interfaces—all with the hope that the functional requirements will just work themselves out. This is hardly ever the case.

Clients and designers alike put disproportionate effort into certain aspects of a design. Website home pages, for example, usually get lots of attention and many rounds of revisions. However, these most visible aspects of a design don't always represent a significant part of the user's actual experience. Like me, I'll bet you spend more time reading a book than looking at a cover, more time using software than reading the associated marketing literature, and more time on a website's content pages than looking at its home page.

You need to pay just as much attention to functional areas of an interface—even if your client doesn't even know they exist. Sign-up forms, system alerts, and e-mail notifications matter and affect whether end users are able to complete the tasks they set out to. Similar nondigital considerations might include user manuals, warranty forms, or staff identification cards. Good designers know that their work extends beyond the glamorous parts.

By focusing more on how you architect design—and that includes all of the content you're working with—you will provide users with better experiences. A magazine design can be less rigorously thought through, because its use is mostly linear: You start at the cover and flip the pages. That doesn't make poor design practices any more acceptable. Think about every project like you're an interaction designer. Ask how the result will be used, whether your cues are consistent, and if there are easier ways to guide the user. Doing so will generate clearer and more intuitive design—regardless of the discipline you specifically work within.

In spite of having used computers for over 35 years, I still find print dialogs almost impossible to use without feeling the desire to punch the person who designed such monstrosities.

Organizing Information

Content within a design requires structure; otherwise, it can be inaccessible and its usefulness diminishes. By grouping information you get a better sense of the material and how it should be presented to make it most beneficial to those who are looking for it. Thinking in terms of groupings (or *buckets* as I like to call them) provides an easy way to organize, shape, and structure content effectively. It also helps define projects that seem abstract or nebulous. A large part of what any good designer does is to organize the assets at the beginning of each project: They survey the content (e.g., text, charts, video, photographs, illustrations, legal fine-print) they have to work with, define buckets that best contain this content, fill them with relevant content/data, and examine whether this organization method compartmentalizes the content appropriately.

Creating a system for organizing content into a structure that makes it intelligible for users requires you to understand the content you're working with and how it will be used. For instance, the buckets for a course syllabus might be organized by time or topic. Website navigation might be sorted by the type of visitor or anticipated actions. A slide deck might be organized by the stages in a plan. Even this book relies on buckets; they're called chapters.

You'd be wise to first sort the content your design needs to contain into as few groups as possible. Most times, this involves a handful of core buckets, which you then subdivide into more granular categories. This act is analogous to what you do when you organize files into folders and subfolders on your computer's desktop.

Careful use of language can help you identify patterns in content. Try to label groups with a verb or use just a single word for each category. For example, when we redesigned the Vancouver Aquarium's website, we decided that a few key categories were required. These would be action driven and organized by how different groups needed to interact with this organization. Additionally, we'd use single words to make these categories easy to scan and back them up with a small amount of supporting text. Ultimately, we settled on six categories: *Visit, Experience, Act, Join, Learn,* and *Plan.*

Whichever device you use to parse content, apply it consistently. Do everything you can to avoid exceptions or one-offs so you can

minimize the number of buckets you use. Getting into the habit of organizing the components of a project will help you establish order and isolate inconsistencies. When you find content that doesn't fit within your structure, you will have to rework the groupings, delete the errant content, or find the most suitable place for it.

To determine and analyze the content you have to work with, you should plan groupings rapidly on a chalkboard. If you don't have a chalkboard in your space, get some chalkboard paint and apply it to a wall. Doing so is cheap, the surface is easily cleaned, and it gives you lots of room to think systems through. Alternatively, you can use scraps of paper or a whiteboard.

Then flesh out your groupings in a spreadsheet. The detailed nature of a spreadsheet will highlight points you might have forgotten. With your arrangement in place, you can then assess the content buckets. If groupings are overflowing or empty, your structure may not be right for the content you're working with. You'll need to determine why certain areas don't have enough text, find ways to split up overly full areas, or rethink your system for organizing content altogether. Whichever method you choose to use, this is the time to decide how your content will be organized. Moving words around on a chalkboard or in a spreadsheet is easy. Once a design is applied, text is set, and images are in place, it's a lot more costly to rethink how you've organized the content.

Failure to create efficient organizational systems is common in websites. I'm sure you've seen these faulty and confusing interfaces. Navigation bars are jammed with links, content sometimes feels shoehorned in place, and inconsistencies emerge when a visitor moves between sections. These blunders, and others, arise when there's a lack of clarity in the designed item's purpose. Alternately, they may be the by-products of an organizational tug-of-war in which departments fight to meet their requirements without asking what the users need most. In the worst case, an incompetent information architect or designer is to blame for such messes.

A word of caution: be wary of any organizational system that results in a "Miscellaneous" or "Other" section. The appearance of these classifications signals an incomplete and flawed approach. If you encounter such a classification, erase the board, delete the spreadsheet, and start again.

Thinking About Visuals in Systems

The beauty of the visual treatments in your designs may be irrelevant. Consider sale signs: The most effective ones can be poorly typeset, have competing messages, and be unsightly. Although you and others might find these treatments distasteful, the signage may benefit from such imperfections. A sign put together in haste sometimes leaves the impression of good deals to be had. Therefore, the argument can be made that "taste" may not matter as much as ensuring that your visuals fulfill their purpose.

Approach the design of visual treatments with function in mind: Pause, consider what you need to achieve, and then determine which conventions will establish a consistent tone across uses and media. Maybe you're working for an engineering firm that needs to evoke a sense of technical capability among its customers; alternately, you might be creating visuals for a kids' play place that needs to be bright, bold, and colorful. Whatever situation you face, your choices need to be informed by suitability.

I like to think that all designed things live within an ecosystem of some kind, whether the setting is a real one or completely fabricated. But once certain rules are in place, they can't be broken. Consider film: Movie-goers will readily accept the most preposterous notions—a talking duck, cars from another planet that turn into robots, or pretty much any *Die Hard* movie. That said, what movie-goers won't accept is a flick that doesn't respect the rules it set up at the outset. Such deviations rattle the viewer's belief and ruin the moment. I experience this with computer references in films. Somehow, I'll accept that men can jump unassisted from a ten-story building and walk away unharmed. But when they later use a Windows machine that runs OS X, I shout to my wife, "This is so fake!"

A sense of natural order applies to any design. If you're tasked to design packaging for a quaint 100-year-old brand, your design choices must be appropriate. Setting the text in Helvetica or adding a QR code (a machine readable two-dimensional bar code) might make the presentation disjointed. Disconnected visual syntax leaves viewers unsure and can compromise the brand.

Establish guidelines for your visuals at the outset of your project. An overall plan will inform the smaller decisions you need to make

and will help you establish context and tone. You'll better understand whether the design calls for ornate treatments, minimalistic ones, or something else. All visual design treatments should trickle down from broader concerns, such as how they help further the organization's strategic objectives.

Your goal is to establish rules for the visuals you employ that are clear, simple, and easy to administer. Avoid exceptions because they are representative of bigger design flaws. Variations should only occur when the user needs to take notice of an area or some kind of important function or notification. An alert, for example, might be quite different from the overall visuals in a design to focus emphasis on that particular item. Be very careful when you introduce variations to your visual system; each one can erode your overall design and require the viewer to learn new associations.

You form visual systems when you define the characteristics of all items that live within the design environment you have created and when you adhere to these conventions. Such systems are informed by—but not limited to—hierarchy, type, balance, tone, and spacing of elements. As you define the visual conventions in use, they will shape how you treat images and the way you integrate text and other content. With every convention you clarify, the design you are building becomes more defined. Keep in mind that no visual treatment should ever be selected casually or out of novelty; instead, visual treatments must help support a visual system that unifies the presentation.

Liberate Yourself

Creative people tend to revel in having a sense of freedom in their work. What few realize is how systems and order can liberate them from a litany of often overwhelming questions and requirements. By embracing a pragmatic design philosophy and applying more rigorous methods in your process, creating effective design becomes less restrictive. You might, however, hesitate because you think that employing just one approach will make your design repetitive and mechanical. Relax. Believe me, there will be ample variety in the clients you work with and the deliverables you generate.

When you define the way you work and build systems for your

projects, you create rules that guide you through the process. This readies you to craft a concept and design approach that you can apply with ease. When you have systems in place, the design you produce should never result in repetitive solutions because each situation is different; you're forced to look at every project carefully, which in turn enables you to produce design that is unique to each of your clients.

Scratch the surface of any notable design solution—your iPhone, the application of the EA logo, or the instructions for your new IKEA table. When you do, you'll find underlying organizational systems that relate to big-picture strategies and carry through to execution. These important systems help define and strengthen design that is best suited to the client. Unfortunately, many designers instead create their own "house style," which results in derivative work based on past habits rather than their clients' needs. Consistent methods also equip you to notice when you're missing the mark or repeating yourself and creating a design solution that you've already applied elsewhere.

Each of your projects should move through the same working process and practices you establish. When you manage all your projects in one way, you develop standard procedures that minimize the time you spend organizing files, preparing documentation, and searching for lost e-mails. (You'll learn more about these work habits in Chapter 10). As a result, you put more of your effort into your clients and creating design that meets their needs.

Systems Lead to Good Design

Thinking in systems isn't optional; it's a prerequisite for good design. In fact, I'd go so far as to say that systems and design are synonymous. The search for order should be central to your practice.

Good design is logical, explicable, efficient, and removes all extraneous details. Through consistency and alignment of all elements, good design clarifies experiences and makes them intuitive and obvious. It is adaptable and moves between uses without interrupting the audience, creating the sense that all aspects of a design are intrinsically linked and organized. The more that users witness these designed pieces working together efficiently, the stronger their impression of the design is.

Design is a search for natural form and is an evolving process. The final result can, in retrospect, feel implicit. Structure is everywhere—particularly in design. By thinking in systems, you adopt a viewpoint that allows you to start with the largest concerns first and then zoom in to the smallest ones. There's an efficiency and ease that comes from doing this. Once you have the main design concerns in place, you are free to just fill in the missing parts. And as long as the primary and secondary pieces fit together properly, you're more likely to create suitable design.

Up Next

Now that you've explored systems thinking and learned about its benefits, I'll help you apply this perspective to your design work. In the next chapter, I'll introduce The Design Method we've developed at smashLAB and discuss the working principles involved in this process.

Introducing The Design Method

The Design Method is a framework you can implement in every design project to achieve appropriate results. This blueprint helps you gain understanding, craft a plan, develop ideas, and ultimately produce and apply them.

Presenting The Design Method

The Design Method is a philosophy and approach that lends clarity to and facilitates your work. It helps you understand the situation and problem, and then allows you to determine what the design solution needs to do. The method walks you through an increasingly detailed series of stages. This top-down approach prevents fumbling around with styles, instead enabling you to shape your choices around what your design and client actually need.

Many design process philosophies exist. Some are rigidly structured and driven by rationalism; others take a more emotional approach and favor improvisation. Some rely heavily on observation; others encourage an approach in which designers and users collaborate closely. Some divide the process into seven stages; others pick six, and still others three—heck, I think they come in all sizes. In fact, crafty agencies treat the design process as a marketing gimmick and put great effort into creating proprietary names and pretty flowcharts illustrating how their "unique" process works. (You can likely imagine what I think of this last practice.)

It's hard to say that any one process is better than the rest. Each has a place for some client, designer, situation, or discipline. The important point is that you employ a process that suits you and your clients, and work it consistently instead of just winging it and doing what feels good at the time. (I did that once, and as a consequence, I now have a tattoo of Selena Gomez and a puppy on my left thigh.) If you help clients communicate messages, ideas, values, and the like, you'll find The Design Method to be particularly suitable to your needs.

The Design Method shares similarities with other processes, although it's also different in many ways. It's rational and ordered, overwhelmingly straightforward and logical, but it also involves using your intuition. It requires an involved dialogue with clients; however, it doesn't ask them to perform tasks they are neither trained nor equipped for. It doesn't assume that the initial specifications are the right ones; instead, it begins with research, observation, and questioning in order to evaluate what deliverables are most suitable. The method is rooted in how a studio works, not isolated theory. The result is process stages and approaches that work better in practice than in a textbook. You'll find that this applied view shapes the process

stages, recommendations for work habits and practices, and the language I use to describe this method.

The particular slant of The Design Method is informed by a *communication design* standpoint. The reason I mention this point is that some of the approaches used in product design, for example, aren't directly transferrable to what brand, graphic, and communication designers do. Communication is key to our work at smashLAB regardless of the form it takes. We might build a visual system, website, content strategy, application, or signage system; in each case, we are helping to create or facilitate communication.

Certain design approaches are sensible on paper but difficult to incorporate in actual practice. The Design Method is applied and works well for designers who need to solve often ill-defined visual communication problems. In fact, this method has evolved at our agency over nearly 15 years of daily practice. We've experimented with several approaches in the past and learned from each of these tests, adding what worked to our process. We didn't come by these learnings easily: By taking so much time to sort out this method, our agency has become increasingly productive and successful—more than that, our clients get effective work because of this approach.

To apply this design methodology, you must agree to follow the stages laid out later in this chapter. Don't try to skip a step, get fancy, or make your process any harder than it needs to be. Just follow the process as intended; I promise this approach won't lead you astray. Every day I apply this method, and it continues to delight me. Although The Design Method may seem, and actually is, deceptively simple, it has never failed me when I followed its well-ordered steps.

The Fundamental Stages of The Design Method

Most design processes share a number of common stages and tasks. In The Design Method, all activities are organized into four broad stages, which I'll outline in a moment. These stages are defined quite generally so you can grasp the core activities, and then shape presentation and details according to your specific needs. You'll determine your own working phases and create corresponding documentation based on these steps. You might also develop small leave-behinds, booklets,

diagrams, visualizations, videos, or slide decks that help your clients understand the way you'll work with them.

Some methods have organized their work into a few broad stages, such as *Reflect*, *Observe*, *Make*, and then *Repeat*. Others seem to like alliteration, and use the groupings *Define*, *Design*, *Develop*, and *Deploy*. Still others sound more scientific, starting with *Discovery*, and moving into *Interpretation*, *Ideation*, *Experimentation*, and *Evolution*. Regardless of how you present your process to clients, odds are that you'll be working through a few common stages. The Design Method is based on these stages, which from here on become this book's area of focus. They include the following:

1. **Discovery.** Gathering data and becoming familiar with the situation through observation and analysis.
2. **Planning.** Identifying key needs and issues, and developing a strategy and actionable plan to address these concerns.
3. **Creative.** Exploring conceptual options and potential design directions, and organizing these possibilities into a clear vision.
4. **Application.** Implementing the approach and building out design elements along with testing, measurement, evaluation, and refinement.

The point of identifying these fundamental stages, and working within them, is to lend structure to your design process. But in actuality, these stages sometimes bleed into one another. Although Discovery starts the process, you never stop learning about your clients and their needs. Planning, too, is most exhaustive at the beginning of projects, but you'll continue to plan smaller points throughout your project. The Creative and Application stages involve a cyclical set of tasks: You'll hatch ideas, develop prototypes, run iterations, test your approach, and refine your design. Following these stages will help you mitigate whims that would otherwise leave you bouncing through projects at random.

Although the overlapping aspects of these stages may turn out to be murkier than you like, design isn't that absolutely segmented. This lack of clarity has become even more prevalent in recent years and relates, in part, to how many design projects are now digital in nature. A digital setting allows you to assess results, adjust, and redeploy more rapidly and inexpensively than other settings in which changing

The Design Method relies on four key process stages; however, the working phases you employ are informed by the kind of design you do and the project milestones you establish.

and redeploying items increases time and cost. The management of American Airlines, for example, probably wouldn't be keen to change its identity a week after launching its redesign. After applying the new visuals to all of its airplanes and branded materials, such a task would be substantial regardless of how the new treatments were received.

You'll likely personalize the language you use to describe your working process and how you segment your work modes. That's fine. Part of doing so will involve the kind of design you perform for your clients. Additionally, you may find it useful to determine the actual working phases, or service items, your projects require. Doing so will help you add detail to how you estimate, schedule, bill, and manage projects. You'll have to do this on your own because no one else knows the size, type, or scope of projects you work on.

At smashLAB, we generally break down our working phases into: *Discovery and Planning, Information Architecture and User Experience, Creative and Production, Technology, Content,* and *Deployment.* The phases we use make provisions for interaction design projects and content creation, because they are a big part of what we do for our clients. Again, these working phases are more specific than the process stages described in The Design Method. Process stages and working phases are different in that the former identify broad actions, whereas the latter are used to estimate project requirements and correspond with billable service items in our time tracking.

For most designers, crafting visuals feels more like design than knowledge gathering does; therefore, you might be inclined to

jump right to the Creative stage. Doing so is akin to renting office space before you've written a business plan—not a particularly wise decision. Once again, you need to understand the project situation and determine a sensible course of action. The Discovery and Planning tasks deserve your sweat first. Having worked through these stages, you can then move into Creative and Application, knowing that you've taken the right steps. For years, I made design the wrong way. To help you avoid the same mistakes, let me tell you why I did and how I remedied my clumsy ways.

How The Design Method Came to Be

This book and method directly stem from my ignorance and need to find a more sensible way to create design. Like many designers, my career didn't follow the standard path of design school, interning, and finally becoming a designer under the tutelage of more senior designers and art directors. Instead, I studied painting in art school and did production for a newspaper. These visual language and technical capabilities provided a starting point to begin my career as a designer. The part I was missing was the *how* and *why* of design.

Like me in my earlier days, many designers just want to make innovative work and challenge design conventions, especially when they are new to the craft. I shirked the task of doing research and documenting my findings; all I wanted to do was to pull out my markers and play with ideas. My early forays into design suffered from this blind enthusiasm. Eventually, I started to ask what my design needed to accomplish. The more often I started a project with this question and answered it in a clear fashion, the better the response I would get from clients and audiences. The design solutions that got the most praise were often the most plain and obvious.

The Design Method was born from experience. The observations that shaped this approach came from opening a studio we had hardly any right to run and learning about design in a hands-on fashion. The questions we faced ranged from how to determine what steps to take in our projects to the best way to version a file. The method we used became stronger with each varied job our agency faced. Through these projects we learned to recognize patterns in the work we did and

determine which aspects of our process might be repeatable in future work. Similarly, we knew we could gain efficiencies by standardizing project phases and tasks.

In our first approach we itemized every project step and created detailed task lists. This act helped us identify stages in our workflow, but adhering to these lists became unwieldy. Being so granular meant that every job needed its own set of tasks, which often numbered in the many hundreds. On projects with overlapping deliverables (like a website and a corporate identity), the task lists didn't transfer well. Worse yet, they were so inconvenient to keep on top of that they interfered with our work.

Later, we sought technologies that would help us better organize our methods, but software fell short as well. After spending many weeks looking for software that would magically solve our problems, we realized that a GANTT chart creator, a task manager, or a collaboration tool could not accomplish so much. Although many good technologies exist, these tools need to support a well-defined process—not take its place.

For a long time we didn't believe we even had a stable process, given how we'd adhere to an approach for a while and later encounter its limitations. But after we began incorporating certain techniques, these methods clicked together in our studio and produced the results we had hoped for. There's an irony of sorts in how much our agency utilizes (and espouses) methodology now, given the organic and rather cumbersome path we took in developing it.

We've now earned an applied sense for how to effectively create design. Between analysis and hands-on learning, we've established a series of rules and systems that work quite well—particularly for those who are asked to design items that may still be undefined. One of the core notions that allow The Design Method to work is to employ a singular approach, which we affectionately call the *funnel*.

The Method as a Funnel

When you think of The Design Method, picture a funnel. This device helps you move your design in one direction and continually refine your actions. Many requirements, questions, and possibilities go into

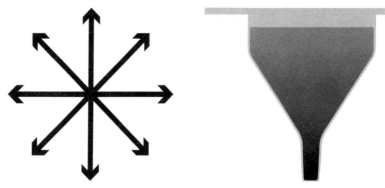

Many people see design and creative work as a tangential process; I prefer to think about my work as though it's running through a funnel—always getting narrower and clearer.

the funnel at the beginning, but these must narrow and keep you moving toward a single trajectory. This perspective runs contrary to the way many designers treat the design process. They tend to confuse creativity as a fragmented, tangential venture in which the number of options presented is congruous with the quality of service afforded.

Those who want to deliver good design efficiently need to regard the whole process of design differently. You can't consider wayward tangents and the creation of dead ends to be of any value to your clients. Instead, you must understand that you need to identify a target. Yes, getting there will require experiments, but these need to be directed—not just random creative dalliances. You should also recognize that you can only reach that target by controlling your impulses, concentrating on an end goal, and narrowing your options to make them more manageable.

The Design Method is a process of refinement in which you sort out the big issues first and move on to smaller components. A comparable scenario would be choosing a place to stay on vacation. Before you'd book a hotel, you'd start by determining your destination, what you wanted to do there, and the dates for your travel. Then you'd choose the most important attributes for a hotel (e.g., budget, quality, location, amenities) and narrow your search appropriately.

Although the hotel analogy might seem a tad pedestrian, the comparison is useful when you consider the way some create design. Many start by weighing every possibility available, and even act on some of these impulses, without taking time to determine whether

these possibilities deserve consideration. These alternatives might prove interesting and entertaining, but they waste time. Given how labor-intensive design is, such indulgences soon prove costly and are best avoided. The tough part is trying to break your clients of their deadly "three options" habit and instead funneling all your effort into a single approach.

We meet with designers and studio leads on a regular basis, and it continues to baffle us that many—if not all—still present three different design options for every project. They all acknowledge that doing so is foolish and hate having to work this way, but oddly enough, few designers seem willing to try another way. The three option approach is akin to asking a chef to present three meals, scrutinizing them at length, and then chucking each item on a plate and mixing them together into one big mess. This is madness—madness I tell you! Nevertheless, designers seem powerless to break from this tradition.

How did we abolish this pointless habit at smashLAB? We logically explained our "one concept approach" to prospective clients, presented it as a benefit—which it is—and used it as a point of differentiation. "Why hire a studio that squanders your funds by creating options you'll never use anyway?" Let me elaborate on how concentrating on one concept produced by utilizing the funnel approach can save you time, more wisely allocate your clients' money, and reduce aggravation for all involved.

Only One Concept (or Design Direction)

The most visible aspect of the funnel, in practice, is in providing one—not three—concepts for your clients. This is a central principle of The Design Method. You complete Discovery, develop a sensible plan, and then present a single design direction. This path will then be either vetoed or refined, but you will not force your clients to evaluate multiple approaches while hoping for the best. Such requests are not fair to your clients—in spite of how desperately they may beg for more options. Working in such an inefficient manner is outright unethical.

It's important that you strengthen your understanding of—and belief in—this singular approach to creative concepts and design direction. Most clients worry that without alternatives they'll miss

out on opportunities. They think that having three different flavors of a design will help them pinpoint the one that's right for them. Although the desire for many options is completely understandable, this perceived need results in a flawed means of producing workable design. You need to prepare them to understand the pitfalls of this outdated and costly practice.

The challenge of showing more than one concept or design direction at a time is that the multitude of options makes it difficult to weigh the merits of each solution. Viewers tend to confuse each option as part of a whole and lump their observations together. Compromising objectivity in this way makes the collection, and parsing, of feedback on individual directions difficult because all opinions become combined. This often leads clients to think they can have the best of all options by just picking aspects of each direction and merging them into one "super-design." (We call this *Frankensteining*, and I've never seen it work out favorably.)

Additionally, it's your job as a designer to edit options to those most viable for your clients and their audiences. Designers shirk their duties when they make clients answer questions about design direction—particularly given that most clients aren't equipped to anticipate the potential limitations of certain approaches. Will they know that the laser-cut card option comes with a prohibitively high print cost? Do they appreciate that the complex logo won't reproduce at small sizes? Are they supposed to implicitly know that using many custom fonts in a website will affect the load time? You are the one who needs to identify issues and help your clients avoid such pitfalls.

Another problem involves the necessary requirements to present three viable options for more complex design projects. Consider websites: They are layered, dimensional settings that take time to produce. Creating three variations for a website compels you to either split a limited number of hours three ways, diluting each option, or create one viable option and then apply some peripheral changes to create two more—often trivial—variations. Neither is a workable option, so you're forced to either triple the design budget or work at one-third of your billable rate (which aren't great options either).

Of course, providing only one option becomes more or less relevant depending on the effort required to produce a prototype fit for your client's consideration. For example, showing a few logo variations

at one time isn't difficult—even though doing so might bewilder your client. On the other hand, presenting a few website or identity options at one sitting is less practical, simply given the onerous amount of time required to properly consider and develop such items.

More on how to present your work is discussed in Chapter 9, "Presenting Work to Clients." For now, just know that The Design Method is built around supplying one concept or approach. For some, this viewpoint will prove a more substantial hurdle than for others. However, you can probably appreciate how much more sensible it is to create and refine one option than it is to create three options and make your client determine which functions best. Clearly, this part of the process will make some uncomfortable; don't let how unfamiliar it is stop you from experiencing its benefits.

How many targets can you hit at one time? Precisely. So, I stop aiming for three and instead concentrate on just one. Believe me—that's hard enough.

The Design Method Works

You may disagree with the approach presented in this book. That's OK, and you probably aren't alone. I've talked about the same ideas with some who passionately tell me that this approach is too dogmatic and simply can't work. But because I've approached design in various ways over the years, I can honestly tell you how well a singular, knowledge-led, systems-based approach works. This method allows you to pinpoint the direction you need to take your client, identify the sequence in which you produce items, and outline a way to replicate these steps on future projects.

Clarity is a rare treat in an industry in which each project is so different from the next. By establishing one trajectory, you can

concentrate on what you need to achieve; therefore, you are better equipped to make workable design. The Design Method forces you to ask good questions at appropriate times. When you adhere to this approach, a set of checks and balances emerges, and helps focus your efforts on the items and considerations that matter most.

An additional benefit of implementing The Design Method is that your business can gain operational efficiencies. Following this method allows you to better organize resources and staff. It enables you to create standardized documentation and repurpose these templates. Additionally, you'll begin to realize a natural project flow by adopting these organized steps. Not only do you need to create effective design, you need to produce work in an ordered and predictable fashion. Part of this cogent approach involves presenting your reasoning to clients in a manner that's clear, accurate, and organized.

Providing personalized guidance and clear documentation to your clients affords them a more pleasant and consistent experience—don't underestimate the importance of this level of service! You can make the greatest design and still fail if your clients feel ignored, poorly supported, or don't understand what you're proposing. Consider the customer experience your clients receive when they work with you. Many designers fail to do so and think the design product is the only part that matters. The way your customers feel about their time with you is pivotal in ensuring your studio's economic viability and survival.

Each time you run the process, you'll learn what works and what doesn't, retool your steps and refine your working methods, and improve the output of your work. This continual refinement will strengthen your studio and the relationships of those working within it. Finding ways to make better design and communication is what this process is all about.

Additionally, The Design Method is so darned sensible that once you fully implement it, you won't be able to revert to your old ways of working. Designers bring order to the projects they're tasked with and the people they help, but many mistakenly believe they can achieve such order through slipshod practices and a lack of process. You know better. And by applying this kind of rigor in your process and actions, you become part of the maturation of design from a pursuit confused for being solely about decoration to one prized for its practitioners' ability to resolve complex problems in many different settings.

Design Methodology in Increasingly Varied Settings

Design-centric approaches are being applied to global-scale problems. You find evidence in the substantial coverage business publications give to the greater possibilities in design and how "design thinking" has become a popular term among many who have never even stepped foot in a design studio. The challenges society faces are becoming progressively vast: resource concerns, social issues, and the threats of climate change, to name a few.

You are tapped to help with these bigger challenges because the way designers think is so unique. You are given an incomplete set of information and are then tasked to build something that may still be undefined. You need to conduct research, ask questions, and probe for insight in settings you're unfamiliar with. Thereafter, you form a hypothesis, prototype options, and test them without necessarily knowing how success will be measured.

As a result of all the variability, the possibility of a simple cookie-cutter solution for all problems becomes less workable. For this reason

The One Laptop per Child program—from infrastructure to hardware—proves a delightful example of what impacts can be made by applying design thinking to massive challenges.

good design methodology needs to be adaptive. It can't falter in the face of these diverse challenges; instead, the process needs to be resilient enough to adapt as parameters change.

The advantage of knowing how to approach and solve vague problems is that other new challenges become less bewildering. In fact, I've used The Design Method approach to design the interior of my home (and I am certainly no interior designer), inform the position of organizations, and even write this book. Actually, the method presented in this book is ideal for structuring a lengthy document. In effect, you can use The Design Method to help you make sense of many big problems you face in countless situations.

Up Next

The first step in The Design Method is Discovery, which focuses on gaining understanding of the situation you're designing for. In the next chapter, I'll explain why achieving this insight is so important and detail how to ask questions and get the information you need to create a sensible plan.

CHAPTER 5

Gaining Understanding: The Discovery Stage

Through observation, analysis, and documentation, you gain perspective into your client's situation. The Discovery stage of The Design Method prepares you to plan, then ideate, and finally produce appropriate design.

Discovery is About Knowledge

Discovery is the knowledge building stage in The Design Method, and it is critical in your role as a designer. If you don't properly understand the situation you're designing for, how can you make anything good, not to mention appropriate? Nevertheless, many pay Discovery lip service or skip this step altogether because they believe they are too smart and talented to bother with such seemingly tedious steps. Surprisingly, I once saw a design studio's proposal that allocated four hours to Discovery, which made me wonder, what could anyone "discover" in such a short amount of time?

This stage of The Design Method requires you to immerse yourself in your client's world and that of its users, customers, and stakeholders. This is no short order. You need to survey what they directly report to you and also probe to access less evident information. It is your responsibility to "get" what your clients talk about, empathize with their customers, and recognize disconnects that may elude the organization that's hired you. In the best case, your Discovery work could lead to opportunities that even your clients' competitors fail to properly identify.

You are not truly a designer if you do not gain knowledge about your clients' situation. This point cannot be stressed enough. Designers obsess about details like print techniques, paper styles, typographic ornaments, and reconciling design elements—all relevant concerns. However, to their detriment, they can be less inclined to apply this same rigor to the grunt work involved in getting to know their clients and the challenges they face. Achieving insight isn't difficult, but it does take time. Make this investment and you will acquire knowledge that's available to all designers but is all too easily missed when this kind of observation is skipped.

Most designers choose a career in design so they can work with visuals. As such, the following comment may leave those designers uneasy: You can hand off Creative tasks but never refrain from completing Discovery and Planning tasks. Some designers think they can pawn off the investigation and thinking to interns or account managers. This mistake limits such designers from experiencing the design situation firsthand. You need to personally see, feel, and be subjected to what you're designing for, not rely on information

collected by proxy. When you bypass this work, you're removed from the thinking part of the job. This omission relegates you to producing only visuals. In fact, many designers are stuck in the role of visual stylist: They can make the most beautiful work but still have little influence over any bigger design discussions.

If you are overtaxed and must delegate a part of the design process, it's best to remove yourself from the Creative and Application stages. Few designers want to admit this truth, but Planning and Discovery need more brainpower than the rest of the gig. If you can understand the situation, identify the problems, and then determine a means to address these points, someone else can take over and execute your plan. You might not be as interested in strategy as you are in visuals; nevertheless, if you want to create suitable design, you need to be part of the big thinking. The question then is how to get started.

Entering Foreign Territory

As a designer, you must be comfortable with the unknown. You'll start most projects with no idea as to how they'll eventually turn out. You won't always know what a particular client expects from you or how that client will behave as the project progresses. You'll also work with

Cast aside your predispositions, and treat Discovery like a journey. Take notes, snap photos, and even collect a few "souvenirs" you can refer to later in the process.

clients in industries you have little personal interest in. For example, you may be enlisted to help a company that deals in insurance, provides a weight-loss solution, or engages in real estate development, all of which you might not care about in the slightest. However, your interest is not the most pivotal matter. Although you might sometimes have the luxury of choosing your clients, you might not always. In addition, you can't limit your professional practice to only what you find interesting. Can you imagine a doctor turning away sick patients because she's uninterested in dealing with certain ailments?

The varied industries you'll work within may use vernacular and customs unfamiliar to you. Asking you to quickly grasp all of these conventions may be unreasonable; nevertheless, you'll be required to do so. But this does come with a fringe benefit: When you work with a variety of groups, you'll be exposed to new learnings. Here are some of the unanticipated facts I learned when I had the pleasure of working with different groups: Residents of small communities universally complain about parking meters—even when they cost as little as five cents to use; the annual expense to feed an otter in captivity is $35,000 (and you thought your German Shepherd was expensive!); black isn't a good color for a helicopter, because it shows too much dirt and makes the chopper look ill-maintained. Although these may seem like trivial points, they help illustrate how varied your assignments can be.

With all the information each new client brings, you may struggle with how to begin the Discovery stage. My advice is to start with what your clients need to achieve. Determine not only what they want to create, but also what they need to make happen. Sure, they want a new website, but why do they want it? What is your design solution supposed to help fix, improve, or change? Do they have unspoken expectations they can't yet articulate? Do they ask for one deliverable, when another would serve them better? Once you figure out what their needs are you can define the scope of the project. But you must first put aside your personal biases to obtain this knowledge.

Assume You're Wrong

You probably think that you observe situations accurately. Most people share the same sentiment. But this misconception can lead you to

make assumptions prematurely. The only assumption you should ever make when you start working with a new client or on a new project is that you are likely wrong, or at least not fully informed to make critical decisions, because you begin with incomplete observations.

Prejudices, misconceptions, and biases are common when you start any design process. Therefore, you can't leap to respond to your client's problems without adequate observation and preparation. You first need to suppress any preexisting beliefs. Forget what you know, and accept your ignorance. This mindset enables you to observe accurately, see what others have missed, and ask questions you might otherwise have thought "dumb."

Consider the following inaccurate assumption: When we started to work with a heli-ski operation, we assumed its guests were all 20-year-old adrenaline junkies who said "gnarly" and "tubular" a little too frequently. We were wrong. Heli-skiing requires a substantial financial commitment, which excludes many young people from a week of fluffy white bliss. Our client's actual customer-base was primarily composed of middle-aged judges, entrepreneurs, doctors, and other professionals.

Had we acted on our assumptions instead of asking questions, we probably would have designed inappropriate materials for our client. Once properly informed, we understood that the audience would respond better to evidence of epic ski terrain and would respect the professionalism exhibited by the operation's committed guides. Customers would also be more captivated by the welcoming —and rather spectacular—environment than images of "radical dudes" attempting death-defying cliff jumps.

Assumptions are easy to make, but their usefulness is often of no value. Many assume they know how to parent—until they have kids. Those screaming, barfing, pooping bundles of joy quickly punish new parents for their earlier hubris. They also force a rethink of prior assumptions. Life is forgiving in these instances and allows for (almost) graceful learning. But audiences are rarely this kind. When you make assumptions that lead to ineffective design, users will ignore the client, fail to use the design, or call you out for creating such an aberration. Assumptions needn't limit your work if you just take the time to learn from your client.

Start Asking Questions

If asked whether they'd rather be ignorant or stupid, most people would probably answer ignorant. The former you can change; the latter leaves you with limited options. In truth, most people are ignorant of a number of subjects because there are too many to understand them all. By accepting this fact, you are free to ask questions and lessen your ignorance about certain topics. Achieving understanding isn't difficult, but new learning does take effort and time. And, you'll need to invest this time again with each new client who requests your services.

Your ability to create good design has a lot to do with your willingness to listen to the responses of your clients, their customers, and other related parties, and weigh what they tell you. Even if they don't realize it, your clients and those around them have all kinds of answers. Don't be the "genius" who knows all; instead, let those who do know inform you. Subsequently, you'll gain understanding you couldn't achieve on your own, and your job will be easier.

Early in our agency's development, we did some design work for a law firm. After watching *Law and Order* for years, we figured we had an appreciation for what law firms wanted to convey to prospective customers: They were no-nonsense negotiators who would take an aggressive stance for their clients. In our initial discussions, I

While many consider design an act of one's hands and mind, your facilities of observation play an important role in helping you achieve insight that allows you to produce effective design.

mentioned that if I ever needed a lawyer, I'd want to hire a "pit bull." When one of our clients heard this, he turned to me and responded, "And that would make you an idiot." He then went on to explain that a good lawyer shouldn't seek out a fight, but instead provide dispassionate counsel that would sidestep unnecessary conflict. Again, my assumptions had gotten the better of me.

In spite of my ignorance, I did learn from this dialogue. Our client's words affected how we approached the project. Actually, that one comment changed how we viewed the entire assignment and how we presented this law firm to its customers. These sorts of experiences were invaluable in our early years. Keep in mind that your clients already have plenty of observations, ideas, and experience, but sometimes all this knowledge is mixed up in a jumble. Your job is to solicit their input, and then filter their comments, clarify their feedback, and continue to search for the building blocks you'll need to comprehend your client's overall situation.

Get a Handle on the Basics

In your initial research, you should survey all aspects of a design project to understand the following: Who are your clients? What do they do? Why? How long have they done it? Where do they operate? What are they selling? How is their offering different from other options? Are they better than their competition in some way? You need to ask these questions, and others, at the beginning of the Discovery stage—even if the answers may appear obvious. You might find that what seemed clear isn't.

Most clients fail to understand that their knowledge isn't common. They'll use industry-specific jargon as though these terms are common fodder. They may believe customers are well versed on their offering when the opposite is the case. They'll also think you know more about their organization than you do. Given these inaccurate beliefs, your clients will be unable to provide all you need to get a strong sense of who they are and what they do. Therefore, you need to ask for planning documents, strategic roadmaps, brand strategies, communications and marketing plans, and identity standards documentation. Request past literature (brochures, manuals, leave

behinds) and samples of ad campaigns, and get access to media libraries (photos, video, standard descriptions, schematics). You also need to review sales data, analytics, and other metrics.

Keep in mind that your contacts at the company might not have a strong handle on what exists within the organization. Perhaps they recently joined the group and don't know what legacy marketing collateral can be tapped, or their position limits them from knowing what's at their disposal. (For example, senior management may be unaware of what assets frontline staff utilizes.) Also, discourage your clients from editing what they provide you. What one person sees as irrelevant may turn out to be very useful to the design process. Have them provide you with access to any item (or people) that will help you understand their operation.

A day or two spent reading a group's communications documents will quickly indoctrinate you into their nomenclature, presence, and industry—even if they are unfamiliar to you. Within these documents, you may uncover patterns, missteps, or untapped opportunities that might provide crucial insight. Later in the Discovery stage, you'll collect your findings and present them in your documentation to your clients. This action will draw your clients' attention to how they see their company and what messages they're disseminating. Odds are that most of what you present won't come as a surprise to your clients. That said, forcing a review of this content may help them identify if certain parts are incorrect, in need of update, or no longer relevant.

Reiterating your findings illustrates to your clients that you heard what they said and are equipped to move forward in an informed fashion. This step is more critical than you may realize: Many of the biggest client hurdles are the result of small misunderstandings. Listening and then mirroring your client's sentiments lessens the risk of communication errors.

Get Firsthand Knowledge

It's surprising when designers create a design for something they haven't personally experienced. The risk of your design solution missing the mark increases exponentially when you fail to gain firsthand knowledge of the product or brand you're working with.

Before you open Photoshop, start a sketch, or write a word of your plan, you need to become familiar with the item or brand by experiencing it like anyone else would. Determine what you like and dislike about it, and test how long it takes to break. With a hands-on understanding, you'll know exactly what you are helping your client sell, promote, or improve. Your direct experience may provide insights even your client missed.

Many long-time managers and employees start to take their organization's offering for granted. They get tired and fail to stay objective about what they make, for example, like the restaurant owner who cooks but never tastes the food he prepares. Experience whatever you are working to promote. Do this early on in the Discovery stage before you're tainted by what your client has to say.

If you're designing ecommerce and online member tools for a zoo, you should visit the venue like anyone else would. If you're creating advertising for a software provider, visit its sales page, type in your credit card number, and use the technology like a real customer. If you're helping a hotel with branding, reserve a room and see if your stay lives up to its promises. Don't tell anyone you're conducting this investigation; just do it and document your experiences.

Although I can tell someone who's never ridden a bike all about how much fun it is; they still won't fully understand. In order for them to appreciate the experience, they'll have to get on a bike for themselves. The same applies for the work you create. You can't just rely on others' stories; you'll need to gain a firsthand sense of their product or service.

Hands-on activity centers on observation. In a way, your job is like that of an ethnographer. You need to experience and gain unique perspectives by witnessing occurrences from different angles. Your clients may be too close to what they do, and their customers might not feel comfortable telling them what problems they face—instead, they just move on to another provider. Although you are close enough to understand the situation, you're sufficiently removed so you can provide an objective viewpoint while soliciting opinions, reactions, and critical data from stakeholders.

Set Up Discussion Sessions with Clients and Stakeholders

Talking to your clients and stakeholders in a controlled setting will help you collect data and establish rapport. At the beginning of these sessions, some clients might be reserved, but don't let this interfere with your approach. Their nervousness will soon dissipate. People love talking about themselves, so make sure you are armed with a list of investigative questions. Even the most introverted people become excited to share their views once they warm up to you.

Setting up these discussions to be fruitful takes practice, and you'll find these sessions to be quite fatiguing. In this setting, you're a facilitator. You'll need to foster a positive and relaxing dynamic that allows those present to contribute openly. You'll also need to listen attentively to what's being said and record this information. Bring a couple of colleagues with you to help you do this. You can introduce participants, discuss the process, and lead the meeting. One colleague can serve as a backup—covering points you miss and lending additional perspective; the other can document the discussion.

You'll also need to determine the best discussion format for your client. Sometimes you'll work with a small group that needs only a single two- or three-hour session. Clients with more complex needs may benefit from two sessions, spaced apart, to give them some time to reflect and allow thoughts to percolate. With larger organizations, you might choose to conduct sessions with specific groups to establish a comfortable and safe environment. For example, conducting a session for management and another for staff may allow those in each group to speak more freely without fear of reproach.

Your clients are more attuned to their problems and opportunities than they might realize. They just find difficulty in articulating them. Because they're wrapped up in the mechanics of their operations, they are unable to see the most obvious path. So, just let them talk. Don't monopolize the meeting; the discussion shouldn't be about you. Validate their responses with nods and smiles. Probe deeper by asking for more details. Give them permission to share their opinions, and appreciate that at times you'll need to nudge the dialogue forward.

Organize your questions into three categories: those about the organization, about the challenges they're facing, and about their audience. You can also ask questions about their competitors and other organizations they admire or believe they are comparable to. Project directives and how they intend to measure success also need to be resolved. Start building a list of questions that suit the types of clients you work with, and then add to this list over time.

Use these sessions well. At times, you'll find that participants obsess over one point of discussion more than it seems to warrant. Take note of these seemingly sensitive topics, but don't allow these points to monopolize the session. Keep moving the discussion forward, and don't worry too much about every little detail yet. You can always return later to fill in any gaps.

These sessions aren't solely about gaining knowledge; they are also about fostering a sense of ownership. Most people have opinions about design and feel even more strongly about the design that represents the organizations they work within. Don't underestimate the power of a few to kill an otherwise effective and well-considered design. (Recall the overblown public revolt Tropicana faced after Peter Arnell redesigned its juice box.) Involve stakeholders early to get them invested in the process. In turn, they will also recognize that their perspectives and suggestions are valued.

Find Underlying Problems

Before you can do any design problem solving, you need to identify the challenges your clients face. Are they losing market share? Do their customers not understand their value proposition? Is their message being drowned out by other, more persuasive, companies? Does their

website have substantial usability problems or content that isn't doing what it should? Some clients will be able to clearly articulate these problems. Although this is helpful, you shouldn't be satisfied with these points alone. Other times your clients might be able to identify symptoms but be unable to pinpoint their underlying problems. For example, they may know that sales are dropping but not associate this behavior with a poorly considered sales funnel on their website. Taking steps to ask additional questions about these issues will usually help you spot correlations.

Other clients won't be as forthcoming. They'll tell you that they're great: They have more customers than they can handle, are experiencing steady growth, and have little real need to change. You'll have to wonder then if they are doing so well why this meeting is happening. (If you ran a company that had no problems, why would you change anything?) The presence of a design, marketing, or advertising agency tends to be symptomatic of a problem needing to be solved—often more than one. So get to work and try to locate these underlying obstacles.

One way to direct the conversation is to reframe the discussion. Some won't verbalize their problems for fear of acknowledging a weakness or failure they're not yet ready to face. By instead calling these challenges "pain points," it seems to liberate more guarded individuals to speak freely. Taking the severity out of the discussion allows your clients to acknowledge smaller organizational discomforts; as a result, they gain comfort and might even disclose other, more substantial difficulties they face.

Another option is to utilize probing questions to see if you can shake some problems loose. Is their staff happy? Is their organization operating at its best? If not, what stands in their way? What one thing would they change about their organization? What do customers misunderstand about it? What groups do they most admire and want to be like? If they were to start the organization again from scratch, what would they do differently?

Most clients don't realize all the challenges that can be tempered through good design. So, structure the discussion in a way that allows them to point out other challenges. Perhaps they can't give all of their customers the same level of service they once did. Or maybe some customers call too frequently and ask repetitive questions,

putting pressure on the staff's limited time. Or, they might believe their organization isn't able to reach qualified buyers. Each of these examples can be addressed through design, as can so many others.

Identify the Audience

A critical part of the Discovery process involves pinpointing the audience your clients want to better reach, service, or engage. Your clients hold only a partial view of their situation. Their perspective is clouded by their desires and extreme myopia. This isn't a put-down; it's simple fact. I can see what clothing looks good on others but have a terrible time dressing myself. The same happens with organizations. They're so close to what they're doing that they can't assess their actions accurately. As a result, the issues your clients identify may be inconsequential to their audience. In addition, they may be unaware of the real obstacles their customers face. Therefore, you need to speak with your client's audience. But before you do, you should learn all you can from those who deal with these end users on a personal level.

Your client contacts may not interact with the company's customers directly, but someone within the organization does. This individual may be a receptionist, box office attendant, guide/docent, delivery driver, retail associate, or accounts person. Find out who works with customers day in and out, and get to know that person. Ask what complaints are common and what the audience prizes. Although these perspectives may be incomplete and represent only a partial view of how the user is engaged, this sort of conversation can enhance your understanding of the audience.

You can ask several focused questions: What are the users, or customers, like? Where are they from? How old are they? What do they need and want? (Remember that need and want are very different.) Do they face certain limitations? Why do they frequent, or avoid, the operation? How are they motivated? What drives them bonkers? What are they passionate about? This last point can be pivotal in uncovering what motivates your client's audience. For instance, I'm convinced this is the reason Disney advertises its theme parks as a way for parents to connect with their children. Moms and dads are more passionate about their kids than anything else in the world; they know

the moments they have with them are precious. Although I detest this tactic, it's a far more powerful appeal to "key decision makers" than photographs of brightly colored amusements.

Look beyond the obvious as you consider the audience. You might be concentrating on the front-line consumer, but other notable groups may also be worth considering. For example, the organization might rely on investors they need to keep happy, or influential outliers may exist. What are their needs? What prevents them from getting the most from the organization? Are the people within the organization in fact part of the audience?

As you work through these informative questions, certain audience groupings will develop, which will prove helpful when you compose the creative brief during the Planning stage (see Chapter 6, "Determining Course: The Planning Stage"). To understand these groupings and how they fit into the design project, you'll need to ask even more questions. Are there certain common needs or notable characteristics between these groups? Are certain ones more important than others? What kind of percentage breakdowns do you see in each

Many designers create in a vacuum, unable to imagine those who'll actually use the design they create. Take the time to meet your users; they're the important ones!

group? How do the groups differ from one another? Is one under-serviced group resulting in more profit than others?

Keep in mind that those who currently make up the audience may not be the only people to talk to. Other groups may be easier, more productive, or better suited to working with, but your client might not even realize these customers or potential customers exist. During one project, we found that every competitor was marketing to white, middle-aged male executives; however, our research found that half of their actual customers were women—a part of the market that no one seemed to be speaking to at all. (Sometimes I wonder if the biases of Don Draper's era still persist.) Ask who's being ignored but shouldn't be and how this audience differs from that of your client's competitors. All of this information will become useful as you develop personas, a little down the road, in Chapter 6.

Interview Customers and Users

Many organizations have difficulty finding the time to talk with their customers and users due to all the day-to-day demands they face. But these missed opportunities are unfortunate, because such conversations can provide wisdom that can help these groups achieve excellence. Consequently, feedback loops contain only a partial set of opinions being voiced.

Angry customers typically make themselves heard. They call at a moment of frustration, ready to rant, scream, and fight. Although your clients might not enjoy receiving these calls, this feedback can help organizations identify weaknesses. It's a pity that other customers aren't as forthcoming with their feedback. Happy and indifferent customers usually have little impetus to say anything.

There are a number of ways to obtain opinions and reactions from audiences. Surveys and questionnaires are easy to instigate but offer questionable value. Forms and rigidly structured questions with limited response options provide little room for commentary from your client's audience. Customers may tell you that they're "dissatisfied," "indifferent," or "highly satisfied," but you can't glean detailed meaningful data from such simplistic responses. Therefore, you should ask your clients to provide a sampling of customers

you can personally reach out to. The mix of people you interview is up to you and your client. Perhaps you'll select individuals who interact with different parts of your client's offering. Or, you may try to find a combination of folks who are experiencing different levels of satisfaction with the company. Alternately, you might identify prospective groups that don't yet work with your client. Again, the sampling depends on the situation, but you owe it to your client to make selections that will yield the most useful information.

Begin by interviewing a handful of individuals. Briefly research who they are before placing the calls. Additionally, develop a set of questions for them that you and your client deem relevant. E-mail in advance to request a discussion, and schedule a time for each call. Start your interviews by explaining why you're calling, how many questions you'll be asking, and how long the session will take. People are busy, so be sure to limit your calls to 15 minutes to avoid scaring off or exhausting your client's amenable customers.

Although the people you speak with may not be able to clearly articulate their observations, feelings, and challenges, they can provide clues. The real importance of these interactions is actually the opportunity to openly solicit feedback while scanning for relevant perspectives. Your role at this stage is as investigator: getting people to share their thoughts with you while gathering key information.

Good detectives (and designers) never take statements at face value; they listen just as much for what isn't being said and take note of awkward pauses. They might also probe, bait the audience, and ask leading questions to access the most useful information.

Don't let any one comment influence your findings too heavily. Misreading a single opinion as being representative of an entire audience can lead you to make inappropriate decisions. So, look for common discussion points among the interviewees. These almost unilaterally exist and tend to be some of the most useful findings. By the time you've completed your calls, you should start to see patterns in the comments you've received. If not, consider expanding your research pool. But don't be fooled by what people say. It's what they do that counts.

Recognize the Discrepancy Between What People Say and Do

Although interviews are informative, you need to temper contributions with a degree of caution—perhaps even cynicism. The reason is that there's a real gap between words and actions. For instance, you keep saying that you plan to exercise more, but that doesn't change the fact that most of your activity is limited to bicep curls with your computer's mouse. (For the record, I'm right there with you.)

What users say they want and what they actually do can be quite different. Learn to spot the difference! (Even if they say they want to be healthy, they may reach for the slice of pizza.)

The dynamic found in interviews—particularly when there is more than one participant—also has an impact on the quality of data. People don't always behave naturally in these settings. Some want to make sure their voice is heard. Others feel rude in not lending an opinion— even if they don't have much to say. In addition, certain individuals fear that they'll look foolish if they respond incorrectly.

Given the emotional drivers at play in an interview, you have to consider resultant findings potentially inaccurate and in need of verification. So, don't just ask for opinions, observe your audience in action. In some settings this will be easier than in others; either way, avoid interrupting their experience. People act differently when they know they're being watched. Don't just ask questions; observe their behavior as well.

Imagine, for example, that you're helping a transit authority find ways to better interact with its riders. A good first step might be to

take one of the trains and witness the experiences people are having. Are they happy, frustrated, or indifferent? Which passengers seem frustrated? Can they easily find their way to their ride? Do they struggle to understand information? Where are the bottlenecks in their process? When you can see customers' reactions for yourself, why limit your findings to people's descriptions of an experience?

Survey the Competition

No organization operates in a vacuum. Clients who claim not to have competitors are lying, delusional, or haven't done their research. (All of these scenarios warrant equal concern.) The reason to examine your client's competition is to understand how others solve the same communication problem. You also need to comprehend how your client is situated in the competitive landscape.

Ask questions about the competition in your initial client/stakeholder discussions: What groups does your client compete with? Which ones are considered leaders in the space? What do they do well? Where are their weaknesses? Do they employ tactics that should be avoided? Are there up-and-comers that concern your client?

Sure, the feedback you receive from these questions will be loaded, because clients find it difficult to gauge competition accurately. That's OK. These misapprehensions may prove enlightening. For example, does your client consider its company to be the market leader, even though its customers perceive the company differently?

After asking these questions, do your own homework: Get familiar with these competitors' websites. Seek out examples of their marketing materials and general collateral. If you can, experience what they offer on a personal level. Contemplate the tools they're using, how they engage customers, and the tone of their communications. Note what they do well, what their weaknesses are, and how they fit among their competitors. Perhaps even summarize each organization's position in a quick sentence and plot each entity on a positioning matrix.

Don't limit your research to just those competitors you've been led to; do your own investigation. Are there others who your client hasn't identified? Additionally, are there indirect competitors, or offerings, that represent a threat to your client? (McDonalds, for example, might

be considered a competitor for a kids play place. The company fights for the same discretionary spend.) The purpose of your survey isn't to find a way to imitate others; in fact, learning about the competition can help you avoid other's overwrought marketing propositions or existing brand positions. Your investigation doesn't stop with competitors; there are others you can learn from.

A positioning matrix helps you get a sense of the competitive landscape, and how your client's offering might fit among all of the others in the marketplace.

Examine Parallel Offerings

Many organizations let ego get in the way of their presentation. They allow rivalries and biases to affect the way they perceive situations, which leads to imitation without first determining what changes they need to make to achieve success. One way for you to help sidestep this tendency and possibly cajole your client into implementing some alternative approaches is to research organizations in different sectors that face similar challenges. At smashLAB, we call these *comparables*.

A good comparable for a law corporation might be an architecture firm. Both sell time and trade on the reputations of their partners

and staff. The cost of engaging one of these groups is substantial, and each is equally mysterious to prospective customers. In spite of these similarities, these two types of organizations present themselves quite differently. Examining these differences can lead you to new understanding about your client's situation and prevent you from seeing your client's position in an overly narrow way.

As when you scrutinize competitors, you'd be unwise to bombard your clients with too many comparables. You could begin by surveying dozens of groups from many different industries. When the time comes to show these selections to a client, it's best to prune back your examples to a selection of no more than five. That's a sufficient number to present the most important findings and deliver value acquired from your observations.

Contrary to your competitor survey, comparables need not take into account weaknesses. Neither you nor your client is interested in what these organizations are getting wrong. Remember that you aren't competing with them. Focus on what they're doing right and what you can learn from them. This assessment process is like traveling to another country: You don't intend to live there, but you can experience local customs and learn from some good approaches.

Audit the Current State

Once you have a good sense of the competition and comparables, you can consider your client's situation more closely from the many different angles you've identified in your surveys. You can start anywhere and take lots of notes. The more you analyze, the better handle you'll have on your client's present position.

Be careful to not dismiss what your client already does well. What parts are working? With those ideas in mind, determine what they should hold onto in the new design solution. Some designers love the idea of throwing out all the existing materials and starting from a blank slate, because they want another great sample for their portfolio. Taking this approach isn't always in your clients' best interests. Survey the current materials and choose the best parts to incorporate into the new design; additionally, you should note what's working and remind your client of these achievements.

You were hired to provide design services because something isn't as desired, and your job is to put your finger on what that is. Figure out when the disconnect occurs. At what point between the vision and materials do ideas fail to be conveyed or presented as they should? Are there issues that clearly stand in the way of the organization's efforts that just need to be eliminated? What tools aren't working as they should? Usually, these problems aren't difficult to pin down. They tend to be quite obvious to those who aren't as close to the situation. The trick isn't necessarily in identifying them but in noting your observations constructively. Someone on the client side may be passionate about the same items you believe to be deficient. If you aren't diplomatic, you might poison the process and unwittingly turn an ally into an enemy.

Keep in mind that at some point the design and marketing approaches that no longer work for your client probably made a lot of sense. Pointing fingers is easy, but little is gained from playing the blame game. Every client is on a journey, and you're along for one stage (more if you're lucky) in the organization's evolution. Provide clear and constructive feedback, and be sure to avoid any silliness or mockery. This sort of ribbing can sabotage you even when it's well intentioned.

Batten Down the Details

Sometimes, while you're contemplating big situational issues, you'll fail to ask the more basic—but equally essential—questions. To operate effectively as a designer, you need to consider the strategic needs, implementation details, and all points in between.

At the beginning of any design project, you must discuss details, in part, to identify any potential deal breakers. This discovery needs to happen long before you've committed to any path, because certain requirements may preclude approaches that would otherwise be viable. Additionally, you can become overly wrapped up in all the excitement at the beginning of the job and not even consider whether the client might have neglected to bring up practicalities that really do need to be taken into account.

Let's look at a brief example. You have a great idea for showcasing motion graphics on screens in your client's lobby. The client loves

the idea and tells you to move ahead. What's next? Do you take a few days to conceptualize artwork? Spend a day compiling a detailed cost breakdown? Or, take 15 minutes to quickly suss out ballpark costs and determine whether the option is viable? Creative impulses will lead you to do the first; a need for accuracy will push you to do the second. However, the third option is where you determine whether the approach is worth any more of your time. If it is, you can move forward. If it's not, you just saved yourself days of lost billable hours.

My point is that if you don't ask practical questions at the outset, you set yourself up for lots of pain. Some critical questions could include: How will this designed object be made? Does this item need to be shipped somewhere? Might some aspect of its use impact build requirements? Does the output device create certain limitations? And one of the most important questions is: how much does the client have to spend on production? No one likes to talk money, but at some point this discussion becomes inevitable.

The details mentioned might seem almost too obvious to worry about; perhaps that's why missing them is so maddening. There's little as embarrassing as learning that the job you just completed is too expensive for your client to print. (Ask any designer who has been in the business for a while. They'll share their version of this horror story.) Although the Discovery stage doesn't seem like the part of the job for securing firm details, you still need to determine the parameters you're working within.

Always Seek Out Opportunity

The approach to Discovery discussed in this chapter is quite comparable to any other high-level business review or SWOT (Strengths, Weaknesses, Opportunities, and Threats) analysis. This stage allows you to pinpoint the state of the operation, identify the competitive landscape, outline challenges and potential risks, and uncover potential opportunities.

As you work through the knowledge gathering part of the design process, you'll inevitably observe ways for your client to better conduct affairs. Although not all of your observations will prove accurate, you should document any notion or perception that crosses your mind.

Running an operation is a cloudy experience, and few ever think there's enough time to sufficiently get their jobs done. As a result, you have a clear opportunity to spot an important issue that your client simply hasn't had time to identify.

For example, one of my clients works with international clientele. The company was losing sales because prospective customers worried that the distance between them and the company would inhibit responsiveness—specifically due to time-zone differences. Over the course of the project, we realized that in spite of the company's small size, its staff rarely answered its phones, preferring to e-mail and letting the automated phone system route the calls. My client didn't think this mattered until we noted that those in foreign countries might feel more assured should a human answer their calls. Although this solution seemed obvious, the notion had eluded them.

Expand your observations beyond the project at hand. Remain open to anything that might help your client achieve their aims, and convey this information at the appropriate time. Providing this input may be of huge benefit to your client and help illustrate that you're a source of meaningful insight that extends beyond what they might have expected. Your engagement needn't be limited to the deliverable they first brought you in to work on. Through Discovery, you might uncover new opportunities your client may not even be aware of, yet.

Although the hat and pipe may not be necessary, your ability to see what others don't can be a huge asset—one that will set you apart from those who don't think it's part of the job.

Keep Turning Over Rocks

Even though I can't properly address all the opportunities that might arise for the projects you take on, I can point you in the right direction. But your role isn't about following a set of step-by-step instructions. You'll need to view each situation critically and determine what rocks you need to overturn to find hidden nuggets.

The Discovery stage affords you an allotment of time to root around and learn everything you can about your clients, those they service, and their current situation. By using this time effectively, you can research critical aspects of the project and start to organize your thinking. If you are sufficiently observant and analytical at this stage, you'll move to the next stage of The Design Method well informed.

Up Next

The second stage in The Design Method, Planning, involves creating a strategy to help address your client's problems. In the next chapter, I'll detail how to establish goals and objectives, develop personas and scenarios, prepare a creative brief, and produce a workable plan.

Determining Course: The Planning Stage

The Planning stage involves outlining your high-level strategy and then creating a plan that further clarifies directives, audience, and tactics. Only with this plan in place should you move on to the Creative stage.

Design is a Plan

Although many think of design solely as an outcome, design is—quite literally—a plan. Design is a blueprint, diagram, recipe, or schematic for the construction of an object, concept, process, or system. A house plan is a design. A flowchart documenting the way users interact with a system is a design. A script for a film is a design.

The Planning stage of The Design Method is not optional. In fact, without planning, you don't have design. Creations made without planning certainly exist, but these dalliances are called explorations and doodles, whereas design is defined by intention and approach.

Planning helps you facilitate good design solutions by concentrating your efforts, lending direction to your work, and ensuring that you take appropriate steps. Although the benefits of planning are many, they don't make this activity any more fun. In fact, planning makes design feel like a job. Less than 10 percent of my time at smashLAB is spent using design software. The bulk of my efforts go into meeting with clients to discuss needs, thinking through ideas on a blackboard, detailing plans in word processing applications, and creating slide decks to accompany client presentations. Depending on why you chose a career in design, this job description might make you uncomfortable, but it's best to get used to this actuality. Planning tasks are necessary in the creation of design that works.

Admittedly, "winging it" is more enjoyable and liberating than the planning a designer needs to do. Such random actions also fit better with what many expect from creative people. But that prejudice doesn't make indulging in such behavior acceptable. Creating effective design without any preparation would require a superpower or savant-like capabilities, which you probably don't have—I certainly don't. When I act in a random and uncontrolled fashion, the results are equally unpredictable. To create design that works for my clients, I know I need a solid plan in place. I hope you share this perspective.

Your design solutions are shaped by every cumulative decision you make. These decisions also involve countless micro-decisions about, for example, whether to use a heavy or thin typeface, what printing methods to utilize, whether the designed item will be matte or glossy—you get the picture. Even an approach that appears random requires you to make a deliberate choice to allow it.

Given the multitude of decisions you must make on every design project, you have to find a way to manage them. The Design Method involves grouping these decisions so they're easier to make sense of. The highest level of the decision making occurs during the Planning stage. By sorting out the big points at the outset, it is easier to make subsequent decisions. Don't let the hard work of planning dissuade you from determining an intelligent course of action for the design you've been tasked to create. By planning well, you'll move smoothly into the Creative and Application stages.

Creating a Sensible Plan

Some reading this part of the book will be overwhelmed by the notion of establishing strategy and defining plans. And for some of your design projects, the approaches that I present might seem like overkill. But you have to appreciate the underlying need for a methodical approach and means of acting in all of your projects. Without having a sense of what you'll do and how you'll do it, you'll just be making meaningless sketches instead of plotting a sensible course of action.

During the Discovery stage, you begin to understand your client's situation and identify obstacles. Planning for design allows you to put that information to work and think creatively about how to solve your client's communication problems. Your strategy and plan don't have to be earth shatteringly brilliant to work, so relax. Kasparov is not on the

You wouldn't build a house without a plan—so why would you even think of creating visual communication without one?

other side of the chessboard waiting to lay a smackdown on you. You just need to develop a reasonable way to address the situation at hand.

By establishing goals and objectives, and then determining a strategy to help reach them, you'll create a sensible approach to direct your actions. You'll use the information you gained during the Discovery stage to play (intelligent) hunches, and then add shape to your plan. Tools like personas, scenarios, flowcharts, sitemaps, content inventories, wireframes, and content strategies will all add dimension to your plan. You'll continue to look critically at your approach and explore whether it's still sound by repeatedly asking "why?" This stage of The Design Method should consist of recommendations, a creative brief, and the documentation you create for your client.

In spite of how little I once expected to be involved in high-level planning and strategy as a designer, I find I am increasingly tasked with such matters. These demands are the result of design no longer being just about craft; design is a thinking pursuit that has to help clients achieve their objectives. As long as you don't try to complete all tasks at once, but instead use The Design Method to detail small steps and then follow them, you'll do fine. Your first step should be to outline goals and objectives for your design project.

Establishing Goals and Objectives

Most clients enter the design process with a muddled set of desired outcomes. Many speak in generalities, such as "generate visibility," but fail to clearly identify what they actually need to achieve. Therefore, you have to take command of the situation, challenge any vague aspirations, and clearly document your client's goals. Keep this list short. A list of three goals is ample, and more than five might indicate you haven't fully determined what must actually be achieved.

Many people see goals and objectives as one and the same, but they aren't. Goals are broad hopes that can be optimistic in nature but should never sound like phony corporate speak. Fight back against phrases like "create awareness among the general public." What does that mean, anyway? Avoid ambiguity: Be clear and concise, and don't create overlapping goals. Let's say you're working for a healthy snack conglomerate that represents numerous brands fighting for clarity in

its overall presentation. You might define the company's goals as: 1) Become known for light, fun, healthy snacks; 2) Better leverage the relationships between sub-brands; 3) Create a feel-good umbrella for these brands to operate within. Goals are like long-term hopes, whereas objectives are more like a set of substantial tasks to complete.

Objectives are more defined and measurable than goals. As such, you can assess your actions and determine whether you were able to meet the project objectives established at the beginning of the assignment. As a project comes to a close, you can return to your list of objectives and evaluate whether you have fulfilled these requirements. For the healthy snack conglomerate, the objectives could be: 1) Define a position for each sub-brand; 2) Design identity standards that link all sub-brands; 3) Create a single online presence for the organization that represents each brand.

Take the time to flesh out and refine your client's goals and objectives for the project. Push your client to take an active role in this discussion. If you can pin down goals and objectives, you'll have the first piece of your design puzzle in place. Then you can move on to developing a strategy to work toward these goals. You probably won't find this easy, but did you really expect design to be a cakewalk?

Determining Strategy

Your design requires a strategy, or a mapping of possible routes to help your clients achieve their goals and objectives. Before you can determine any tactics or shape your implementation plan, you need to first develop a high-level approach, or strategy. The words "strategy" and "plan" have different meanings but are often used interchangeably. A strategy outlines *what* you'll do, whereas a plan details *how* you'll do it.

The amount of effort you put into defining a strategy will depend on the kind of assignment you're working on. For example, a brand development exercise will impact an organization for years and thus involve more time and scrutiny than an online campaign with a six-week life span. Regardless, the relevant part of the Planning stage is that you consider what you're going to do now and later, and how you'll make it happen. It's in establishing a vision—and a means of implementing—that you can produce the results your clients need.

When you're developing a strategy, you need to determine what the client wants to accomplish, what broad means you'll use to reach this target, where you'll act (e.g., areas, markets, media), and who you will engage. You should also establish which general capabilities and systems might need to be put into place to help fulfill this outcome. Brevity is key. A strategy should be quick to convey, whereas your plan for acting on your strategy will be more lengthy and detailed. For instance, a soda brand's growth strategy might be to reach new markets by engaging influential teenagers online. The company could then use advertising to reach this audience and encourage teens to create outlandish videos that would be shared on the brand's website and voted on for prizes. Although this is a general strategy, it provides enough direction to move confidently into more tactical planning.

A more in-depth plan might then involve a detailed outline of which channels you'd use to reach this audience, the specific messages you'd convey, and how you'd incentivize the audience. The plan would also document requirements, identify a timeline, and provide a breakdown of associated costs. Developing your overall strategy and an in-depth plan demands that you use your intuition.

Playing Hunches

A strategy represents a well-informed instinct about what might work, and your plan should include many prudent thoughts on how to act. But you'll play hunches on the creative approaches that might work best in your unique situation. The only designers who guarantee results are the inexperienced ones. Long-time practitioners appreciate that even the most reasonable approaches involve informed speculation.

Little is assured when you're working with the unknown. Therefore, you work with what you have, and you do your best. You avoid playing hunches until you're suitably educated on the nature of your client's needs and the overarching situation. Once you do have this knowledge, you can start considering possibilities, linking ideas, and hypothesizing potential solutions.

Given all the variables in a design project, you won't always know when you're taking the right approach. But if you don't try out options, you won't be able to move forward. Trust in The Design Method to

refocus your efforts when you stray too far from the directives you and your client have outlined. As you develop an approach and write up your strategy, your ideas and methods will be forced through filters: You'll need to flesh out how you'll convey messages, examine who to speak to, and critically question whether your messages are accurate, relevant, and honest.

While questioning your approach, you may find that some areas just aren't reconciling as you'd hoped. Such complications are indicative of The Method telling you that your approach needs more thought and refinement. You'll need to return to your goals and objectives and your creative brief (discussed later in this chapter) as a means of examining whether you are making appropriate choices.

Shaping Your Plan

In most instances, you'll develop a strategy and then act on it by creating a plan and ultimately a set of deliverables. Your plan needn't be lengthy, but it requires more detail than your strategy. For the design of a poster you might be able to just create a one-page plan, or a creative brief coupled with some specifications might suffice. For an ad campaign, your plan would be more elaborate because it would need to illustrate the way campaign elements link together, examine audience segments, and include blocking charts, media buy details, and campaign targets.

The important part of a plan lies in how actionable it is. Some marketing folks make vague recommendations no one knows what to do with, such as "use social media to engage your audience." This approach might be a start, but you'll need to do better by filling in the "how." Social media actually doesn't engage anyone. Instead, a good story, an interesting debate, or a funny picture or video is the type of content that might engage an audience. Social media is just the plumbing that connects the audience with this content. If you made the suggestion that a client engage its audience through social media, your plan should outline the audience you'd speak to, the specific tools you'd use, how you'd gain the interest of prospective audiences and motivate them, and the way you'd convert that excitement into long-term value for your client.

Some of the points discussed here might not seem like they're what designers should be concerned with. But understand that the time when a designer could solely concentrate on visuals has come and gone. The only design types who can work purely visually are illustrators, and that's another job altogether. As you step into more complex roles, you'll be forced to understand requirements your predecessors perhaps didn't need to.

Don't allow the variability and potential depth of planning requirements intimidate you. Just concentrate on solving your client's communication problem sensibly and methodically. After you cultivate the "what" (strategy) and "how" (plan), you can then move on to the Creative stage with defined expectations, parameters, and associated tasks. In the following sections I'll present some helpful Planning tools commonly used by interaction designers that you can implement while preparing your course of action.

Planning for Interaction

Interaction design is a discipline that primarily focuses on shaping digital things (devices, apps, etc.) people use. The advantage of using interaction design practices is that they provide an analytical approach that many communication designers would otherwise miss out on. Due to the scope of and space in this book, properly addressing this discipline is not possible. That being said, a peripheral understanding of these tools will be of benefit to you. Therefore, I'll discuss just a few general considerations relating to interaction design: *Personas* help you visualize whom you're designing for; *scenarios, user stories,* and *use cases* provide insight into how people might actually use your design solutions; *flowcharting* adds another way to visualize these interactions; *sitemaps* and *wireframes* are principally used in designing websites; *content inventories* and *content strategies* are valuable devices for helping to define the content in a design and how it should be shaped. Some of these tools are primarily relevant when you're designing for the web; the rest will lend themselves to many other types of design projects.

Every designer should learn from the complexity and interrelated nature of the many elements (visuals, text, code, information

architecture, user experience conventions) involved in any interactive property. This complexity is not unlike the requirements of a visual identity system, a collection of works (e.g., a series of books), or an advertising campaign. All parts must link and work together to achieve the desired result. An ad campaign with inappropriate copywriting will mitigate the possibility of success—in spite of beautiful visuals. Similarly, a website with poorly considered user flows will negatively impact the visitor's experience—no matter how seemingly compelling the interactive elements might be.

Interactions and content, and the experiences they enable, are as important as any visual treatment you might devise. Even a car brochure from an automobile dealer is more than just a brochure. To design this item, you need to take numerous considerations into account: Whom is the brochure intended for? Do they have any unique needs (family requirements, environmental concerns, or a car that adapts to difficult driving conditions)? What are they looking for in an automobile, in a car dealer, and in their lives? What information should you present in this document? What will it sound like? Whose voice should the materials employ? How does it link to other media? What assets (photos, diagrams, technical specifications) do you need to design the brochure? Will the sales representative want to include notes on the brochure? Should it have room for a business card? Does this document need to result in some kind of subsequent action?

Designers who are thinking solely about their portfolio might fail to ask the preceding questions and instead start thumbing through award annuals looking for treatments to apply. But by thinking more functionally about a simple printed piece—and utilizing interaction design methods—you can achieve a smarter way of working. All of the questions relating to the car brochure can be answered by using the interaction design tools presented in the next few sections. You can start by addressing the first question (who is the brochure intended for?) by reviewing your Discovery findings and then creating personas.

Developing Personas

Personas are fictional users that help designers better appreciate the real needs of those who will use their design solutions. During the

design process, you can develop and use personas to help inform and validate your design approaches. Personas can mimic real individuals who are representative of common users, or they can be entirely fabricated to achieve the same end. Persona development is as useful in the design of a brand, product, environment, advertisement, or package, as in designing interactions.

To create a suitable design plan, you must consider and build it around the audience or end user. Sometimes this viewpoint isn't easy for designers: They can't appreciate that the type is too small because their eyesight is perfect. They can't imagine why an image needs to be compressed further because they have a fast Internet connection. And they can't understand why people say their site is difficult to use because they've spent the last six months ensconced in it. Developing personas forces you to consider those who'll use what you're designing.

Personas are a logical extension of the audience fact-finding research you did during the Discovery stage. So by now you should have a good sense of whom your design solution is intended for. Now is the time to fill in the details. Talk to your client about the 5–10 types of people who exemplify the audience you need to reach. Then consider their habits and characteristics as you assign shape and qualities to them.

To know who they are, you'll need to determine age, cultural background, gender, lifestyle, vocation, literacy level, likes and dislikes, hobbies, and whatever else you need to give your personas dimension. You'll also need to know what motivates them. What do they care about? Why are they using this designed item? What do they need? And, what matters to them? You want to achieve a sense of these individuals and apply enough detail to get inside their heads.

Try to avoid creating duplicate personas, which just makes extra work with little value. Instead, examine the variety of people you need to communicate with. Take into account how they are different and how their needs vary. Some personas will serve as archetypes, representing the primary types of people who will use the designed item. Others will be more specific users—possibly fewer in number (these less common examples are referred to as *edge cases*).

Consider the following example to help illustrate the creation of personas. Imagine you are helping a public art gallery create a new website and have learned that a few specific groups are the primary

Wilhelm Gisbert
Tourist

- 63 years old
- German tourist on holidays
- Has one day left in the city
- Speaks mostly German; some English
- Language skills make navigating hard
- Would like to visit a major attraction
- Dislikes using translation dictionary
- Recently bought a smart phone
- Concerned about costly roaming fees
- Needs really basic information

Kenzie Pat
School Teacher

- Young and eager sixth grade teacher
- Works at a suburban public school
- Wants to engage students in topics
- Believes learning comes from "doing"
- Explores ways to get students involved
- Likes to take kids out of the classroom
- Appreciates supplemental materials
- Uses these to enhance lessons
- Loves when students enjoy learning
- Encourages thinking about careers

Gyeong Uk
Event Planner

- Enthusiastic and hard-working
- Plans private events
- Focuses on high-end weddings
- Goal is to surpass her expectations
- Worked at an event agency for 5 years
- Has started her own business
- Knows the city's memorable locations
- Works long days
- Finds that event details often change
- Values flexible/accommodating venues
- Needs quotes/images on short notice

Persona development helps you understand your audiences and the factors that affect and motivate them. Understanding your audience is a pathway to more functional design.

users of the facility. The average visitor is local and approximately 45 years old. Young adults also attend openings and galas, and senior citizens visit on quiet weekdays. All participants use the gallery's website to get information about hours of operation, current programs, and gallery closures. From each group you could create one persona and consider how the visitor's needs and attributes vary. But these personas wouldn't reflect all the people who visit the gallery and website. Students come for group tours led by teachers who use the website to plan their visits. Donors use the website to view AGM (annual general meeting) notes and ensure that their funds are being put to good use. Artists visit the site to get information on application procedures and deadlines. In addition, journalists, event planners, tourism groups, prospective visitors who don't speak the local language, visitors with accessibility or mobility limitations, and many others use the site for their own respective needs.

The preceding hypothetical example consists of many varied individuals you could learn from through persona development. Over 10 personas could be created for the art gallery example and clearly not cover all those who might need to use the website that you're building. My point is that the needs of each party are different—sometimes dramatically—and will affect how you design this site.

Distill all of your notes about the habits and requirements of each

group to 6–10 bullet points and avoid getting too detailed. Invent names for your personas and visit a stock photography website to find images to represent these fictitious people. Although you might feel like you're playing make-believe at first, keep in mind that this practice is a very useful tool to help test your plan. The main intent is to establish a set of appropriate examples that give you a perception of the audience you're building for.

Scenarios, User Stories, and Use Cases

With personas in place, you can then consider how these people will interact with the design, how they'll use it, and what they want to achieve through its use. By using additional development tools, such as scenarios, user stories, and use cases, you appreciate the needs you're designing for and uncover potential obstacles your audience faces in achieving its goals. Such approaches are standard practice among interaction designers but less common elsewhere. The infrequent use of these practices by other types of designers represents a lost opportunity because a great deal can be learned by using these tools in nondigital design settings. Let's explore each of these tools in depth.

A *scenario* is a narrative that chronicles one way a system might be used. This construct anticipates the goal, users' knowledge, and how they might interact with the design. The scenario needn't be overly specific—a paragraph or so—but should help you understand the important tasks. Scenarios are typically created during the Planning stage of a project. Here's an example:

> *Uta Heisenberg is in town for the day with only a few hours before her return flight to Germany. A representative at a visitor information center tells her that the city's art gallery is worth visiting, so she pulls up the gallery's site on her mobile phone. She clicks the link offering basic information in her native language and learns that a contemporary pottery exhibit is at the gallery. Uta loves ceramics and enjoys seeing what new artists are doing. She checks the hours, quickly scans the rates, and then clicks the Map link to get detailed directions to the gallery.*

A *user story* tells a story about someone using the product. Go figure. This approach affords a quick way to identify how a specific person would use a designed item and for what reason. User stories are short—often a sentence will do—provide limited detail, and use common language. You can utilize user stories at the beginning of and throughout a project. Here's an example:

> As a journalist, I need to download a photo from the site's media library to finish my article.

A *use case* is a granular list that defines the steps taken by a user to complete an action. Use cases start with the trigger that initiated the activity and then describe the required interactions between the user and the designed item to reach a goal. A use case helps identify requirements by examining how a procedure will execute. Here's a very brief example:

1. *A member receives an e-mail alert to renew her pass.*
2. *She clicks the Renew link at the bottom of the e-mail.*
3. *A browser window opens showing the sign-in page.*
4. *The member types in her e-mail address and password.*
5. *She then clicks Submit.*
6. *A logged-in screen loads and displays member options.*
 ...and so on

Admittedly, this last example is briefer and more rudimentary than a proper example should be; nevertheless, this quick overview gives you a sense of how this tool can assist in the creation of a design and how each approach varies from the others. To extend your knowledge of these topics, you'll find plenty of varied approaches, examples, and worksheets in books and online. For now, this simple introduction should help you get started.

Even if you use these tools only casually, scenarios, user stories, and use cases are surprisingly beneficial in helping you determine requirements, add dimension to design solutions, and identify possible shortcomings. They can also be illustrated through flowcharting.

Flowcharting Actions

Determining the sequences, or *user flows*, associated with the items you design can help you understand the requirements and constraints you need to design for. User flows illustrate the path followed by users through an interface to fulfill their objectives. The fact that user flows are common in interaction design doesn't limit them to digital settings.

Not long ago our agency helped a city craft a campaign aimed at locals and visitors from select markets. The intention was to make them aware of cultural opportunities and encourage them to buy tickets, take in shows, and enjoy the city. The multifaceted campaign combined digital display advertising, social media updates, an event calendar, a contest component, and a handful of videos that documented visitors partaking in events and activities.

One concern with this campaign was that the audience shouldn't just see one ad but rather be engaged in many ways throughout the duration of the campaign. Therefore, we created flowcharts that documented the varying ways we'd reach the audience, the path they might then follow, and the way we'd bring them back to the campaign and associated events. Working through this flow helped us determine

Campaigns are often complex, with many interrelated parts. That's why we try to map the potential flow of users and activities—like you see in the above diagram. I admit, it may seem a little confusing; however, having this to work from helped us understand what we needed to build, and how each element would work together.

which assets the campaign required, how to customize messages for a specific stage of the visitor's engagement, and even what didn't need to be created. As a result, we knew we needed information kits to engage partners and local media; conversely, we realized that our chosen display media channels precluded us from creating bigger, more interactive, digital display ads.

As with many other planning tools, you can easily trick yourself into thinking that you needn't take the time to utilize them because you might be in a hurry. Fair enough; however, you lose out by not benefitting from what they can afford. Many designed items seem to work until you inspect them more closely. The simple act of sketching out the flow of actions allows you to identify redundant steps and spot those that don't work as they should.

Planning a Sitemap

A sitemap is a bird's-eye view of a website's structure and provides clients, designers, and developers a broad overview of a website, showing how content is grouped together and how a user can navigate from one page to another.

At the initial stages of planning a website, a sitemap is most useful because it allows you to rapidly visualize the site at a high level. Although a text-based list of site content forces you to imagine structure, it is more difficult to use to recognize relationships than using a simple drawing with all the associations mapped out.

When you build a sitemap, concentrate on identifying the main sections, pages, and relationships, and avoid making it too granular. Also, you might find utility in creating visual ways to delineate page types and overall importance. For example, you can identify groupings, pages, stacks (e.g., numerous blog posts), and future pages with unique outlines, colors, or icons. Similarly, hierarchy can be shaped and implied visually. We've found success in sorting sections into primary, secondary, and tertiary groupings and then assigning a color to each.

Some confuse a sitemap as an illustration that shows how each page links to others, but linking between pages isn't the purpose of this tool. Instead, the sitemap technique helps identify where pages fit and how they are organized. Drawing a sitemap is a great way to start

planning your websites and help clients visualize the structure of their website. However, a sitemap can take time to prepare, augment, and keep up to date. Therefore, you should treat a sitemap as a starting point and more heavily rely on your content inventory as you continue planning the design.

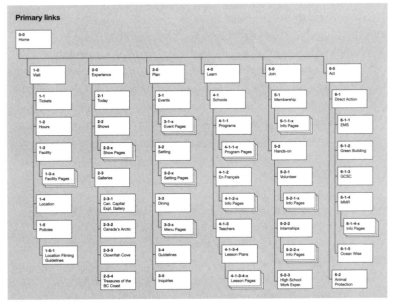

Sitemaps aren't meant to work as exhaustive site inventories; however, they do help you visualize the relationships and broad requirements within a website or application.

Developing a Content Inventory

A content inventory serves as a catalog of a website's contents. The inventory identifies pages, sections, and functions; it also notes the text, images, applications, documents, and other assets in the site.

This inventory tool should be used at the beginning of a project to understand legacy content and structure new content. Your content inventory will also help you estimate resource requirements and associated costs. As your project progresses, the content inventory becomes a living catalog that documents progress, identifies needs, and aligns the efforts of all collaborators. Later, during the Application

stage, you can use the inventory to organize new content and maintain consistency in metadata and naming conventions.

If you're redesigning a website, begin with a content audit of the current site. The audit should involve a crawl of the entire property and the creation of an inventory that shows what currently exists. You should pair the initial inventory with analytics data to understand what content is relevant, missing, or unimportant. Consequently, you'll identify which pages to keep, discard, merge, split, or recategorize.

At the beginning of a site design, the sitemap and the content inventory are developed somewhat in tandem. As you learn more about the site's content, you'll augment the overall structure and reflect your changes in the sitemap. Later in the process you'll make these changes almost entirely in the content inventory. The main reason for linking the two tools at the outset is to present a high-level as well as a detailed site structure to your client.

We set up our content inventories as spreadsheets to make sorting, organizing, and editing easier. Each page has a unique identification number, and columns in the spreadsheet are created for the New Page Name, New URL, Previous Page Name, Previous URL, Document Type (e.g., PDF), and HTTP Code. We make columns for the Page Title, Meta Description, and the Template used by the page. Other columns assign an Action (keep, delete, etc.) for each page, a Rationale for the Action, and room for Notes. We then identify the current status of Text, Images, and other content.

The last part of the content inventory contains an area for analytics findings that document Page Views over the past 30 days, Page Views over the past year, and Average Time on Page over the past 30 days. You can set up your headings as you'd like, but the items noted here provide a very clear sense of what a property contains and how to act. Such detailed inventories aren't as big of a concern with a small site, but when the one you are working with has many hundreds of pages, a content inventory becomes a necessity.

Just because a content inventory is described here in relation to websites doesn't mean you need to limit the use of this tool to interactive properties. A content inventory can be equally useful in the design of a magazine, a book, or any other content-rich setting. The order and clarity that this tool provides is staggering and helps minimize the risk of errors and oversight.

Building Wireframes

Wireframes are visual guides used to establish webpage layouts, navigation schemes, and user interactions. They are essentially a schematic representation of a webpage that focuses on form and function. The fidelity of wireframes can vary greatly—from loose sketches to detailed vector illustrations—but their core purpose remains the same. Like sitemaps, clients, designers, and developers use them as a common reference.

Because wireframes do not use color, photographs, or refined text content, these guides are not visually complete representations of a website. Wireframes use Greeking (placeholder text), as well as boxes and lines to represent and determine placement, scale, organization, and flow. Designers should never consider visual treatments before working through the development of wireframes. Even the design of a book would benefit from the creation of thumbnails first, which principally fulfill the same function as wireframes.

My preference is to start with very loose sketches of the core pages in a website, and then increase the size and detail in these drawings. As these blueprints become more refined, you can move them into a vector drawing program. Wireframing is a key design stage: In fact, I'd argue that the development of wireframes is more important than the creation of comps because many of your system's underlying visual rules can be sorted out during wireframing.

Some feel wireframes should be created in a very loose fashion and not include lots of detail. I disagree. A productive wireframing exercise should help you define the hierarchy of elements and the relationships between them, and help you structure and test the grid and identify navigational treatments and cues. Additionally, you should use your wireframes to establish conventions, like typographic standards, specific page types, and template usage, to ensure that all of your client's content can be effectively contained in your design.

Some designers and developers employ more agile development approaches in which they start to code loosely without rigidly pinning down wireframes. There are certain advantages in taking this looser approach, particularly as screens become more varied and design patterns are forced to work in more responsive settings—in which the same layout may need to change to adapt to different screen sizes.

In the past, you could build wireframes assuming the page would be relatively fixed in nature, but that's no longer the case. Still, taking the time to at least map out the approximate placement of page elements can minimize potentially costly missteps. With your wireframes in place, the next phase should be to determine what goes into this system you have created.

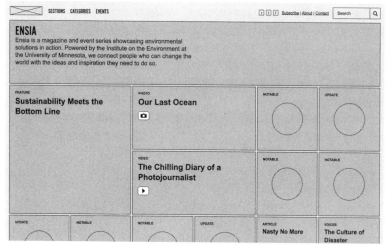

Most wireframes start out simply as pencil sketches; as you refine them, they can become quite detailed, making the creation of comps that much simpler.

Determining Content Strategy

A content strategy involves planning the creation, delivery, and management of all content in a designed setting. Most commonly used in the development of websites, use of a content strategy results in a presentation that is clear, ordered, and cogent versus one that is disjointed, random, and potentially confusing. Defining a content strategy enables you to do more detailed planning in tone, style, media selection, scheduling, and many other components. Those who contribute and publish content to your website, magazine, book, or other content container can then adhere to these guidelines.

Developing a content strategy can be complex, because the activity demands that you examine an organization's reasons for

delivering content. If nothing else, it should compel you to have a critical discussion with your client. Many clients are convinced they should utilize every available content delivery device. They create blogs (sometimes many) for their organization, printed documents, microsites, Facebook pages, Twitter handles, e-mail newsletters, YouTube accounts, Tumblr blogs, podcasts, Instagram pages, and the list goes on. This plethora of new communication tools has turned many organizations into publishers of content, which forces them—and you—to define and shape the content being created.

A good content strategy helps you and your client generate more consistent content, appropriate to the audience and setting. This results in a better user experience, greater brand uniformity, a more pleasing pace and flow, stronger personalization, clearer overall communication, and content that is easier to scan, locate, read, and comprehend. Using this tool also increases operational efficiencies and even affects SEO (not the black-hat variety).

In addition, a content strategy might provide general recommendations on how to shape stories, a plan for content creation, and a style guide to help inform those tasked with preparing content. Other potential components might include a glossary of common terms and usage requirements, a means of determining appropriate placement or media, a framework for metadata creation, and a list of standard workflows documenting the tasks involved in the creation, vetting, approval, and distribution of content.

Although many confuse content strategy as being solely focused on textual content, it needn't be limited in this way. Content strategy can help define image selection, use, and presentation. This tool can also be applied to illustrations, documents, data, forms, video, diagrams, animations, alt tags, and other content housed within a design solution. This strategy can also inform content practices in peripheral media, such as Facebook posts, tweets, press releases, and so on.

Few give content the credit or attention it deserves. Keep in mind that most design needs content more than content needs design. A book containing good content can live without design; however, a book without good content can't be made great through design.

Now that you're familiar with several interaction design tools, I'll provide a few other general suggestions related to the Planning stage.

Recognizing the Traps of Shadow Planning

Throughout the Planning (and Creative) stage, you'll understandably want validation for your choices; however, this need for reassurance is not always practical. Although you might be able to locate examples of how others have done what you want to, you must keep in mind that they worked in different settings and their results might not be directly applicable to what you're doing. Shadow planning happens when designers imitate others by placing too much weight on what already exists and misuse phrases like "best practices" to make their copycat approaches seem more acceptable. In actuality, this shortcut removes design from the process and leads to limited and derivative work.

An example of such derivative action was demonstrated in smartphones circa 2006. As an early adopter, I can tell you that the experience was painful. Microsoft, RIM, and Nokia owned the market, and their OSs were primitive. Other companies entering the market seemed to fall victim to shadow planning. They looked at the conventions in place, copied the ones that worked, slapped on a logo, and claimed to have designed a viable solution.

The designers at Apple might have looked at what already existed, but they certainly didn't want to reproduce the same experiences. In its place, they created a whole new model. In creating iOS and the iPhone they concentrated on the finger and touch instead of replicating desktop paradigms. By doing so, they designed a tool that changed how the public viewed mobile devices. All of the other players quickly tried to play catch-up—in spite of the dramatic lead they initially had—to a new adversary that until then hadn't done anything substantial in the mobile space.

Shadow planning allows you to trick yourself into thinking that following others' steps will insulate you from failure. Unfortunately, a universal path to success is rarely easy to identify and follow. Instead, you need to think critically and devise a plan of your own.

Challenging Approaches and Beliefs

Many designers experience discomfort when they're providing big-picture strategic advice and fleshing out design plans. You

have to push this fear aside. The moment you're brought into a major project, like the redesign of a corporate brand, you make a substantial commitment. In fact, you become part of one of the biggest discussions any organization will ever have. Your clients need you to step up to the role and help them assess, plan, suggest opportunities, and remind all involved to challenge every assumption, idea, approach, treatment, expectation, and possibility.

Although there's little assurance that your counsel and actions will result in success, you mitigate the risk of failure by tapping the intelligence and wisdom of your clients and remaining inquisitive. Your clients might be acting out of habit, or tradition, without seeing much need to change. But by asking them *why* they're doing what they are, you could achieve great insight.

Asking *why* resulted in ketchup bottles that dispense contents from the bottom instead of requiring the diner to brutalize the bottle to release the condiment. Asking *why* allowed Netflix to redefine the delivery of entertainment to audiences. Asking *why* resulted in car co-ops that rethought the car ownership model, minimizing environmental impact, reduced driver costs, and allowing members access to a vehicle when they needed it.

You ask why not just for your clients, but also because the question relates to the work you produce and the way you produce it. It forces you to look at every suggestion you make, every approach you implement, and every visual treatment you apply, and ask additional critical questions. Does your approach support your client's goals and objectives? Is your strategy the most suitable means of acting? Does your plan hold up when you consider the group's overall efforts? These questions involve determining why you're doing what you are and whether you're acting out of impulse or making the right decisions.

Making Recommendations

You bring fresh eyes to the projects you work on. Don't ever forget how important your outside perspectives can be. Being open to spotting opportunities during the Planning stage means that you can potentially offer recommendations your clients will find helpful.

If you have many suggestions, group them accordingly by using

By systematically listing recommendations for your client's project, you add real value for your client—and make clear that you're about more than pretty pictures and nice swirly type.

headings like Marketing, Communications, and User Experience to help cluster points, making them easier to understand. Don't limit your feedback to points that are design related. If you see ways that your clients could be approaching their work better, note these possibilities in a somewhat general way. Because Planning is evolutionary, your first recommendations needn't be definitive. Some of the suggestions you make might be rejected. No matter; the important factor is that you have an opportunity to present them and gain a sense for whether they might be useful.

Additionally, you should review the problems you identified during the Discovery stage. Reflect on each of these pain points and determine whether you might be able to address some of these challenges in your design solution. I've found success in listing challenges and providing a few bullet points along with possible steps to note what could be done to deal with each problem.

Crafting the Creative Brief

A creative brief is a highly refined document that benefits everyone concerned by its accurate, cohesive, and succinct form, so it's best to aim for one page worded concisely rather than three pages of

meandering content. The purpose of this brief is to provide a rapid overview of the project at hand to the parties involved in the design solution's use, creation, and vetting.

Suppress the urge to make your brief aspirational or grandiose. Just address all points clearly and simply. State what you're marketing and the role of the item you're designing. Describe the audience you need to reach and what you need to say. Back up your claims by explaining why your statements are true and relevant, and detailing the competitive advantage. Wrap up with three words that describe the tone you intend to achieve. You might also want to write a short sentence to help clarify what you hope to accomplish through your selected tone. Here is an example of the creative brief I composed before I started writing this book:

What are we marketing?
A book that helps designers better understand process and employ it in their daily practice.

What is the role of the communication?
To illustrate the benefits of consistent and logical design process, and outfit readers with tools for working in this manner.

Who are we trying to reach?
- Practicing designers
- Design students
- Those who work with designers

What do we need to say?
Working in a practical and procedural manner helps designers work consistently, makes studios run efficiently, and results in the most suitable design for clients.

Why is this true and relevant?
- Designers who ignore process tend to work inconsistently.
- Methodology can help designers sidestep creative blocks.
- Clients get better service from designers who work methodically.

What is the competitive advantage?
- Clarifies the nature of design and demystifies processes
- Provides actionable processes/tools for creating good design
- Is informed by working designers who use these same methods

What is the tone?
Accessible, usable, clear/organized
(i.e., *The Design Method* is an *accessible* book on design
process that provides highly *usable* suggestions in a *clear*
and *organized* fashion.)

Having reexamined all of the Discovery and Planning material you
gathered and organized, you should have all you need to complete
your brief. That doesn't mean the creation of your brief will be easy.
Most likely, you'll have to work harder on this short document than
on many other items you create. Avoid jargon, decorative phrases,
and vague promises. If you start writing phrases like "a life-changing
Web 2.0 platform," you should rewrite your descriptions so they read
plainly, such as "a photo-sharing app."

Look for overlapping content in your brief. If your descriptions
blur from one area to the next, you probably haven't yet achieved a
sufficient level of clarity. A trick you might use to test the strength
of your brief is to look at your points and ask, "compared to what?"
There's comfort in writing superlatives like, "best in class" or "easiest
to use," but these phrases don't mean anything because everyone uses
them. If the item you're promoting is that easy to use, support your
argument with evidence. A good creative brief should clearly state and
make understandable the job ahead.

Preparing Documentation

Clients and users alike rarely understand the amount of careful
consideration required to make functional design. But by summarizing
your planning in a set of organized documents, you'll be able to easily
illustrate your logic and decisions to your clients.

One document should house your overall strategy and general
plan. Interactive projects will require an IA/UX (information

architecture/user experience) plan that outlines how you're organizing the website or application's functions, structure, content groupings, interactions, conventions, and models. However, different projects will require varying documentation—perhaps a content strategy, media plan, technology plan, or other documents as the project necessitates.

Amassing findings is one part of your job; getting this data into a format your clients can understand is another. For this reason, crafting standard documents for use on all projects makes good sense because it allows you to use the previous version as a template, strip away the client-specific data, discard any unnecessary pages or sections, and then fill in the blanks. Smaller projects need less documentation but still require evidence of your logic to discuss with clients. Sometimes a simple two–three page document will do. With more casual clients, an e-mail sorted by headings and bullet points will suffice.

When organizations want a greater number of participants involved in the process, a slide deck might also be useful for presenting an even more succinct summary. By its very nature, a slide presentation forces you to keep your ideas and observations brief and to the point. Avoid long-form sentence structure in these documents; such length will make your document impossible to work through in a single session. Schedule two–three hours for each plan you present. Any longer than that, and you may be getting more granular than your clients will appreciate (you can tell this is happening when their eyes

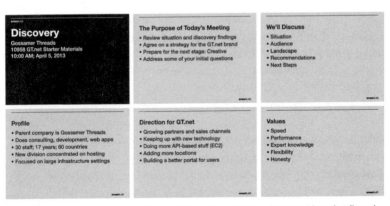

The way you present your work to clients will make the difference between ideas that fly and those that die. Produce clearly organized presentations that help convey your thinking.

start to glaze over). Typically, you can spread out these presentations a little, because you'll probably develop your general plan, UX plan, content strategy, and any other required plans a few weeks apart.

Presenting your findings and recommendations always takes longer than you might expect. Odds are that you've collected and recorded a substantial amount of critical thoughts and data, and you'll want to convey all of your observations and beliefs thoroughly. Look carefully at your notes when you compile your presentation: Group your points logically and edit them. Remove any content that doesn't add to the plan. Eliminate extra words, merge similar points, and ensure that your suggestions are actionable. The stronger your plan, the more apt you are to achieve success. I discuss presentation and documentation in greater depth near the end of the book, in Chapter 9, "Presenting Work to Clients."

Keeping Your Design Project Moving

Although strategy tends to remain intact during a design project, plans generally evolve. What's important is for you to ensure that this evolution moves you closer to implementing your strategy and achieving your objectives. The longer a project goes on, the easier it is to get bogged down, go off on a tangent, or get mired in approaches that don't address the concerns you set out to remedy. Therefore, review your initial plan regularly to make sure that you're progressing on schedule and on budget.

At smashLAB we start substantial documents and presentations by recapping the creative brief. This practice helps to remind our client why we've made certain choices and ensures that all parties are aligned. Because the creative brief details the design approach in a more applied manner, making it easier for many to envision, we refer to that document often with our clients.

Internally, the goals and objectives are more useful. To reference this short list easily, I keep a printout on my desk or on the adjacent wall and refer to it often to make sure we're doing what we first proposed. If we're veering off course, I want to know early in the process while there's still time to change the approach. You should do the same. Regularly check your goals and objectives, and ask *does the*

approach still work? If you start making excuses for deviating from your initial plan, stop and take a hard look at your entire project to determine the reason you need to do so. Sometimes your objectives will require minor tweaks—that's OK. Just don't get so wrapped up in your ideas and their implementation that you lose sight of what you were supposed to help your client achieve.

Up Next

The third stage in The Design Method, Creative, focuses on exploration, selection, and refinement of ideas. In the next chapter, I'll explain how to use all you've learned so far and continue to move through the funnel. You'll learn to define a single creative approach that clients can weigh in on prior to you crafting the design assets.

Working with Ideas: The Creative Stage

In the Creative stage of The Design Method you define a concept and design direction, and evaluate their effectiveness. You'll then obtain client approval to follow this creative path in the Application stage.

"Oh Yes Indeed, It's Fun Time..."

Regardless of my arguments supporting the need for sober observation and thinking, working with ideas and exploring implementation possibilities are the most rewarding parts of the job. With all of the Discovery and Planning stages finally behind you, the fun can begin!

Well, not so fast. You'll apply the same sort of rigor to the Creative stage (and later the Application stage) as you did during the previous two stages. During the Creative stage, you'll focus on establishing a concept and design direction. These two pieces will help you gain the confidence and buy-in of your client, allowing you to move into the Application stage. You'll ideate, work through creative blocks, and evaluate your ideas—which means you'll also be forced to kill some of the ones you might like most.

You'll benefit most from the Creative stage of The Design Method by subscribing to a few essential notions. These include enlisting a colleague who can challenge your thinking, generating many options quickly and efficiently, and working in broad strokes at the outset of your projects; later in this stage, you'll edit your many potential ideas down to one concept and set of visual styles for all involved parties to review and agree on.

One point that may surprise you in this chapter is that the Creative stage of The Design Method doesn't involve building out any design assets. Instead, it's about establishing a general idea and then figuring out how it will look and feel. In doing so, you clarify your creative plan before you begin producing design elements. Once you have your client's approval, you can move into the Application stage, confidently prototype your design, and then refine it.

Let's first examine how your enthusiasm surrounding the creative work might be thwarted—right when the fun is supposed to start.

The Creative Conundrum

All creative people have at one point or another dealt with "blank page syndrome." You embark on a project with gusto, which soon fades and turns to dismay. The ideas don't seem good enough. One is boring. Another is overly outlandish. The next is too much like your

last project. And the others seem like rip-offs of designers you admire. Instead of seeing opportunities, you're surrounded by dead ends.

Doubt creeps in, pressure builds, and moments seem to last for hours; even so, days fly by with little to show for your hair pulling, paper throwing, and wall punching. You wonder if you are cut out for the job and fear that you are an impostor. You ask why you never have the right idea, whereas other designers appear to easily find inspiration. Take some comfort in knowing that all creative people

Some are scared of ghosts, others are unnerved by snakes; however, few fears match that of the creative person facing a (shudder) blank page.

share these frustrations and uncertainties at some point.

People get jammed up at the Creative stage for a few reasons. Many creative obstacles start from a lack of preparedness. Designers leap to generating ideas without properly knowing their client or determining a strategy and plan for the project. Then, without sufficient groundwork, they set the bar immeasurably high. Having just read Sagmeister's *Made You Look*, Fletcher's *Beware Wet Paint*, or Hall and Bierut's *Perverse Optimist* documenting the work of Tibor Kalman, these designers want to match the wit, surprise, and innovation found among these great minds.

Another obstacle faced upon moving into the Creative stage is a shift from analytical tasks to those requiring you to synthesize and generate possibilities. Sure, Planning requires such tasks, too, but that is done with words. Transitioning to concepts and visuals adds a layer

of abstraction. This complication can lead you to spawn random ideas that then can become tangential. Such divergent thinking will leave you with more questions and problems than you can handle.

The biggest challenge is that you think too much about what you *could* do and what others have done, and this anxiety prevents you from simply doing the work. You procrastinate and make excuses: Too many obstacles exist. The parameters are ill-defined. The client, the budget, the timeline, or some other variable is to blame. Sometimes these challenges may be real, but dwelling on such obstacles just wastes your time and energy. Instead, you just need to get to work.

You'll find a way around these obstacles by continuing to use The Design Method funnel (discussed in Chapter 4), which will help you maintain focus and keep you moving toward your goals. The Design Method removes some of the randomness from the design process because it is divided into a series of tasks that make the job ahead more manageable. And in the event that you are still stuck, you can refer to some blockbusting tips I provide later in this chapter.

By working through the Discovery and Planning stages, not only will you understand your clients and their situation, you'll also know what you need to accomplish. This preparation puts you miles ahead of your peers. The logical nature of your work up to this point continues as you generate ideas.

Being a Methodical Designer

Ideas are slippery. Those that seem great now might not later in the process. In addition, most people aren't able to see new ideas accurately. Time lends clarity; unfortunately, you can't just stop working while you're waiting to find out whether an idea is any good. Again, methodology helps you make decisions and differentiates you from those who are victims of chance.

As a methodical designer, you move into the Creative stage fully informed, using a well-thought-out plan to help guide your efforts. You don't confuse your role with that of an artist; instead, you understand your function as a designer who needs to deliver a suitable design solution that fits your client and fulfills the plan you've agreed on.

You'll explore options, analyze which are most sound, and

document your tactics. You'll then measure these options against your initial goals, objectives, and the creative brief. By narrowing your choices and decisions further, you'll establish a design direction that works with your creative concept. Along the way, you will continue to employ the same systems thinking perspective discussed in Chapter 3.

Some Key Principles for Developing Creative Work

Before exploring concept development, you need to understand a handful of essential guidelines that will shape how you develop creative work. These perspectives are important because they expedite how quickly you can deliver good, workable ideas and design guidelines for your clients.

First, you must work with an editor—someone who can vet your ideas long before you present any ideas or implementations to a client. In an agency setting, this assignment would be delegated to an art director or creative director. If you do not have access to either, you'll need to work with a colleague who knows the client and project but isn't actively involved in brainstorming ideas and producing visuals. Designers at smashLAB use me in this capacity. On projects where I am the designer, I rely on my business partner to fulfill this role. His knowledge of the client, coupled with his distance from creative tasks, allows him to challenge my logic and lend objectivity to the process.

Second, you must value time and act efficiently. It's all too easy to overinvest your effort in one part of the project, and then find out too late that you're short on time. Such sloppiness will impair the quality of work you provide, put your job or business at risk, and diminish your mental health. You need to ration time appropriately, make clear decisions, and access client feedback early and often. This discipline will help you avoid endeavors that would otherwise wreak havoc on your schedule, budget, and objectives. Set a personal time limit for every task you take on; this restriction will frame the amount of effort you put in and help minimize dallying. With this increased speed, you'll be able to rule out weak leads early, which will more quickly bring you to a viable path. Although you might think that moving fast will result in sloppy work, the opposite is the case at this point. A little pressure forces you to make more immediate decisions and curtail

procrastination. Additionally, because you're usually more excited about a design project at the beginning than at the end, working quickly allows you to capitalize on this excitement at the outset and helps you make big advances before you tire out.

Third, you must use broad strokes. You'll first manage big issues, and then deal with the smaller ones. You'll survey tone, articulate your concept, explore possible styles, and clarify your course. Avoid leaping to granular decisions too early. Choosing appropriate tools will help you stay generic. Avoid the computer and the level of control it provides to create elements in detail. Instead, doodle on napkins and sketch ideas with markers on large sheets of paper. This same practice also works during the Application stage, when you finally move your rough drawings to the computer. You'll use placeholder text, low-resolution images, and simple shapes. Explain to your clients that this crudeness will help keep their project on time and on budget. Rather than fill in specifics early, you'll always determine a path and get their endorsement prior to moving forward. In doing so, you'll identify obstacles before they become insurmountable.

With all of these principles in place, you can start to look at the overall tone of the project and how it shapes your design solution.

Considering Tone

In the previous chapter you defined tone in the creative brief. You chose three words to describe the feeling you wanted your finished design to convey. These three words are important because they serve as a compass of sorts as you move further into the design process. You'll use them to help you make design decisions, measure success, and ensure clarity in the solutions you generate.

Words are tricky. What a word connotes to one person isn't necessarily what it implies to another. To my sons, the word "fun" means a day at an amusement park; to me, the same word implies a couch, a bottle of scotch, and a good movie. You and your client also associate different meanings to some words; in addition, these meanings can change over time. This is the reason you need to investigate the words you use to describe tone, define them visually, and then achieve a shared understanding.

Create a folder on your computer for each of the words you've chosen for a project's tone. Starting with the first word, run an image search on the Web and fill your folder with visuals that align with your perception of the word. You won't organize these selections yet; instead, you'll focus on collecting as many as you can. Once you've covered all the relevant associations, you'll move on to the next word and repeat the search.

Then examine your selections. Have you sufficiently surveyed the available images? Are they accurate? Does each tone seem distinct? If some images overlap from one tone to the next, you might want to rethink your choices. You don't want your tone selections to convey three synonyms; you need three discrete terms that help define the project—and perhaps client. If necessary, revise the three words you've selected for tone until they work.

Next, create a mood board, which can be in the form of a single printed sheet, a slide in a PowerPoint deck, or a PDF for onscreen display, containing a sampling of the images you've selected. You can assemble a mood board in a variety of ways. My preference is to choose one of the tone words, and then use five terms to describe possible associations with that word. I then pair these five associated terms with approximately ten images to create a mood board. Then I apply a basic visual hierarchy to them, making the images most appropriate to each tone largest. By avoiding repetitive imagery, the variety helps establish parameters for what each tone selection represents. I then repeat the procedure for the other two tone words, creating a mood board for each.

On a recent project, we chose the words Solid, Experienced, and Personal to describe the tone of our client's brand. On the mood board for Solid, the possible associations with this term included stability, engineering, dependability, timelessness, and strength. Our image selections included a Leica M9, a stool, a diver's watch, a lathe, a massive tree, Dwayne "The Rock" Johnson, an Eames Aluminum Group Management chair, a DeWalt drill, an old Jeep, and a wooden mallet. When we searched for images for the words Experienced and Personal, the results showed very different images. These tonal observations helped us establish the associations we wanted to help the client achieve with its intended audience.

Searching for images can be a bit overwhelming and can take a

substantial amount of time. The power in this task not only helps you define connotations, but also helps you investigate alternate ideas related to your chosen terms. When you later present these mood boards to your clients, you'll be able to better understand whether or not your perceptions are shared. These boards will also provide you and your client with a strong understanding for what you'll need to convey in the finished design.

Through the exploration of tone, you'll become familiar with relevant associations for your project and client; this awareness will help you start to generate ideas.

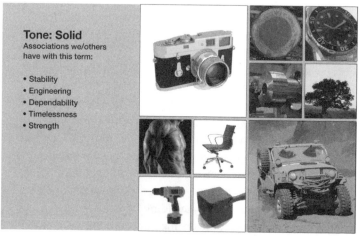

Determining tone is a critical part of the creative process. By establishing these notions and mapping their meaning, you establish shared ground with your client.

How to Generate Ideas

Now you can start to determine a creative plan for your design project. This activity is called *ideation*, and it involves the development of new ideas—conceptual or applied. In this stage of The Design Method, you'll concentrate on conceptual ideas, keeping your ideas loose in nature and not worrying too much about specific implementations until later. (You'll start to determine visual treatments later in the Creative stage. During the Application stage, you'll use the plan you establish here to inform your design assets.)

Ideation is most successful when you're doing it, not thinking about it (which leads to analysis paralysis). By acting, you're more apt to discover new possibilities. Pick up a pencil and start writing, sketching, and doodling. Your ideas needn't be good; you don't even have to return to them. Just start recording your ideas on paper, a chalkboard, or some other device. Your actions and efforts can help silence those doubts in the back of your mind.

Although you might encounter the odd situation in which your first idea is a gem, such lucky breaks are uncommon. It's difficult to see ideas clearly when they're right in front of you. Given a few days' reflection, your favorite ones might turn out to be weak or derivative. To accurately assess ideas, you need other ideas to compare against. Additionally, it is difficult—almost impossible—to fairly judge ideas during their creation.

People sometimes call ideas their "babies." But this is a risky way to perceive your ideas because regardless of how bad your babies might be, you'll believe you're stuck with them. Instead, you should scrutinize, rethink, and discard bad ideas when necessary. However, sometimes you'll look past their shortcomings due to the attachment you feel toward them. In design, this loss of objectivity is dangerous. Once you like and settle on a path, you tend to commit to it. Thereafter, changing course becomes difficult. Novice designers commonly handicap themselves in this way. They're so new to ideas that they become infatuated with the first ones they conjure up. Then they overinvest time and effort, even when these initial ideas don't warrant this amount of attention.

The antidote to the preferential treatment of ideas is to create a number of possibilities, refining and analyzing the concepts after exhaustive brainstorming has been completed. Volume is of utmost importance during the Creative stage. Write down every idea that comes to mind. Pull 'em out, put 'em down, and keep moving. Don't stop to think about whether they are good or not; just keep cranking them out. The more ideas you come up with, the more likely you'll be to happen upon a good one.

If you keep your ideas somewhat general, you'll be able to document them more quickly. You might be able to devise hundreds of ideas in just a day. By putting very little detail into any of these individual ideas, you'll be able to assess them fairly when it's time to

edit. Keep in mind that euthanizing a creative concept you've spent the past year working on is devastating, but doing so with one you put four minutes into isn't nearly as tough.

Generating Ideas and Breaking Creative Blocks

The Design Method focuses your efforts and therefore helps concentrate and direct idea generation, reducing the number of erroneous deviations you might make. Nevertheless, the synthesis of new ideas can still cause anxiety. At such times, I use the following techniques to help cultivate ideas and break through creative blocks.

SEPARATE BRAINSTORMING AND EDITING

Design requires you to analyze data *and* synthesize possibilities. At times you can do both effectively; at other times this split focus might prevent you from accomplishing anything. Although there's certainly an appropriate time to edit your ideas, you should avoid this kind of analysis during concept development and brainstorming. Your focus won't be easy to maintain; it's in your nature to want to determine whether you're taking the right tack. It is at this point that discipline is critical. Whether you're brainstorming individually, or with others, make sure you record all your ideas regardless of how inferior they might seem. The simple act of documenting ideas removes the possibility from your head, and frees up your mind to come up with others. Your current idea might not be any good, but it could lead you to the right one.

TAKE THE SHORTEST PATH

Your problem might be in looking for too novel an idea. It is not surprising that most want to come up with smart ideas. While waiting for one of those, try another tactic: Solve the problem in the simplest way possible—even if the result is inelegant. For example, perhaps you are tasked with publicizing the opening of a new ski shop. You might try a stark poster set in Helvetica with an offer, address, and little else. Or, imagine you need to create a clever video to promote a new service. How about writing a script in a plain style and just telling the story simply? You probably won't use this script in your final video, but that isn't the point. This exercise is a means of breaking your deadlock and getting your ideas flowing. Once you've broken that barrier, you're more likely to generate other ideas that might work.

CHANGE YOUR ENVIRONMENT

Ideation requires a clear mind. Every phone call, question from a colleague, or e-mail alert breaks your concentration, making your brainstorming sessions sputter and fizzle out. Try leaving the office and finding somewhere free of such distractions. You might be more successful holding a cup of coffee, a beer, or a hot dog in your hand. Lounging around your house in your pajamas might help as well. Writing on napkins at a pizza shop might be more freeing than typing at a computer. If the environment is noisy, put on some headphones and play Bach, Philip Glass, or Slayer. The music you listen to is up to you, but choose a selection that drowns out surrounding conversations. You can also change the time you work. The hours before 8 A.M. and after 8 P.M. tend to be freer of interruptions, allowing you to get into a productive flow. The benefits of this tactic are threefold: you focus your efforts, break the stalemate you're facing, and change the setting to open up new possibilities.

USE TIME LIMITS AND DEADLINES TO YOUR ADVANTAGE

The luxury of time can quickly become a burden. In the event of excess, you might overanalyze, hesitate, and become anxious, resulting in the creation of little or nothing. Don't let the project sit for so long that you lose your mojo. It might take you a whole day to clean a house if you aren't in a rush, but when guests are on their way over, you can do a lot in just an hour. The same is true when you're dealing with ideas. Sometimes you take hours of dilly-dallying to get 20 minutes of productive brainstorming at the end of the day. A deadline can drive you to the fruitful part of your efforts more quickly. Pick a task, set a deadline, and go. You might be surprised by how much ground you can cover in just a few hours, as well as the quality of the results.

DESCRIBE THE SITUATION

It's hard to solve a problem. It's even harder to solve a number of problems concurrently, especially on vague projects. So, try to define the situation simply at the outset. Open a text editor, set the type to a large size, and write what you're doing as succinctly as you can. Don't stop because the

```
● ● ●                    Untitled
My clients are architects.

They make green buildings.

Their problem is that many don't want to
pay more for green buildings.

I'll solve this by illustrating the
overall savings to be found through these
methods.

It will look like a set of simple charts
and information graphics.
```

answers seem obvious. Just fill in the blanks until you've addressed the following points: My clients are _____; They make _____; Their problem is _____; I'll solve this by _____; It will look like _____; It will look this way because _____; It will make viewers feel _____; I'll use the following treatments (_____, _____, _____) to make this happen; and so on. Although this technique sounds somewhat basic, it can help. By removing the ambiguity from the challenge, you'll be able to center your efforts once again.

MAKE WAY MORE THAN YOU NEED

The problem with one idea is that you'll treat your singular idea too preciously. Aiming for volume during ideation can prove beneficial. Look at the task at hand and choose an unrealistic number. For instance, you might aim to generate 100 ideas, 500 sketches, or 1,000 subtle variations. This abundance might sound nutty, but it can be liberating. Shooting for such high numbers puts your focus on creating, not analyzing or seeking perfection. This technique loosens you up and reduces the pressure to create superior work. Grab a pen and paper, start brainstorming and sketching ideas, and do it quickly—setting a timer will also help! If you hit on a good idea, put it aside and keep going. Once you've spent a sufficient amount of time—perhaps a day or two—tape all your notes on a wall. Then select the top five, and refine those ideas.

EXPLAIN THE CHALLENGE TO A COLLEAGUE

For me, creative possibilities tend to blend together and result in a kind of mental soup, which leaves me spinning and unsure of which way to go. Not verbalizing my thoughts makes my situation worse. What I do find helpful is talking to one of my colleagues and explaining the situation I face. Having to put my thoughts into words helps me make sense of them. Additionally, the person I'm speaking with may lend suggestions of his or her own. These contributions have a dual benefit: Not only do I get access to outside perspectives, but their ideas might rattle new ones loose for me too. It's like a group of friends trying to figure out where to go for dinner. Most will be stuck for ideas until someone suggests a lackluster option. Then the floodgates will open.

> So, this company makes a great new anti-depressant.

> Uh-huh...

> Just one issue—it only comes as a suppository.

CREATE SOME LIMITS

In art school I faced an assignment that required students to make 20 paintings in two weeks. These works had to measure 16" x 20" and be of the same subject. Students groaned and complained, but at the end of the assignment they had interesting work to show.

The next exercise was restriction-free, and we could paint whatever we wanted. Everyone was thrilled, but two weeks later no one had any interesting work to show. From these two assignments I learned that people sometimes create more interesting work when they face a limitation. Humans show their most ingenious selves when they're up against restrictions. So, create some for your work. You might choose to work with only one color, or just text, or at a particular size. Whatever these limits are, having obstacles to work around might prove easier than swinging at an invisible foe.

INTRODUCE A RANDOM ELEMENT

Sometimes you'll just be stuck. No matter how you look at the problem in front of you, the solution turns out to be the same. If you find you're limited by sensible thinking, stop thinking sensibly. (Although this suggestion might seem at odds with The Design Method, I'd argue that applying randomness in a deliberate way is fair game.) Grab a book from the shelf, flip to a random page, and apply the first item you see to the project you're struggling with. You might select a word, image, or concept. Your choice doesn't actually matter. The fact that it's unrelated to the project—even if at first bewildering—

is beneficial. When you connect disparate items, you can spark unexpected combinations. If nothing else, making connections might break the stranglehold you are in and ease your intimidation.

You've been spinning in circles for hours, or days, and you are no longer making progress. Stop. Collect what you've done and file these plans out of sight. Putting away these materials will free you of your dead ends, legacy thinking, and all that limits you. Then grab a scrap of blank paper and begin again. A clean slate affords new possibilities and allows you to treat the problem like it was brand new. In the back of your mind you'll know you can return to your earlier ideas if necessary. Therefore, this new creative session won't involve as much pressure as the first, and it's the reason this session will be different. No matter how stuck you may feel by a particular idea, you can always start over. Isn't that a liberating thought?

Many other ideation and blockbusting methods exist, so feel free to research them. But don't get carried away doing so. There's no one trick for generating ideas or eliminating creative obstacles. These techniques just help you change your perspective enough to see your challenge in a new light. And once you have your ideas in place, you can start editing them.

Editing Your Ideas

After having brainstormed a number of different possibilities and prospective creative concepts, you need to edit them down to make sense of your options. Sometimes this process will go quickly, and you'll find that a few of your ideas are clear winners; at other times the decisions won't be quite as simple.

Editing isn't as difficult as it might seem initially. If you've collected your ideas on individual scraps of paper—which is the best way to do it—you can start grouping ideas. (Sure, you can use an iPad or whiteboard for ideation, but doing so makes seeing all of them at the same time more difficult.) You can group content by subject or approach (e.g., a pile for literal ideas, one for ideas that use metaphors, etc.). Alternately, you might start organizing batches of strong,

mediocre, or weak ideas. The purpose is to find a way to reduce the number of decisions you need to make.

Some of your options will seem more appropriate than others because they're closer to solving the problem, more adaptable in varied settings, or just better suited to your client's personality. The process of elimination should result in a few selections that warrant further discussion. At this time you should bring in someone like a creative director to edit and challenge your choices. However, this individual needn't come from a creative background—sometimes it's better if the person doesn't. Working as an editor, this person just has to understand the project and be fully briefed on what you need to accomplish. Present your selections to this person and work together to determine which concept seems most viable. The editing process will also be easier if you give the editor veto power, because there are times when someone needs to break a deadlock.

Once you choose the best option, you can then move forward; or, you might select a few approaches to investigate further. Should none of the chosen ones prove good enough, you could start another brainstorming session. But you'll eventually need to make a decision and then refine this idea.

Documenting the Creative Concept

When you've arrived at a workable idea, you'll need to document it in a one-page creative concept. (Remember, you're only going to develop a single concept, as explained in Chapter 4.) The creative brief you developed during the Planning stage pairs nicely with the creative concept. The brief outlines what you intend to do; the concept document defines how you'll bring your plan to life. The creative concept is short, much like the brief, and is challenging to write, because the ideas you're working with are still incomplete and difficult to elaborate on fully.

Give your concept a simple title that encapsulates the idea in a few words. A general title works best because it affords you some flexibility. We asked one client that worked with changing media to explore *new forms* in its corporate identity; thus, we titled the concept New Forms. On another project we felt it made sense to utilize handmade, natural,

and agrarian themes, so we titled the concept The Farm. With a title in place, you'll add a sentence to explain your approach. If you require further explanation, your concept might not be adequately defined.

Next, you'll need to provide a rationale for your recommended direction. In a sentence or two, document why you're proposing this concept. Use plain language. You're not trying to sell the idea; you're just identifying why it makes sense. Then present implied notions; do so with a few bullet points that explain what the user might infer from your design concept. It's far too easy to make these points sound sales-like, so be sure to do what you can to avoid rhetoric.

Then add points about why you like this concept. Note why you've chosen this concept, what opportunities it affords, and any benefits it has over other ideas. Perhaps you think the concept will be adaptable in various settings or that the intended audience will respond to this approach well. Out of all the concepts you brainstormed, this one stood above the rest. Use this part of your concept document to tell your client why it is the frontrunner.

The last part of this one-page document consists of a section dedicated to tone. You can repeat the three words that you used to describe tone in the creative brief, but first determine if those words are still appropriate to the concept you've developed. If not, you might tweak the tone, or perhaps you'll need to reconsider the concept. There's nothing wrong with making such changes at this stage. The following is an example of the concept for the design of the book you're holding.

Concept: Function

Approach: Mirror the book's content by providing a reason to support every design choice.

Rationale: Given that the book is about making appropriate design in a disciplined fashion, this sensibility should be echoed in the way we create the book, as well as in all of the design implementations.

Implied notions:
- Design must be driven by purpose.
- Design doesn't interfere with the message.
- Design is not decoration.

What we like about this concept:
- Ties directly to the content it supports
- Enables a simple, informative design approach
- Frames our visual/diagram selections
- Illustrates that we "practice what we preach"

Tone:
- Accessible, usable, clear/organized

Design concepts should be clear, practical, and useful. You'll see these characteristics in the (good) concepts you develop: Done well, your creative concept documents will be a logical fit for the client or product you're designing for. At this point, you're eager to present this concept to your client—don't worry; you'll get to that after you've paired it with a design direction. But first you need to apply a little more scrutiny to your concept.

Creative Evaluation

Creative people see so much possibility in their work that they get excited about concepts earlier than they should. You can temper this inclination by applying rigorous analysis to your concepts to gain some much needed objectivity and help ensure that you're not being diverted by more fleeting interests.

Of course, you'll first want to review the goals and objectives for the project and determine whether the concept you've developed can achieve those targets. (Although you might think these goals obvious at this point, it never hurts to double-check them.) If you see alignment on all points, you can return to your creative brief and review each point to ensure that your concept works as it needs to.

Use the following questions to check for alignment with the creative brief: Does the concept suit your client and its service or

product? Will it resonate with the desired audience? Can it work with the intended message? Will it illustrate the client's competitive advantage? Is it compatible with the chosen tone? You should be confident that your concept doesn't conflict with any of these points. The one exception is tone, which can evolve as you continue to develop the details of the concept—typically without any major upset.

Then start to check over your concept in more depth. Does your concept fit with the client's other efforts? Can it be produced efficiently, on time, and at a reasonable cost? Might it limit your client in any way? Is it perhaps overly similar to the presentation of another competing organization? Will it age well, or is it too rooted in trends?

Don't be lenient with your concept. If it doesn't hold up, rethink your approach. Course corrections are inexpensive at the idea stage but very costly once you've started to refine assets. Don't think that everything will just work out. Get used to discarding ideas early, before you've sunk hundreds of hours into building out your design.

You should repeat this evaluation two more times: 1) after you've established the design direction (you'll do this next), because at that point you'll have added fidelity to your vision, which should ensure that you're on course to meet the design objectives; and 2) while building your assets during the Application stage.

Determining Design Direction with Style Boards

Having developed a general creative concept, you can move on to establishing visual styles. You'll begin this activity with more research, probing, selection, and analysis, culminating in the creation of style boards. Style boards are different than mood boards in that instead of illustrating tone, they identify potential visual conventions.

At this point many designers would sketch out ideas or comp their own set of elements. Although such notions are admirable, they're quite impractical. Creating these items from scratch is time intensive and can prove to be a waste of energy should your client not agree with your vision for the design. Style boards afford a quick way to get your client's buy-in on a visual intent before you build out treatments.

Developing style boards helps you explore possibilities, clarify your design vision, and validate your concept. Start by creating a series

Photography

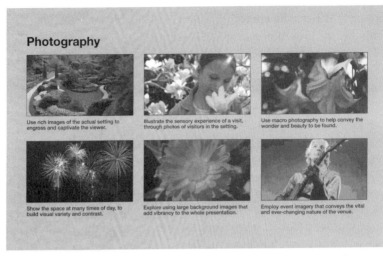

Use rich images of the actual setting to engross and captivate the viewer.

Illustrate the sensory experience of a visit, through photos of visitors in the setting.

Use macro photography to help convey the wonder and beauty to be found.

Show the space at many times of day, to build visual variety and contrast.

Explore using large background images that add vibrancy to the whole presentation.

Employ event imagery that conveys the vital and ever-changing nature of the venue.

Style boards function as a device to rapidly determine visual treatments and ensure that your client shares the sensibilities you've deemed suitable for the project.

of folders with headings, such as Color, Form, General Treatments, Illustration, Motion, Ornaments, Photo Content (documenting potential subject matter), Photo Treatments (illustrating possible photo styles), Textures, Typography, and UX Elements. Then select one of these folders and start searching the Web to find images that might support your concept. Don't worry too much about your initial selections; you aren't married to any of these items. Just investigate each style board topic and see what you can find. As you do so, your sense for what might work will become clearer.

Keep in mind that you are not trying to find a design to copy. Blatant replication of others' work is not design. The purpose of this exercise is to feel out the visual direction, and come to an agreement with your client on how certain notions should be conveyed. The way you visualize "contemporary" styles and the associations your client has with that notion might be completely different.

Once you've collected a sufficient number of images, you can start narrowing them down. Highlight six images in each folder (any more than that creates repetition), and then start arranging these images in your style boards. Typically, I create these documents in an application like PowerPoint or Keynote. Start each slide with the appropriate heading, and then present each image along with a sentence to explain

why you've selected the image and how the selection relates to your vision for the project's concept and design.

By following these steps you'll gain a clearer sense for how your design solution might work. Additionally, your style boards will serve as tools to help prepare your clients for the vision you have in mind. The vision in your head isn't in theirs. Style boards help you bridge this gap and make your client more comfortable with the process and the design you'll eventually provide.

Just a word of caution: Style boards are a bit of a visual feast. It's not uncommon for us at smashLAB to present over 60 images to help our clients get a sense for the potential design. The problem occurs when clients think that all of these materials will be reflected in the final design. To moderate their expectations, remind them that style boards are just tools for aligning expectations, not a representation of a completed solution.

Fostering a Collaborative Process

Most new designers present completed design assets to clients far too early in the process. Producing any design assets before agreeing on a trajectory is a mistake. Although you might prefer to create design in isolation, your clients want to be involved in the process—and deserve to be. Likewise, attending a client meeting with a creative design fully developed is risky. Premature completion of a design puts all your eggs in one basket. If your clients don't agree with your suggested course, you'll need to return to your studio and start again. Plus, you'll probably anger your client.

Imagine being impressed by a homebuilder's work. You meet with him and talk about needs, expectations, and budget. After some negotiation, you agree to hire him but ask him to hold off on breaking ground until after the summer holiday. You inform him that once you're back in town you'll meet again to choose plans and discuss details further. The summer passes and you call your builder, ready to get started. He's happy to hear your voice and asks you to come by the lot, noting, "I've got a surprise for you!"

You're a little concerned by the strange remark, so you quickly drive to the site of your new home. Upon arriving you find a finished

home where there once was an empty lot. Beaming, he shows you the completed house and asks what you think. In spite of his enthusiasm, you're scared. You didn't want this house and it's not what you'd have asked for. Wasn't he supposed to show you plans, blueprints, or materials samples? Weren't you supposed to be included in decisions? Must you accept this house, or is he obliged to fix what he's done?

Such an occurrence wouldn't likely happen in real life. But actually, designers do something similar when they present designs prematurely without first discerning their client's expectations. This tendency can alienate your client, force you to start over, and disappoint everyone involved. You can avoid this mess by providing plans and blueprints. In the Creative stage, blueprints consist of documentation containing the creative concept, style boards, and any other item that helps your client understand your thinking and feel comfortable moving forward.

Getting Buy-in from Your Client

Once you feel confident in the creative plan, you're ready to present your work to your client. You'll conduct a presentation to verbalize your thoughts, show visual examples to support your thinking, and answer any questions. Take your time and ensure that there aren't any misunderstandings. It's important that you convey your ideas clearly, so your clients can respond in kind after being fully informed.

After this meeting, you can provide documentation (typically a PDF version of the slide deck that accompanied your presentation) to your clients for more detailed analysis. Doing so allows them to review what you've presented in private, where they may feel more comfort in voicing their opinions. Once they're prepared to, you can meet again to answer any other questions or discuss concerns. At that point, you can make revisions or go back to brainstorming should that be necessary.

Don't be overly concerned by having to backtrack a little if your client requires this. In my experience, this review process goes quite smoothly—as long as I adhere to what was learned during Discovery and agreed to during Planning. Most times, you'll only need to make minor variations to the suggested concept and styles. In the worst-case scenario, you can mine some of the other ideas you generated with the added benefit of now knowing what your client responds well to.

In Chapter 9, "Presenting Work to Clients," I'll provide more information about documenting and presenting your work. For now, I just want to stress that achieving buy-in from your client during the Creative stage is imperative to facilitating productive and successful design. In fact, your ability to achieve your client's endorsement might affect your career path more than any design specimen you produce.

Many are talented and creative, but talent isn't enough when you're designing work for others. You can generate wonderful design, but if your client vetoes what you've presented, your brilliant creation might never be completed. Actually, if you allow the dialogue to erode to the point at which a client emphatically says "no," there might be little you can do to resurrect this specific creative plan, let alone the relationship you had with your client. Once a client's mind is set, changing it can be almost impossible. Do all you can to avoid such an impasse.

I don't propose pandering to your clients. The Design Method simply presents a way to shepherd your clients through the process and gives them what they need: involvement and ownership, coupled with well-ordered steps and viable decisions. When you sufficiently involve your clients in the discussion throughout the design process, a certain comfort and rapport is established. You'll need to show them what's happening, ask them for feedback, and provide opportunities for them to make changes and point out concerns.

The best way to gain your client's confidence is through frequent communication. If you disappear for too long, your clients will wonder what you're doing. Did you put another client ahead of them? Are you losing interest? Are you jumping ahead without letting them voice an opinion? Pick up the phone and let your clients know how the project is proceeding. End meetings with notes on what to expect next and when you'll meet again. Good designers observe thoroughly, plan carefully, and deliver great ideas; they also make a concerted effort to communicate well with their clients.

Up Next

The final stage in The Design Method, Application, involves moving forward with your creative plan and building assets. In the next chapter I'll explain how to prototype, test, evaluate, and refine your

implementation to deliver an effective design for your client. I'll also review some good practices for managing how you build and hand off your design solutions to colleagues and suppliers.

Making Design Real: The Application Stage

Having determined a creative approach, you now build out your design. The Application stage involves prototyping, testing, analysis, and refinement—followed by production and ongoing iteration.

Applying Your Creative Direction

You've reached the final stage of the process, and it's now that you get to the part that feels like design. Many will think it strange to not start creating their design earlier, but they feel this way because they don't realize that design isn't solely about building design assets. Only by addressing research, planning, ideation, and visual styles before the Application stage can you then apply all you've learned in conjunction with your plan and creative approach.

The Application stage is spent in the workshop. You'll first build a model using internal and client feedback to refine this prototype. As your design takes shape, you'll test it repeatedly and evaluate its performance. By doing so, you'll be able to determine viable paths and refine your design. You'll repeat these steps until you've achieved a design that's ready to be put into production. Depending on how long your client wants to engage your services, you might continue this process beyond the launch of your design—using real-world feedback to further inform iterations of your design.

Although I'd like to say that the Application stage is made easy due to all the careful thinking you've done to this point, that isn't the case. Applying form to your design comes with its own set of substantial challenges. Your visuals won't always do what you intend. The implementation might not resonate with your client or audience. Or, you'll build a model that just isn't good enough. These are common challenges during this stage. But if you've followed The Design Method up to this point, you'll benefit from having a clear path to follow and should more easily be able to obtain your client's approval than if you were showing up for the first time with a completed design in hand. Plus, by using iterative methods, you make the process less intimidating and substantially more manageable.

Iteration: A Process of Refinement

Iteration is a design process that involves prototyping a design, testing and analyzing the results, and using what you've learned to refine your approach. Each time you work through this process you create an iteration, and you repeat this cycle as necessary to reach your goals.

Iteration involves creating a prototype, testing it, analyzing findings, and making subsequent refinements. This process can be repeated as necessary to produce the desired outcome.

Iteration in communication design is somewhat different than in the development of other products. The reason is that the testing of visuals is less definitive than the testing of products. Additionally, in communication design, the client's desires often overpower those of the audience. (Hence, you might always need to make the logo bigger.) Therefore, you'll probably run more communication design iterations internally than you would with product or user interface design. In this chapter I've described iterative design quite generally; you can adapt this approach to the project at hand. But first, you need to know why iteration matters.

Many designers try to perfect one design without creating distinct versions of their efforts—a habit that leads them to make all their revisions in the same file or document. They then tweak and tinker but fail to document the nuances as they progress. After muddling through their alterations for a while, they might find they've come full circle back to where they started. Without a way to see the evolution of their design, these designers make many changes, but fail to actually move their design forward.

By not documenting the path you've travelled, trying to recall what you've already done becomes almost impossible. Your memory can't provide accurate visualizations of past iterations, leaving you with little to compare and contrast against. Working in a single file can also

hinder your process. When you concentrate on just one item, you start to treasure your work and are reluctant to try new approaches because you worry that you'll ruin what you've built. This set of unnecessary obstacles slows the development of your design.

Iteration forces you to document the steps in your progression. Even if you dislike its current state, you need to record each substantial step. This collection of progressive steps allows you to analyze your choices and make informed decisions, because you're better at gauging what you can see than what you attempt to remember. Even before you start creating more formal iterations, you should be versioning your work. It's easy to version your sketches—just number and organize them in a folder where you can refer to them. The same technique works when you're using software. Whenever you've made notable changes to your file, run a "save as" to start a new version. (I'll discuss filenaming conventions for iterative practices in Chapter 10, "Bringing Order to Your Practice.") Iterations tend to represent larger steps in your development—typically ones you'll show to your client—whereas, versions represent more granular changes you'll make on your way to developing another full iteration.

Working iteratively reduces pressure. You don't need any of the versions to be perfect, because each is just one kick at the can. Similarly, you can't lose by trying another angle, because you can always roll back to an earlier version. You can tinker with your approach, adjust settings, and test how far you can push your design. Sometimes you'll go back a few versions and be aghast at what you earlier thought to be viable. At other times, you'll see that a previous iteration is stronger than the one you're currently working on. In either case, you'll be in a better position for having examples of your progress to reflect upon and learn from. You'll start the iterative design process by creating a prototype.

Building Prototypes

Although the word prototype seems more at home in product design than in communication design, it's still workable and fosters an iterative perspective. A prototype is a model that allows you to test your design and learn what works and what doesn't. It's an early stage

implementation that you should produce rapidly. The model needn't be refined; rather, it's a step in the evolution of your design that advances your concept from theory to a working solution.

Your mind tends to be too forgiving of the ideas you imagine and sometimes fails to recognize where your design might fall short. For example, you might plan to run large headlines atop powerful images for a series of billboards. Your prototype could pinpoint a flaw in this plan by identifying text that might become illegible due to the level of contrast in the photos or images that might not be workable when they are expanded to such a large size. Therefore, you need to test a mock-up—even if it's rough. Sometimes the problems you'll find while prototyping will be small and just need minor changes to remedy. Other times these findings will uncover systemwide concerns that the design needs to conform to.

Prototyping benefits from the same broad strokes thinking you employed during the Creative stage. So, you should start prototyping with low-fidelity implementations like pencil sketches and thumbnails in order to move quickly. The faster you generate prototypes, the sooner you can test, assess viability, and identify points of failure. After you work through certain high-level visual questions, you can then move on to applying greater detail.

As you build out iterations, you'll conduct casual testing to validate your work. For the most part, this practice involves having your colleagues, supervisor, or editor (e.g., art director or creative director) review your work. Similarly, you'll run your prototypes by your client for input. But in the interim, you might encounter some hiccups in the application of your creative direction. Let's look at a few more ways to deal with these implementation challenges.

Getting Around Obstacles

During the Creative stage, you learned a few ways of generating ideas and busting creative blocks. Those techniques are equally useful during the Application stage when you need to work around obstacles, albeit at a more granular level. You've addressed many of the big challenges surrounding ideation and the determination of a concept and visual styles; however, you're not done yet. Now you need to interpret that

creative plan into applied design. Although you can continue to utilize the techniques presented earlier, there are three additional practices that are particularly useful at this stage.

First, kill your darlings. As you develop a design implementation, you often find parts you like more than others. The treatments you see as gems might come in the form of a typographic style, photographic selection, or way of organizing the space. But be very careful not to treat any element of your design more valuably than the rest; your design is a combination of all parts, not a single piece. Such items might even be at odds with the greater goals of the work you're doing. If you get stuck during the Application stage, try removing the items you prefer most. The discomfort that comes with such removals passes quickly and affords new clarity. With time you might look at these same pieces and wonder why you once found them so compelling.

Second, try turning off some parts. Designing visual communication is analogous to tuning an instrument. A design that doesn't work isn't necessarily irreparable; sometimes the elements just need to be brought into alignment. Isolating which part is out of tune is more difficult when many pieces are at work. In this case, try removing variables until you've reduced them to a manageable number. If the layout doesn't reconcile, eliminate all the color, standardize the type, or simplify spacing and hierarchy. If you want to make sense of a motion design sequence, remove the sound track, voice-over, or effects. By limiting these items, you might be able to better identify what's amiss.

Third, try to regain some perspective on the design you're creating. When I was a child learning to draw, I asked an instructor for feedback. Instead of giving any, he just asked me to hold it up to a mirror. When I did, I saw the errors in my work with great clarity. You can do the same with your design implementations or run a variation on this approach: Rotate it 90 degrees; back up and look at it from a distance; squint to get a sense for whether there's an overall balance. Alternately, you can just tuck your design away and look at it a few days later with fresh eyes. If you are writing something and want to find the errors, read it out loud. If you're stuck on a product plan you're developing, prepare a press release to announce the product and read it to see if you still believe in the idea. Adjusting how you examine work—even just a little—can be enough to help you achieve valuable insight into what's working or not.

Using Placeholder and Actual Content

Early in the Application stage, you should use some visual shortcuts to shape your overall composition and flesh out the design. For example, placeholder images and text can help you organize your design and give you a sense of what the final piece could look like with content in place. This technique speeds your process and keeps you from polishing your design prematurely.

As you progress through the process, you'll of course need to place real content into your prototypes. It's only in doing so that you'll get a sense of whether or not your implementation can work. You might envision a pristine layout that's free of dense text, only to find that your client also has to include technical information that requires a lot of extra space. Similarly, upon inspection, you might learn that your client's images aren't of a sufficiently high quality to support the lavish, full-page photo spreads you imagine. Search for real content you can insert into a sample, and then learn what you can from seeing that content flowed into your design.

Never use Greeking text in headlines. Don't think twice about asking a writer to put together a few hundred words to test a layout. Similarly, you can quickly grab photos of your subject by using your smartphone's camera. This simple action gives you a real image to work with instead of using stock photography or a doodle. You'll also benefit by putting real links in your navigation and populating charts with actual data.

The practice of testing your design in a real context isn't limited to text, images, and graphs: You can extend this application to the physical object you are creating. Often, I'm surprised by how reluctant designers are to print out their work, trim a sample to size, and assemble the design. Without transferring that design from your screen to paper, you won't know whether it'll work as intended.

The simple act of producing a mock-up helps you understand if your type is correctly sized, if the margins need to be spaced differently, or if there's a potential bookbinding issue you need your design to work around. If you're creating desktop wallpaper, you should try using the image you've prepared on your own computer's desktop. Images that look great in Photoshop are often too visually noisy to work as a backdrop. If you're designing a label for a winery,

you need to print out a sample, affix the placeholder label to a bottle, and set that bottle on a shelf to see how your design functions. It could be that the beautiful approach you've taken doesn't work on a cylindrical bottle and cuts off the name of the winery. For a client's letterhead, I once selected a unique paper. Later, I learned that he had only an inkjet printer in his office, and printing on this paper resulted in everything getting smeared. (I suggested he just buy a new printer—in fact, I even offered him one of ours for free; nevertheless, he remained rather angry with me.)

So much of what you do as a designer relies on hypothetical settings, loose sketches, and broad hunches. That's understandable and often works out just fine. However, when you can access real content, you should do your best to test how this material works in place. Taking this step early will give you enough time to change course if necessary. Unfortunately, I've seen many good designs break once real content is used in them. But by simulating real usage, you can avoid the frustration of having your design fail in this way.

Determining the DNA

In Chapter 3 you learned how most design solutions have an underlying DNA, which in this context means a series of rules or underlying characteristics that are found throughout a design. You started to become aware of the DNA for your solution when you developed style boards during the Creative stage and established your design direction. As you construct your prototype and iterate, you'll structure and add dimension to your design's composition.

While developing the building blocks of your design, you'll need to determine the kind of setting your design lives within. Is it a flat, layered, dimensional, imaginary, or realistic space? Is the environment linear, random, stacked, or organized in some other fashion? The answers to these questions will help you address other aspects of your design. You'll sort out what kind of hierarchy and scale is employed throughout your design, and determine how to balance areas and unify the system.

As you progress, your design choices will become increasingly granular. For example, you'll

- Establish overall composition and determine the grouping and organization of content and visual blocks (e.g., text areas, image placement, relationships between areas)
- Refine the color palette and nail down typographic selections, sizing, balance, and other treatments
- Outline how to treat textures, shapes, and lines
- Decide which items to place together in which order and how to visually achieve the tone you earlier established for this particular design solution.

This same thinking should go into all aspects of your design. For example, perhaps you'll conclude that all text has to start with an emphatic statement, or each image has to be of an athlete at a moment of triumph, or that each item needs to allude to a particular era.

Once developed, design DNA helps link items in a system together. It also allows you to produce new work more rapidly and have this work align with other elements in the system.

Determining the DNA of your design project isn't easy, but the benefits of having these guidelines in place continues for the duration of the project and anytime you need to produce more work for your client. By determining the design guidelines, you reduce the number of decisions you need to make. In fact, if you define these points thoroughly, you can later hand over production tasks

to junior designers and ask them to complete the rest without much supervision. (Delegating work can be a real luxury when jobs stack up and you're feeling overwhelmed!)

Find a place to document your design DNA. You could use a simple text file to note all the conceptual rules. For more detailed points, perhaps the graphics application you're using is a more suitable place for these notes. Frequently, I create a layers folder in Photoshop for such rules and label the folder *Master Items*. This folder contains my color selections, grid structure, and typographic standards. These references work equally well in Illustrator or InDesign where you can set aside a page, artboard, or layer set to refer back to throughout the design process. When you're confident that your prototype and your design DNA are workable, you're ready to solicit your client's input.

Showing Prototypes to Your Client

Although creative projects start out vague, at some point you'll know you've met the challenges and achieved a reasonable result. Sure, all the details might not be worked out, but you understand what to do and how your approach could work. But before you test your prototypes with outside parties, you need to present them to your client. By doing so, you'll identify any deal-breaking concerns and ensure that your client supports your current path.

Meeting with clients to review prototypes is one of the most stressful parts of the design process. Even if your clients agree to your overall plan and visual direction, the discussion "gets real" when you start showing working samples because this is the first time the abstract discussions you've had with your clients become tangible.

Chapter 9, "Presenting Work to Clients," contains tips for presenting creative work, but I'll touch on these points here. Consider that your clients aren't as invested in your design as you are. You're sold on your idea because you've spent many days becoming familiar with this plan. The distance between you means that they can lend some objectivity while they review the work. However, you'll need to ensure that they're properly prepared to look at your design accurately.

Before your meeting, develop an example that's sufficiently complete to help your clients make sense of what they're looking at.

If you fail to add this detail, the primitive nature of your prototypes might be alarming and deter them from properly considering your design. Use a page of the layout and insert real text, tidy up a couple of icons and illustrations, and place a few decent photos to fill out your comp. Perfecting the entire design would be premature, but polishing a small sample might be enough to reassure them. A few mocked-up examples can help facilitate a constructive feedback session, which should ensure that you're on the right track.

When you present your work, slow down and clearly explain what you've done. Odds are that what you think is completely straightforward won't make as much sense to a client who doesn't work with designers every day. Before you show any examples, take some time to reiterate the brief, discuss what you want to achieve, and verbalize how you arrived at your design. Then, while presenting your work, explain the decisions you made, encourage your clients to ask questions, and make sure they realize that the examples are still an early draft. Consequently, they will have an opportunity to raise concerns and be able to gain confidence in your approach, enabling you to gain more of their trust. Achieving this kind of rapport is no small accomplishment—particularly at a point in the design process that is so often highly volatile.

All this effort to afford your clients comfort and control allows you to be a better designer. The more empowered and heard your clients feel, the more latitude they'll give you to act as the professional you are. Making time for all the explanations, questions, and discussions that might seem pedestrian to you can help you avoid any tedious backtracking and save you time. After making whatever changes you and your client agree to, you'll need to run some tests.

Testing Your Approach and Prototypes

Testing is a necessary and important part of The Design Method. This validation is an ongoing requirement that helps you determine whether your design is viable as is or needs more attention. Testing can be done informally or in a controlled setting and be simple or complex. The way you test your work depends on the phase of the Application stage you are at and the nature of the item you are designing.

The earliest testing of your approach will be informal and should happen as you develop your first prototypes. As noted previously, this practice involves showing your progress to your colleagues, creative director, and client, and asking them to challenge your logic to help you assess how workable your solution is. As you get closer to a viable prototype, you'll expand your testing circle. By locating individuals who match the characteristics of your target audience, you can better realize how well your prototypes function among potential users.

The nature of the designed item also impacts the way you test your work. To validate a website design, for example, you can ask test subjects to complete certain actions. Prior to the session, return to your initial planning and use cases, and devise a series of tasks that suit what your design aims to achieve. These tasks might be as simple as "visit the website and find the hours of operation," or "locate the online shop, buy an item for under $10, and ship your purchase to your home using the expedited delivery option." These sorts of defined assignments are useful because they allow you to determine if your design conventions work well in real use. Instead of aiding or prompting users, simply monitor their behavior and identify common problems. Ask them to explain their thinking while you record their responses and screen activity—to help analyze their actions.

You can also rely on third-party testing experts to assist with the testing process. Alternately, you might set up your own testing facilities. Many UX design books explain how to conduct user testing—some even provide ways to do so on a budget. Also, some online technologies allow you to access people who match the makeup and needs of your audience. These services test certain functions and activities by recording users' onscreen behavior in addition to what they're saying, so you can witness how they make their way through the tasks you've assigned. Although imperfect, such tools can give you a quick feel for the obstacles that might exist in your design.

Testing needn't be exhaustive to produce useful insight. In my experience, testing done with as few as a half dozen users can help identify core problems with a design. Therefore, you should run tests with a small number of participants but conduct a handful of sessions as the designed item develops. This ongoing testing helps you adhere to an iterative design process and gauge the progression of the design.

Testing a designed item that has a highly defined purpose is easier

than when the function of the item is unclear. For example, testing conversion rates (the percentage of viewers who complete a defined action—like calling to inquire about an offer) on a series of ads can help you identify which version works best. Similarly, testing the effectiveness of a website's sign-up form is reasonably straightforward. If the item you're designing can be used in some fashion, ask real people to use it. Have them fill out any required fields or complete some specific task to see if your design works as intended.

Testing the viability of a complex design, like a new brand identity, is challenging and unlikely to produce a clear result. The difficulty lies in how multifaceted the role of the designed item is. A brand needs to work on a number of different levels and is affected by the ideas and associations held in popular culture. Introducing a complex brand design into the marketplace might take years. Therefore, empirical validation of such design systems is virtually impossible, and your testing might need to be more investigatory.

Many people believe in focus groups, but I view their use as an inferior way to test design. Group dynamics soil the testing environment; dominant individuals' opinions get too much attention, whereas other participants' voices can be drowned out. This awkward construct taints your test results and can skew your design direction. Instead, it's best to set up a comfortable environment and provide individual participants with a safe space to respond to questions you carefully considered prior to the testing session. Listen carefully to what they say and what they don't say, and observe what they do.

You can bring in outside individuals by placing an ad in the paper or on Craigslist; better yet, reach out to some of your client's customers or users through one of its newsletters. Offer willing participants a $50 gift card, or something of the sort, for 15 minutes of their time. Then probe for their responses and interpret their feedback. Avoid asking questions relating to personal preference. Questions like, "Do you like this design?" or "Which one of these is better?" result in little value. As an alternative, try to obtain responses that provide input you can utilize. Asking, "Does this item seem contemporary or old fashioned?" or "Describe what kind of a product this design represents?" or "What does the company want you to think as a result of this design?" can help you compare people's reactions to your creative brief—and then assess whether your design produces the desired response.

Analyzing Test Results

Most results garnered from design testing are quite easy to interpret and learn from. For example, if users can't find a key area in the website, you make the path to this section more prominent. If viewers universally misunderstand the message in your advertisement, you reconsider the communication. If audiences react differently to the identity that your client wants to achieve, you retool the styles in use.

At times you'll need to analyze test results more critically by considering a series of questions. Was the test environment suitable? Were the tasks well defined? Were the right questions asked? The reason for this more intense scrutiny is that some clients think that soliciting random opinions is the same as testing. They'll pin early comps on their office bulletin board and ask staff for their opinions without explaining what the goals and plan for the design are. Alternately, they might bring the testing materials home and ask their kids what they think of the design. (Don't laugh—I've actually experienced this sort of "input.")

Identifying a particular usage problem or pattern needn't negate a path you've taken. This finding might just suggest that further

Make a point of continuing to measure any design you create—well after the release/launch—so you can learn from real users and make your work better.

consideration or iteration is required. The need to look at issues beyond face value is doubly important when you're probing for insight on more subjective matters. Test respondents' perspectives can be influenced by a multitude of factors. The immediate data that comes from testing visual design cannot be treated as absolute; just use the results you collect to help you identify areas worth additional investigation and potential action.

Refining Your Work Continually

As you learn which issues need to be remedied, document them simply and work to pinpoint what's causing the failure. As you do so, you'll soon devise ways of solving the problems. Sometimes testing results will require you to wholly rework your design. However, for the most part, such radical reworking shouldn't be necessary.

Instead, you'll create associated actions and determine who might need to address each of these tasks. For example, some changes will need the involvement of content creators, web developers, and project managers. Identify in which order these tasks need to be done, speak with those involved, and ensure that all individuals involved are clear on what's required of them.

It would be a mistake to assign too much time to each cycle in the iterative process. To maintain your momentum, create variations quickly. Don't rewrite your entire plan; just identify what appears to be at the root of the identified problems and rectify those issues. Often, I'm surprised by how even a few little tweaks can make all the difference to reconcile a design that didn't quite work.

Test and measure your work regularly to determine whether you've taken a reasonable tack. Then use your findings to help inform your next set of revisions and refinements. Testing and improvement can—and perhaps should—continue well past the launch of your design. With time you'll gain perspective and can tap a larger pool of collected information, which can guide you toward more accurate findings.

As brands gain awareness in the marketplace, you can again survey audiences for feedback and measure this new information against previously collected data. For websites, you can set key performance indicators (KPIs) and, as the site evolves, you can review analytics and

compare activity and traffic patterns against earlier datasets. Similarly, on critical pages, you can run A/B or multivariate testing. These methods involve creating two or more versions of a page, each having minor variations. The aforementioned techniques are just a few of many that can help identify which design presentation is most suitable.

The creation of a monthly magazine, an e-mail marketing newsletter, or other recurring design projects are well suited for continual measurement, evaluation, and fine-tuning. These items can be augmented regularly without exorbitant cost and can be improved upon. Advertisements—especially digital ads—also benefit from iterative refinement because the deployment cost is minimal, and the time required to push out new versions is equally so.

The design process never really ends. If design had a single end point, the automotive industry would have produced one car and never bothered improving upon its early model. Technologies, users, expectations, and needs are always changing. An iterative design mindset trains you to produce the best work you can at a particular time and then allows you to perfect your design further as time passes.

Producing Your Design

Once you've determined that your prototype is functional and ready to proceed with, you can move into the production phase. This step involves locking down treatments, building out a more exhaustive set of assets, and resolving a number of logistical concerns. Some designers feel that production is beneath them—a necessary, but boring, step. But as a good designer, you should know your tools, plan your time well, and work meticulously to avoid letting little slips sabotage an otherwise workable approach. Producing your work well will help you create the kind of results that will keep clients calling you back for new projects!

If you've followed The Design Method to this point, you'll be in good shape because you will have covered the broad concerns (Discovery), determined a viable course of action (Planning and Creative), and created prototypes that your client has committed to (Application). You then need to apply this same rigor when producing your work. You'll do so by managing logistics ranging from file

preparation and materials selection to scheduling and delivery of assets. You'll also track issues and change requests, and communicate and collaborate with colleagues and partners.

On a print job, production involves sourcing materials, determining application methods, selecting vendors, preflighting (confirming that all files are provided—and work as intended), checking proofs, and running press checks. An identity project requires these same tasks along with documentation of standards for client use and the production of other design assets: perhaps garments, environments, signage, displays for trade exhibits—*oh, the list goes on!* Websites and apps require the cleanup and organization of your PSD files, documentation of UX conventions, link states, break-points (the point at which the layout changes to fit the screen in use), animation treatments, and any other details developers will need to know as they build out your design. Social media campaigns might require you to produce a number of assets for a longer-term rollout, so they are ready when the campaign manager needs them. Ad spots need to conform to certain technical conventions like dimensions, file size, format, and perhaps even ratio of text to image. Similarly, you'll need to consider all the points of contact for the user, ranging from confirmation

We created hundreds of icons for the new Vancouver Aquarium website. In order to expedite all of this work, we used standardized sizing, established common visual treatments, and even automated the exporting of ready graphics.

dialogs to e-mail notifications and updates to ensure that all of these elements are "on brand."

Production is resource intensive and requires a lot of time to produce assets, perfect elements, and work out any new issues that may arise. Given the time involved, it's best to complete this work competently and accurately. You'll also need to continue to refine your decisions to strengthen your design (you thought this part was over and you could now just relax with a Mai Tai—but design can always be made better). Those who produce good design are equally meticulous when it comes to their production habits and the way they operate their studios. (You'll find more on these points in Chapter 10, "Bringing Order to Your Practice.")

In production you should also create tools and learn new techniques that speed your process. Define style sheets so you can format text with a click or keyboard shortcut. Establish Photoshop actions to accelerate image correction. Determine key illustration sizes and treatments, and adhere to them as you build out these assets. The more of these functions you can sort out, the faster and smoother production will go. Achieving efficiency during production helps you meet the project's deadline and maintain your studio's profitability.

Keep an Eye on the Brief

In the throes of production you can be so focused on reaching the finish line that you might bypass details that are integral to the project. Fortunately, you can refer back to that creative brief (and the goals and objectives) you started out with. Dust off those planning tools regularly and determine whether or not the decisions you're making still move you toward the target. If they don't, slow down and figure out where you went off track before it's too late.

Most times, your current progress and output will match what you find in the brief. However, when projects go through countless changes or linger on for months longer than they should, you might discover a detail that you hardly remember. Keep in mind that you did extensive due diligence and charted your course at the start of the project for this very reason—to remain focused as the project progresses. Don't forget about that map now!

The creative brief is also a useful tool to pull clients back to the task at hand. As completion of the project nears, some clients will allow their minds to wander, thinking of how they could make the design more novel or interesting when they should be concentrating on their goals and objectives. If you sense this deviation happening, review the brief with your clients and get them to agree to the plan once again before moving forward. At this stage, straying from the brief would increase your clients' costs. Make this point clear, and don't back down. You have a destination; neither you nor your client should compromise reaching these goals.

Get Nervous about Pesky Logistics

In spite of all your observation, planning, ideas, and hard work, seemingly small production technicalities might put your design in jeopardy. If such a situation occurs, it's highly likely that you didn't work out the project logistics as carefully as you should have. Designers rarely talk about these blunders early in their careers; later, they share these horror stories over a few beers with other designers and hang their heads in shame.

Coming up with a good idea is tough; getting a client's buy-in for it is even more so. But after all this hard work, some designers forget to consider the details: They don't work shipping or mark-up into their print cost; they let a junior designer export all the web images and fail to ensure that the files were efficiently compressed; they run a double-hit of ink on a brochure but then use hairlines in their design, resulting in these lines becoming invisible. I liken these sorts of stumbles to training your whole life to run in the 100-meter sprints at the World Championships, only to trip on an untied shoelace. Small details matter—in fact, these details can make the difference between success and rather epic failure.

One consideration that's often overlooked is how a design will actually become a reality. If you're facing tight timelines, these factors often fade into the background entirely until they become real issues. For example, you might propose a "wicked awesome" look for an information kit, but the associated production process is so costly that it would blow your entire print budget. Or, the catalog you designed

isn't eligible to be shipped as an envelope, meaning your client must send the book as a parcel—which again wreaks havoc with the cost structure. Or, you show web developers finished comps only to learn that the technology in use can't support your neat idea. (Turns out that "simple" idea you had isn't quite so easy to produce. Maybe you should have met with your web guys a little earlier?)

My nervousness surrounding production nuts and bolts might come off as paranoia. However, when there are tens of thousands of dollars—not to mention your reputation—on the line, you need to recognize which worst-case scenarios might occur. Don't get lulled into taking anything for granted. Don't expect that all problems will magically vanish. Don't think that someone else will catch your mistakes. Small, seemingly trivial, issues are often to blame for many gruesome design train wrecks.

Although few will ever call you out for your killer production skills, you should be proud of your ability to bring your ideas to life in a fashion that eliminates—instead of creates—headaches.

There's little as embarrassing as having a production detail ruin a project and force you to look foolish in front of the client you've worked so hard to establish a trust with. So, get nervous. Ask questions about details. Think through how your work will be produced. Double-check your files, and ask others to do the same. Talk to your partners and coworkers as you develop your ideas. Why bother producing a concept your client can't afford to print? Why pitch an idea that the chosen technology can't support? Show your suppliers what you're building. Ask them for quick budgets and to try to poke holes in your thinking. They want you to succeed; don't wait until the last moment to ask for their critical input.

Prepare Checklists and Track Issues

I'm a big fan of checklists, and even though they can't be used to run a design process, they can help ensure that you've considered most of the fine points in your projects. These lists can be as involved as detailed preflighting and quality assurance (QA) checklists. They also serve as a container for all those finicky little reminders, like checking that you've converted RGB images to CMYK and running a final spell check.

Given that many of your projects share similar requirements, you can standardize your checklists for use from one job to the next. Simple, ordered lists of common tasks provide you with a resource to double-check your work against. Group them according to project stages and use them to ensure you haven't missed anything. Some tasks won't happen on every job; that's OK. You can cross off those points quickly and just move on.

Although you carry over checklists from one project to the next, issues are tasks specific to the job you're working on. For management of such issues, designers can learn from developers, because they are always documenting bugs. The tools they use to help systemize error tracking contain priority settings, approval records, and screen capture functionality. On most Web projects, these bug lists even tend to drive the project as completion nears.

Rarely do I miss tasks or problems on our clients' projects. The reason is not due to having a good memory; in fact, it's quite the opposite. I don't trust my memory at all, and you shouldn't trust yours either. By fastidiously making checklists and tracking issues, you'll avoid having these details slip through the cracks.

If you're working within a group, find a tool that allows all team members to contribute items to your lists. These tools can also help assign tasks to specific parties and track who has completed them. If you're a technophobe, write out issues and changes on a big sheet of paper on the wall. It doesn't matter how you track these kinds of points, just as long as you do.

Even the most obvious problems and reminders need to be on your lists. Knowing there's a catchall for all these items is critical. Get these concerns out of your head so they don't weigh you down. By doing so, you'll be reassured that these points have been dealt with before the job ships—and you'll sleep better for having done so.

Catching Mistakes Before Going Live

The more time you spend on a job, the more your observational facilities weaken. I compare this affliction to the avocado-colored toilet in your bathroom. The first time you saw this ghastly object, you vowed to remove the monstrosity. But after a few years of procrastination, you probably no longer even notice this visual abomination. This same tendency to adapt and no longer see problems is very dangerous in design projects. The way around this temporary blindness is to ensure that multiple parties are involved in reviewing a project prior to going live—or to press.

Production isn't a time for subtlety. On digital projects, test every button and link in your functional prototype; vary the device, browser, and settings, doing everything in your power to "break" your design; screen grab and document every glitch—no matter how small. For printed jobs, hand out big, red markers to the others in your office and ask them to review your proofs in succession, circling any problems they spot. These folks needn't be designers; some of the best catches come from those who aren't familiar with your craft or the job at hand.

In between QA rounds, make the necessary revisions, and then transfer the work to the next person in line. As a result, you'll minimize overlapping changes that could contradict one another. Numerous passes will increase the possibility of catching problems before you call the job complete. Just remember to outline and communicate what you want your reviewers to do. Do you want them to check for image suitability? Proofread text content? Try to use the item? If you aren't explicit about what you want them to look for or do, they might not even think to note some of the problems they spot.

Getting Ready to Ship

Depending on the kind of design project you're working on, the completion tasks will vary. Therefore, I'll touch on a few of the high points here, and you can customize this part of the process as necessary for your specific projects.

If you're working on a project that requires outside preparation, you'll need to manage that interaction. Get to know your suppliers,

review what you'll be sending them, provide ample time to run your project, and be clear about what you need from them. An open dialogue between you is vital; when you find good partners, don't let them go. Good printers, for example, are a huge asset. Keep those service providers happy. Don't ask them to quote jobs you intend to give to others. Give them files that are well organized and easy to work with. Oh yes—and pay them on time (they seem to like that).

Clearly document your clients' approval at key intervals. Get sign-offs on work that's ready to go to press, or get their approval digitally if that works best for them. Don't get sloppy and accept a verbal OK. That isn't good enough. You need to protect yourself should the job not work out the way your clients have hoped. Ask them to double- and triple-check small details. On one of my first projects, a brief introductory brochure for a company, I mistyped the client's phone number. No one on the client side even noticed. Fortunately, just before the job was scheduled for printing, I caught this gaffe. *Whew!*

On interactive projects, you'll need to pass your work to a content creator and web developer. Talk to them well in advance of this handoff. Ensure that you're providing them with all they need to set them up for success. Make yourself available to them as questions arise, and be flexible about design points that might change due to other requirements. For example, the developer might need to modify some form elements to make them work throughout the entire site. Rather than push back, try to find reasonable compromises that maintain the design without becoming burdensome for other team members. Most approaches can adapt without being compromised.

The list of requirements at the end of a design project varies from one job to the next. Apps and websites need to be demonstrated to stakeholders, and possibly at public unveilings. Similarly, you may need to provide training on the use of the item you've designed or the way to manage this property and the content within it. They'll need exhaustive QA testing and require a beta period, during which you need to be prepared to address problems rapidly. Advertising materials require numerous checks, revisions, sign-offs, and tweaks. In addition, you'll need to prepare documentation for brand and corporate identity projects, and other design assets that will be augmented and implemented on the client side.

It isn't practical for me to discuss the fine nuances of each

production requirement of every project you'll encounter. However, what I can recommend is that you treat production as importantly as any other part of the design process, maintain clear lists of tasks and issues, and be vigilant in your search for potential obstacles. Your clients don't understand the number of concerns that arise during production, and they shouldn't need to. Their confidence should be in you to deliver good work, on time, and on budget.

Up Next

Now that you've learned to implement The Design Method, you're ready to put it to use. Next, I'll provide you with information on managing your interaction with clients, presenting your plans and design solutions, and documenting your process and thinking. These tasks will cement your role as a design professional and help you lead clients through the design process effectively.

Presenting Work to Clients

Now that you understand The Design Method, the challenge of "selling" your ideas comes to the forefront. This activity requires you to establish clear roles, present your plan accurately, and document your approach in a cohesive fashion.

Managing Client Interaction for Success

Some successful design firms create terrible work; conversely, many great designers run studios that hardly break even. The reason? Design studios are businesses. Those who operate them as such are more apt to succeed than those who treat their companies as an extension of self. You can love what you do, create good work, and be profitable, but if you can't manage client interactions effectively, you'll most likely fail.

Your ability to convey thinking, present sensible plans, and persuade others to follow your direction is critical to ensuring the success of your work. In addition, you'll have to facilitate productive meetings, deal with corporate politics that have little to do with you, and anticipate potential obstacles and determine ways of addressing them before they spiral out of control.

Many designers loathe this part of the job and would rather leave all of these responsibilities to someone else. However, you can't make good design without working closely with your clients. You need to believe in the work you present to your clients and actively convey why you're suggesting your approaches.

Moving Beyond Name Calling

When you read design blogs or attend designer get-togethers, you might get the impression that all clients are devising elaborate machinations to destroy the lives of good creative folks. Or, perhaps that they're just clueless dullards, incapable of understanding the difference between an en and an em dash. *Heathens indeed!*

These snarky writings and comments are indicative of more than just designers letting off steam. It's symptomatic of a very challenging collaboration in which a client, with sometimes little design experience, is forced to edit the work of people with significant expertise in a particular area. A strange notion, isn't it? It's like Mark Cuban giving basketball advice to the Dallas Mavericks team members—sure, he owns the team, but can he perform a decent layup?

Unfortunately, designers rarely move past these catty jabs and take the time to change how they interact with clients. Neither party intends to make the other miserable; it's just a difficult working

dynamic. Part of making the dynamic positive involves empathizing with your clients and trying to understand their backgrounds and situations. You also need to communicate clearly, involve decision makers, define roles, edit for your clients, present your work well, and document your plan. By taking these steps, you can set up projects for success, which is exactly what your clients need you to do.

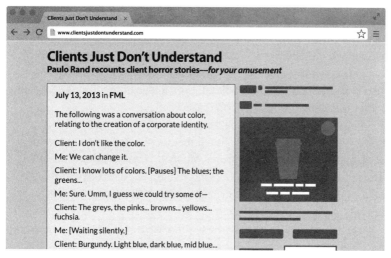

It's awfully fun to read snarky blog posts about clients. Unfortunately, these posts can color your perspective, leaving you snarky instead of asking how to make the situation better.

Your Client's Reality

For you, design is pretty straightforward. You have spent a large part of your life committed to this pursuit and may feel more strongly about your career than those you know in other industries. You see your work as fulfilling and important, and put an enormous amount of effort into your design. However, your clients don't know this. They don't understand your commitment to your craft, how hard you work to keep them happy, or the financial hits you're willing to take just to make a project great. Instead, they have lots of other business issues to deal with, as well as their own lives—a whole other set of concerns.

Frankly, your client is most likely a bit scared of the whole design process. You might have sounded reasonable at the first few meetings,

and the project started off on the right foot. But then the project turns out to be costly and feels unpredictable. Your rate was higher than all the other bidders, and your client had to go to her boss asking for a budget increase. She managed to get the extra funds and hire you, but now her reputation rides on the work your studio has been tasked to create. And honestly, the situation doesn't look good at the moment. She's never worked on a project like this before, and the whole process is new. You use unfamiliar jargon and aren't really paying attention to her contributions and those of her colleagues. Plus, when she tries to lend a hand and present ideas, you seem unhappy and defensive. She doesn't know when it's OK to ask for changes, what's a reasonable request, or which revisions will take you a lot of time to produce—and perhaps cost her company more money.

Before you go off pointing fingers at your client, ask yourself how you'd approach this situation. Imagine that you've selected a team for some big project, and the team members demand a substantial sum. The deliverables outlined in the contract are nebulous, and if the job fails, you lose the entire investment. There are no guarantees. Is there any wonder why the client/designer relationship gets a little tense? Fortunately, there are ways to make this experience easier.

Communicate Well (and Perhaps Excessively)

Design is a communicative medium; similarly, it is a *communicative process*. Design is just one part of what you offer. The other part is the level of service you afford clients. Establishing a positive experience for your clients is critical. Those who've hired you want to feel safe, listened to, and respected. They want to know that you are working on their behalf instead of making something to pad your portfolio. The reasons for your decisions must be made clear to them.

Discussions about creative work are difficult because these matters can be subjective, which can lead to misconstrued comments. So, put extra effort into conveying your message accurately. E-mail is easily misread, so call or meet in person to discuss important points. If you're unsure of something your clients say, ask for clarity. Clients don't mind explaining themselves and appreciate not having to repeat their input and ideas later.

Technical language and references you use might be foreign to your clients, so avoid jargon. When you must use specific design terms, define them. You needn't dumb down your message, but don't expect your clients to care about x-height, asymmetrical balance, or Gestalt principles. Be sure to listen to the terms they use in their industry, and become proficient in speaking their "language." (Your clients will like that you're interested in their work and are paying attention.)

Talk openly about timelines and deliverables. Acknowledge problems and how you'll address them. If you make a mistake, take ownership of the situation. Avoid burdening your clients with your pressures. Instead, focus on their project and how you can help. Remind them why you're doing what you're doing, and how the methods you're using will help them achieve their goals.

Say yes more than no, and instead of dwelling on obstacles, look for workable solutions. Make your client feel confident in providing feedback and asking questions. All of the communication points suggested here will help keep the project on track, but if your primary client contact changes mid-project, they might be of no value; therefore, from the very beginning you need to enlist those who have the authority to make the big decisions.

Involve the Decision Makers

Different people will be involved in the design projects you facilitate. Although many can lend useful input, some have more power than others. Therefore, you'll need to determine early in the process who has approval and veto power. Identify these decision makers and ensure they are present during your very first discussions. It's at this time that expectations and concerns need to be voiced, and misunderstandings corrected.

Designers who don't involve decision makers from the beginning get unpleasant surprises. Senior managers uninterested in up-front legwork often want to have their say once design solutions are presented. Such sporadic involvement can be hazardous. If you're ready to show creative work to a group, and unfamiliar individuals appear in the room, be aware that you're about to get sandbagged. The uninitiated won't know why you've chosen the direction you have,

which can lead them to ask for entirely new directions, completely unaware of what it took to reach this stage.

Throughout the design process you work to establish and refine a shared understanding and plan. As you move through each stage, you continually adapt and achieve a consensus with your clients. Introducing new people to the process—who haven't been a part of these discussions—invites disruption. They won't understand why certain decisions have been made, and might even want to explore new and different ideas. However, going back to the beginning or starting new rounds of brainstorming isn't feasible at such times.

Consistency is critical for producing appropriate design on time and on budget. Consequently, those contributing to the process must be present for preliminary strategic meetings. The decision-making process is cumulative and requires continuous involvement. A unified direction is difficult to achieve when key participants miss meetings. Explain to your clients that they need to be present for the entire process for it to run smoothly and cost-effectively.

Defining Roles

As you present your findings, plans, and creative work, the roles and responsibilities of you and the client need to be clear. Your client's job is to identify potential problems in your plan and then verbalize these concerns. Your job is to interpret what your client says and present viable solutions. This clear division of responsibilities can lead to effective design. Allowing these responsibilities to muddy can put a project at risk and leave everyone involved rather unhappy.

Clients sometimes confuse their role in the design process. The work you do seems interesting, and those who hire you might like to take part in this fun. Some, not all, clients want to be involved in your brainstorming and visual process, but allowing clients to do this work is a mistake. Their role is to look objectively at the work you provide and opine on whether your logic will help them reach their goals. When they get involved in creative tasks, they become invested in certain ideas, which results in personal preferences that mitigate their ability to provide impartial feedback.

Your clients know their business, customers, history, and strategic

The Client's Strengths:

- Industry
- Business
- Customers
- Usage

The Designer's Strengths:

- Message
- Language
- Tone
- Visuals

Both the client and designer play important roles in the creation of good design. However, each one holds certain strengths and insights that the other doesn't. As such, think carefully about the part each group plays, and try to avoid stepping on the other's toes.

needs better than you do. Keep them focused on filtering your suggestions through their knowledge—not on making this process a collective field trip to the "art department." This same focus relates to the kind of feedback that's appropriate for your clients to provide. Although they have a personal preference for yellow rather than blue, their subjective preferences might not matter. However, their understanding of how customers would react to certain imagery probably does. Ask your client to identify problems, not preferences.

Pay close attention to the problems that are voiced, and give your clients ample opportunity to provide their insight. However, stop them from becoming overly involved in solving the problem, because allowing them to do your work can cloud their role. If they don't believe the proposed design will resonate with their clients, ask why. Is the imagery inauthentic? Do the headlines seem too aspirational? Is the intended message obscured in some way? Probe, prod, and push to understand what's amiss, but stop your client from trying to fix the problem. (The worst call you can get starts with the question, "Can you send a copy of that file so we can try some variations of our own in Photoshop?") You come up with the ideas. Your client tells you why they won't work. You correct course and supply revisions. It's a simple relationship if you define roles explicitly and keep them that way.

Edit for Your Clients

Good designers don't just create, they edit. You are trained and focused on determining requirements, researching options (such as paper stock, type selection, or a storytelling method), and assessing viability. As such, there's little need to force your client to work with you on every decision surrounding implementation.

Imagine being in a small bistro for dinner and having the chef ask you to test three types of pasta and choose your favorite. Although this personal touch might at first seem endearing, eventually, such silliness might become off-putting. You don't want to tell a trained chef how to cook noodles. That's his job, and you assume he can make such decisions on his own while you enjoy your wine and conversation.

A designer works in a similar capacity—albeit more customized and collaborative. You are trusted to create mechanisms that result in some kind of meaningful change. Your design might help your client sell more products, improve the story that's being told, or change the way audiences perceive what an organization is doing. Although you need to work in a respectful and inclusive fashion, you can't lose sight of that end goal.

Ideas are a dime a dozen; suitable ones are less plentiful. It's your job to excise deficient and weak options quickly and dispassionately. You make these decisions because you are trained to. You're the one who is supposed to know the characteristics of different paper stocks, the functionality of different typefaces, and the conventions most suitable in an online context, not those who hired you.

Fully explore the possibilities at hand, consider each one with your clients' best interests in mind, and then serve up only the most fitting option. If it doesn't work for them, you can go back to the studio and rethink your selections. Do not offload this work on your client. They will appreciate that you're cutting the options that aren't appropriate or good enough, and that you are respectful of their limited time.

Preparing for Your Presentation

The way you present your work might be the most critical part of the design process. No matter how thorough your discovery is, how rock-

solid a plan you deliver, or how sensible your execution might be, if you can't get buy-in from the folks on the other side of the table, you're done, the design dies, and you go back to the beginning. Sometimes completely workable design meets this fate due to a bad presentation.

Many see group presentations as nerve-wracking and anxiety provoking. Although such reactions are completely understandable, they can be overcome. Eventually, you'll learn, as I did, that presenting work can be easy by just being prepared. As a result, you'll gain confidence and begin to lead presentations like a pro.

Over the years I've watched folks completely bungle presentations. Sometimes the carnage has been spectacular: technology stopped working, presentations failed to load, or the speaker's water spilled all over the table and documents. Each time, I've made a mental note to do everything in my power to avoid being "that guy."

Presenting work to clients is easiest when you consider every requirement and prepare for possible slips and unforeseen circumstances. Schedule the presentation time in advance, and find out who's attending. Also, determine who, from your studio, needs to be there, record the appointment in your calendar, and set an alarm a few days prior to your meeting. Start preparing materials well ahead of the presentation, and ensure that all of your documents are ready the

Create a checklist of standard items you need for presentations. Dongles, remotes, a USB with a backup copy, notes, extra pens, and water are a few that come to mind.

night before your meeting. If you procrastinate and do not complete the preparation until the day of the meeting, some unexpected event is bound to transpire, and you'll be scrambling to get to the meeting on time. (This results in a completely unnecessary kind of panic.)

Do a walk-through of your presentation and make sure your content flows well. Time yourself and verify that you have adequate time for questions at the end of the session. A checklist of items you require for the meeting is also helpful. From your laptop and power supply to display adapters and your presentation remote, make sure you have everything you need set aside and ready to plug in. Bring some water in case none is available to avoid hoarseness or a tickle in your throat. Also, store a backup of your presentation on a USB drive in PDF form. In a worst-case scenario, you can use the PDF on one of your client's machines.

Regardless of how many times you've presented work, something will go wrong. The room will be double-booked, your laptop won't play nicely with your client's projector, or the window shades will be locked shut. Show up 20 minutes early to put your materials in order and casually chat with early birds. If you're running a few moments behind, call and say so. And if you aren't sufficiently prepared, reschedule the meeting. Your client would rather wait a couple of extra days than have you stumble through an incomplete presentation.

At smashLAB, we work with several remote clients. Presenting to these groups is certainly more difficult because it's harder to convey ideas when you can't use your hands, point to the screen, and see how participants are reacting to what you're saying. Given these challenges, I suggest keeping presentations to remote organizations as simple as possible. Run a conference call on a standard landline; traditional phones are generally more dependable than VoIP calls. Then use a screen sharing service that allows you to run through your slide deck while your clients watch from their location. Check to see that they can hear you and ask if they can see the materials clearly.

Skip the "Thrilling" Unveil

People in advertising live for the unveil because the event marks a spectacular moment in which they bank their fortunes on their ability

to put on a good show. The unveil is a Don Draper-esque moment of pomp, arrogance, and risk that's completely unnecessary. If the presenter does well, the client gives the thumbs up, and the agency proceeds with its big idea. If the presenter misses the mark, the creatives go home empty handed. The unveil is one of the more obtuse rituals of the agency world, and one you'd do well to avoid.

Mad Men viewers all reveled in Don Draper's explanation of the slide projector being more than just a wheel. It made for great television—but such theatrics are risky in the real world.

The Design Method isn't about magic shows, thrilling moments, or the glory of winning. Good design isn't show business and doesn't benefit from pointless melodrama. Instead, this method is an ongoing set of refinements that the client needs to take an active role in, from the very beginning. If you present materials regularly, informatively, and intelligibly, you'll get the ongoing buy-in and confidence of your client. By distributing your efforts and acting like a professional instead of a showman, you'll avoid costly missteps and frustration.

Keep a running dialogue with your clients, and check in with them on a regular basis. Use your meetings and documentation to illustrate that the work you're helping them with is evolving. In doing so, you afford your client the opportunity to point out concerns early on and enable them to help steer the process. Your client shouldn't ever be

wowed by what you present to them. There should be no big surprises. What you show should just be another logical step in the process.

How to Lead a Presentation

At the beginning of your meeting, explain what you'll discuss, and what you hope to achieve from the session. Outline the key parts of your presentation and create corresponding title slides in your deck so participants have a sense for how far along you are. Know what you need to convey, speak confidently about the planning and work you believe in, and stick to a format and timeline. Ask all present to hold their questions until the end of the presentation, so the talk runs smoothly and is completed on time.

As you work through the presentation, let the group know what point you're at, and reassure them that you're on time. Although you should avoid deviating from your presentation, be mindful of your audience. Make note of strange reactions or expressions of concern. If someone in the room looks like they need your attention, pause for a moment and find out what's problematic. Don't let this take too long—just address the point quickly. In the event that you have said something wrong, acknowledge your mistake and respond to it (perhaps with a small joke) and move on. You have plenty to say—don't let a small slip derail your presentation.

Some try to present their very best selves during presentations to clients. They dress differently than they normally do, use ten-dollar words, and wax poetic in a way they'd never talk to their colleagues. I suggest you simply behave as you normally would. Dress appropriately, but don't overdo it. (No one expects a designer to wear a suit and tie.) Speak clearly and at a reasonable pace, and avoid putting on airs. Concentrate foremost on getting your ideas across and making sure those in the room understand what you're trying to accomplish.

Stemming Prejudgment of Creative Work

Start your presentations by reiterating the goals, objectives, and creative brief. Although clients would rather see visual examples than

hear you talk about your ideas, don't be bullied into complying. If you jump too quickly into showing visuals, the feedback your client provides might be off target.

Allow your slide deck to lead you through your presentation methodically, conveying all you need to communicate point by point. Keep any printed materials and handouts tucked away in your bag, and avoid passing them around until the end of your presentation. (If you release them at the beginning, participants will flip directly to the work samples and start critiquing.) Only after you have everyone fully briefed and prepared should you show any creative work. And when you do, take your time, ask questions, and address concerns as they arise before moving forward.

Extend this level of control on remote presentations as well. Call first, share your screen, and run the meeting, but avoid e-mailing documentation until you've finished your presentation. If you can get everyone to understand your logic, the creative samples shouldn't alarm anyone. The documentation you supply—after your talk—should just remind stakeholders of the discussion and help make them even more comfortable with your plan.

Presenting Creative Work to Large Organizations

When you are hired by large organizations, you'll need to consider how to get everyone on board. Odds are that you'll work with a few team members and gain their buy-in. They won't open this process to everyone on staff—doing so would stymie the project before it started. However, at some point you'll need to present the new direction to the rest of the staff. The way you do this should not be treated casually.

A few years ago I worked with a company's internal marketing team that was thrilled with what we had developed together. Unable to temper their excitement, they collected the still incomplete materials and brought them to the pub to discuss with the entire staff (largely composed of scientists) over Friday night beers. They then tossed the materials on the table and asked their colleagues how they felt about the new look. Trust a bunch of tired, drunken, scientists to turn everything into a joke. By the time they had cleared away their last pints, the project laid on the table, a lifeless corpse.

A rollout can also go flawlessly: One of our recent clients controlled the release to much success. To get approval from others in the company, our client-side partners presented to each of their department heads and got their buy-in. Then they brought everyone in the organization together for snacks and a group meeting in which they presented the design solution. They reviewed the process we had all gone through, carefully explained the decisions made, and then showed the work. With everyone in the organization in agreement with our plan, they then revealed the design to external stakeholders and finally the public. The reveal was a thing of beauty.

On large projects in particular, it's important to work with your clients to determine a strategy for revealing your design to those who weren't involved in its creation. Determine which groups have to be reached, what needs to be conveyed, and the order in which you'll explain the plan and design. Also, anticipate ways of responding to potential objections. Lots of emotions can be in play when creative work is in question, and those who feel excluded can be difficult to win over. Taking the time to manage expectations and control how your work is presented can help minimize the risk of mutiny.

Documenting Planning, Ideas, and Design

Good documentation explains why you made decisions, allows the client to review your planning in detail, and reassures your client that the chosen direction is sound. These materials also help convey direction to your colleagues and third parties involved in the project. I spend a lot of time documenting design. Sometimes this task happens at the end of a project when I need to outline the use of corporate identity standards. Mostly, though, I document design on an ongoing basis, as the process is unfolding.

Documentation needn't be fancy. Your documents just need to convey your thinking. If you build standard (template-like) documents for parts of your process, like Discovery, Planning, UX, and Creative, you can just fill in the blanks with each new project's details. This can be a real time-saver, and allow you to save your energy for strategy— instead of repeatedly contemplating how to best format a document.

Consider what the most suitable delivery device is for the work

Documents like identity standards are tedious to build but afford the client a manageable way to ensure that the design you created gets used properly and stays intact.

you're presenting. I use slide decks a fair amount because the format forces brevity, and these documents are easy to share between parties. Additionally, after the presentation, I typically create a PDF of my deck and supply that for my client's further review. The only part of the design process I haven't been able to summarize in a slide deck is UX. The space needed for wireframes and sitemaps requires a different format, or printouts, in order to review properly. Similarly, content strategies often work best when they are formatted for a printed page, because they tend to contain more detailed information that will be used on an ongoing basis.

Most of the process recommendations in this book have more to do with larger projects. But you can always ratchet back your process on smaller jobs, as long as you understand how the stages of The Design Method and associated tasks link together. Likewise, you can augment your documentation to suit the project at hand. Truncate parts as necessary, and merge all of your thinking into a single summary document if that will suffice. You needn't address every detail in documentation; just ensure that you've covered all the parts that matter to getting the job done right.

Create documentation that is complete but succinct. The more you can make it so, the higher the likelihood that your client will actually read these materials. And, as always, avoid jargon. Everything you write should be clear in meaning; otherwise, remove the words that

make your documents ambiguous. Where you can, use bullet points to save space and convey notions more efficiently. Additionally, keep in mind that some people won't be present for every meeting. Therefore, write brief paragraphs to introduce sections in your documentation to explain what you're showing and why these items matter. Check over all your documents and consider whether or not the content would be clear to someone who'd never been to one of your earlier meetings.

Up Next

Working within an organized and systems-driven studio makes your design process productive, profitable, and successful. In Chapter 10, the final chapter of *The Design Method*, I'll recommend ways to run your studio efficiently and effectively.

Bringing Order to Your Practice

The quality of your design process, whether you're a freelancer or studio owner, is closely related to the way you manage your business. By integrating order, standard procedures, and good housekeeping—in all your working habits—you'll deliver consistent results and increase efficiency.

Are You a Professional or Hobbyist?

Although there are many interpretations of the word professional; I believe the term implies commitment. Professionals put the requirements of their practice ahead of their personal desires and tendencies—regardless of how difficult it may be to do so. They gain a command of their craft, learn how to manage their process, and run their business effectively.

Many freelancers and design studio principals treat their practice like a hobby. They're passionate about design and mistakenly think they can avoid all the tasks and requirements it takes to run a business. They take on projects that can't be profitable. They treat their staff members as friends. They fail to collect down payments, bill on time, chase delinquent clients, and consider billable efficiency. However, to create a successful business, you need to act decisively and sometimes perform unpleasant tasks, or you'll put your business at risk.

Regardless of whether you're working as a freelancer or managing a larger studio, you need to strive for professionalism in all of your activities. Although you like what you do and want to do your very best, that doesn't mean you or your agency can get away with anything less than professional service. You need to deliver work on time, and your clients should receive the same experience today as they did a year ago. Billing, campaign reporting, project documentation, and all those seemingly boring tasks should be treated with the same level of seriousness as everything else you do.

Find Order in All Aspects of Your Profession

The underlying theme throughout this book has been order. It's order that makes a design intuitive for the user. It's order that allows you to produce effective design constantly. It's order that helps your clients know that they've hired the right designer. And it's order that will keep your studio financially sound.

When I look at the output of many other designers, I consider the work I produce quite plain by comparison. I don't employ elaborate treatments unless they are necessary. I'm not motivated to find "big ideas" and wow folks with my visual wit. I always choose the sensible

approach versus a passing trend. And I firmly believe that what people need from designers is the ability to identify, find, and create order.

Finding order in your workspace is also important, because the setting you work within affects the way you think and your ability to act. Set up a workspace that is free of distraction and conducive to concentrating on tasks. Clean your desk so there's nothing on it but your computer, phone, notepaper, and a drawing tool. Avoid the action figures, foam balls, and cutesy decorations you see in ad agencies— these gimmicks do little to improve the way you work. If you have extra space, buy additional desks or tables. Get plain white ones that you can push together to create lots of room to work. Store project sketches and notes in file folders that you can archive until you need them again. And at the end of every day, put away your tools so you enter a clean workspace in the morning. All you need is a workbench and some tools. With nothing else in the way, you can put all your focus on producing work in an orderly fashion.

Be it in your space, actions, or processes, orderly conduct helps you maintain a dependable design practice. Clients want to know that the design you produce is well considered, appropriate, and effective. They need assurance that when they call in need of your services that you'll be there to help. You can't guarantee your longevity when you're operating haphazardly, can't locate important documents, are afraid that you can't pay your bills, or are unable to work productively with your teammates and partners.

Just like you aim to create order for your clients, you need to cultivate structure in the way you work and in your environment. You need to think about your operation, the procedures you employ, and even the housekeeping routines you maintain. By pairing good process with a well-run studio, you can offer your clients a good product and service, and advance from being an amateur to being a professional— and perhaps even a master of your chosen craft.

Define Procedural Systems

In Chapter 3, you learned how systems thinking is essential for creating good design. Now, you must implement procedural systems to help you produce work efficiently. Unfortunately, I can't prescribe

absolute approaches for you; instead, I'll point out areas to consider and provide central suggestions. The systems you use in your work need to be informed by the way you work, the projects you take on, and your relationships with clients.

Although your clients will focus most on your broad design treatments, it's the small matters that can damage the relationship: not labeling projects accurately, forgetting to run a spell check, or failing to specify print quantities. When these seemingly tiny issues are missed, they can result in substantial errors that anger clients and even make you look like a complete amateur.

Implementing procedural systems minimizes embarrassing incidents. Additionally, through these approaches you can respond rapidly when changes are requested. Training new staff is also facilitated when there is one way to work, which also makes the delegation of tasks simpler.

Procedural systems might involve the development of a spreadsheet that contains all of your estimates. You and your coworkers can then rely on it to recall past costs, determine billable efficiency, and ensure that your pricing is comparable to other projects. Other procedural systems might include setting up time-tracking procedures, developing standard contracts and sign-off forms, and scheduling notifications for progress payments. You might also include running nightly backups to make sure that you don't lose months of work if a hard drive fails.

Maintaining common procedures from one job to the next will help you and your studio run smoothly. Even if you work alone as a

I suggest removing everything from your desk but the absolute essentials. A clean, organized workspace sets you up to produce design more efficiently than you will in a messy setting.

freelancer, structured actions lead to efficiency. Investigate suitable processes, explore how you'll implement them, and document the ones you choose. If you work in a studio, review these processes with staff and partners so everyone benefits from their use.

Replicate Successful Procedures

For the most part, doing something well on your first try takes a lot of time, because you need to sort out what works and what doesn't. It's only in repeating tried and true procedures that you gain speed and produce quality results.

Repetition is contrary to what many designers want to do. Instead, they want each project to be new, interesting, and explorative. However, this desire conflicts with producing design consistently and dependably. Therefore, it's best to find ways to make every process, form, and action in your operation template-able, so you can build a set of tools that you can use from one project to the next.

When you build templates from your core planning documents, these files can easily follow a standard order and format. The advantage of doing so is that you will be less likely to miss any key parts of your planning phase. You can do the same with proposals that have common areas for your agency description, studio philosophy, and client references. These documents also benefit from including tables for time and cost breakdowns, as well as areas for projected timelines and milestones, and perhaps your standard working phases.

Replication needn't stop with the aforementioned recommendations. Build a library of Word documents with digital letterhead and your corporate type styles pre-set. Ready standardized e-mail signatures, so when new staff members come on board, their correspondence matches that of others in the studio. Standardize your contracts and policies in easy-to-locate files that you can update whenever there's a change in how you operate.

Also, maintain forms for printing quotation requests, which will speed your ability to submit price requests and ensure that you've covered all the details. These forms can note the date and project number for later cross-referencing. Include standard slots that identity quantities, sizes, paper, number of inks per side, coverage, and

finishing. In addition, leave a space to record how you're providing files, the proofs you need to receive, where the finished printing should be shipped to, and who's covering the cost.

Consider creating libraries containing UX elements, wireframing items, and common symbols so they'll be handy for future projects. Efficiencies can be found in every aspect of your practice. By putting some effort into optimizing your studio and workflow, you'll work more effectively, avoid mistakes, and set yourself up to achieve quality results for your clients.

Meetings and Huddles

Truth be told, I'm no fan of meetings and would prefer to never sit through one again. However, my disdain for meetings doesn't change the necessity of regular communication—especially with those you work with on a daily basis.

The design process involves making many decisions; it's difficult to remember all of the salient points and determine which ones need to be conveyed to colleagues. Most times, it's only when you need to involve one of your coworkers in the project that you'll brief that person on what's happening. Then you'll be forced to recall the past months of work, choices made, unique situations, and client proclivities—and convey all this information. Odds are, you'll forget some key points or just overwhelm the person you're trying to fill in.

Regular, scheduled, and informal dialogue can ease the pressure when you're introducing a colleague to a project. People need time to become familiar with a client and project. So, tell your colleagues about the client you're working with as the job progresses instead of forcing this information on peers in one condensed session. Your peers will then be familiar with the project and pay attention as you discuss its development. They might even lend a hand before you expect them to, because they'll know what's needed.

Set aside 15–30 minutes (less if possible) every Monday morning to discuss studio activity, new clients, and project progress. Staff can feel sluggish at the beginning of the week and a quick kick-start can inject some energy. You needn't prepare excessively for these meetings. Just compile a list of projects underway, and then ask everyone in the

room to explain how their work is progressing. Doing so can help you spot obstacles in advance and ensure that all involved know the status of their projects and the next steps.

At smashLAB we've also found success with informal huddles. These brief standing sessions serve to quickly align the team while each person conveys key information. You can simply run these huddles as they need to happen, or schedule them for set times in a project's life span. For example, when Discovery and UX are complete, it's worth bringing in developers and designers to talk with information architects and strategists. By doing so, you can identify items that might prove tricky to produce. Then changes can be made, and all parties can mull over what they've heard and be prepared when their part of the project begins.

Some management-heavy organizations hold long meetings on seemingly any occasion. Others have reacted publicly to this tendency, condemning meetings and arguing that they should be eliminated altogether. Both approaches are extreme. For a design studio to run well, those within the operation need to know what's going on. Maintaining an ongoing dialogue and using meetings and huddles where appropriate can facilitate this awareness. There's no need to minimize or overdo these sessions. What you're trying to achieve is a working system in which little is missed.

Ball in Play Workflow

To stay on top of tasks, you'll need to establish a workflow that prevents assignments from slipping through your fingers. Most studios are extremely busy. Sometimes, the demands can result in more work than is manageable. This challenge often leads to hiring project managers to keep the machine running. Although this solution is sensible, it does have its shortcomings. First, if your agency has just a few employees, this extra salary can increase your overhead, putting a strain on the budget. Second, hiring someone new and getting that person up to speed can be a substantial undertaking.

Being a small shop, we had to find other ways of managing numerous tasks. One part of our strategy was to insist that everyone in the studio talk openly with one another. At first, staff had difficulties

complying with this idea. Designers like to put on their headphones and get to work, free of interruption. Changing this habit took a little time, but eventually we'd see a designer pull up a chair next to a developer and elaborate on points that might not have been conveyed in the visuals.

We call this tactic the "ball in play" policy. The logic behind it is that if I've passed the ball (task) to you, I no longer want to think about it. Once you receive the message, the task becomes your responsibility, and you have to let me know if you need something more from me. This simplistic-sounding mindset is surprisingly effective, because it eliminates the ambiguity from the correspondence and forces all collaborators to ask for what they need. The policy allows you to assign a task, get it out of your mind, and move on to another—without having to continually check back on the task.

Mistakes are made when you fail to identify tasks, delegate them, and document their completion. How many times have you heard the response, "But I thought you were taking care of that!" Systems don't need to be complex to be beneficial; just agreeing on how to work together can be enough to keep your studio performing better than many of your competitors.

Essential Tools and Techniques

To do my job well, I need a few tools and techniques. Sure, there are hardware and software needs, but these requirements are obvious. The tools that allow me to manage jobs properly include replicable presentation documents, centralized correspondence, and standardized job folders. Everyone in our shop uses these systems to streamline how we work together.

Each coworker also needs to maintain some kind of individualized task management solution (e.g., Things, The Hit List, TaskProtocol). The software used works as a catchall for small tasks as they arise. If need be, these tasks can be escalated into shared bug folders or group task areas and assigned to the appropriate person. Having a place to document tasks and issues gives you peace of mind that all the details about a project are safely stored (provided you back them up).

Other tools and techniques include:

- Structuring checklists, groupings, and devices
- Storing notes and contact information in one place
- Sharing e-mail folders
- Structuring folders on the server and numbering projects
- Building good files
- Naming and versioning files

I'll discuss each of these points in the following sections.

STRUCTURING CHECKLISTS, GROUPINGS, AND DEVICES

The tools you use to create and manage design aren't that different from those used in other disciplines to collect tasks, group actions, and monitor progress. It's just that many designers fail to use these tools, in spite of how beneficial they can be.

Checklists ensure that all project details have been addressed, or at the very least, have been considered. We use checklists as a way to double-check work at the end of a job and ensure that all pivotal tasks were completed. The need for explicit checklists becomes increasingly important on design jobs that last for many months.

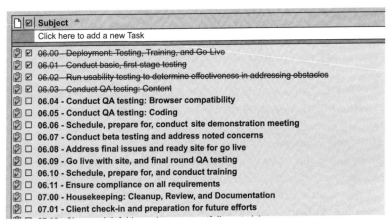

Don't trust wetware to manage project odds and ends. Task management tools are easier, more reliable, and less susceptible to corruption—from weekends of binge drinking.

Determining the grouping of work phases involves pinpointing the steps needed in your work. Doing so allows you to identify how a project is advancing and what tasks should come next. For example, you need to know when Discovery ends and Planning begins. Similarly, you have to understand how to link the results of your strategy to UX and Creative planning, and recognize when content creation should begin.

The simple act of determining how your tasks are grouped will help you plan projects, schedule them, and keep abreast of your progress. Additionally, by taking the time to define these groupings and associated actions, you're more apt to repeat them in future projects. Every job should start the same way and run through the same general phases. Doing so affords better organization of staff and resources, more accurate reporting for clients, and stronger overall project management.

By determining broad phases, you can create devices that you can use across varied projects. These include printed documents, schematics, slide decks, and spreadsheets that summarize discovery findings, set the stage for a creative concept, inventory and organize content, and even prepare clients to carry forward on a plan on their own. Your working phases indicate which documents to prepare, and standardizing them makes their creation that much simpler.

Once you start to create these documents, you can continue to refine them through continued use. Having them at your disposal will speed the rate at which you complete work, serve as a framework for future projects, and help you provide your clients with a consistent experience from one job to the next.

STORING NOTES AND CONTACT INFORMATION IN ONE PLACE

As the years pass, you'll produce useful documents that you use only infrequently. But when you need these files, you'll really need them. To be able to put your finger on them almost immediately, store standard documents in a central place.

Some studios use an intranet; others create a specific area on their file server for documents that are required on an ongoing basis. You might also consider using a wiki or a groupware solution,

like Microsoft Exchange or Zimbra. As you search for a suitable technology, consider how often you'll need to edit this content, how you want your staff or colleagues to use this resource, and ways to keep your documents up to date as your company changes.

Common items to place in this repository might include your studio/agency descriptions, staff bios, video encoding standards, and FTP instructions. Perhaps store your updated UX and QA testing processes in this one central location as well. Certain tools are more robust than others. You might want to choose one that also links to calendar and scheduling functions. These features allow you to identify when holidays are booked, stay on top of appointments, and remember recurring tasks, like insurance and domain registration renewals.

Centralized file storage for all of your contact information and e-mail provides a great deal of utility. When you need the e-mail address or phone number for a client, you can simply run a search from your computer to access this information. Not only will your colleagues be able to find and retrieve this data, but when particulars change and are updated, the information will be current.

SHARING E-MAIL FOLDERS

The one tool that has saved me many times is shared e-mail folders. When a question arises, I can always refer to these archives, check my facts, and locate proof that prices provided are accurate and that actions have been completed as promised. Maintaining shared folders can be tedious, but the associated benefit is worth any inconvenience. Strangely, few of the designers I talk to have ever considered—or even heard of—such an approach.

Depending on the groupware or e-mail technology you're using, you can establish a Public Folder or other repository that's accessible to everyone on your team. You can then set up a folder for each client you're working with. Then each team member simply needs to commit to moving incoming and outgoing e-mails related to a job to the appropriate folder.

With all the back-and-forth communication with clients stored in one place, anyone in your studio can get a sense of the current state of each project. A central location for correspondence also allows you

Subscribed Public Folders	
Bulldog Corp.	1
Buy More Foods	6222
Cyberspec Systems Co...	4081
Hud and Sons Fisheries	41
Innova	356
Maestro Biotech	586
Nakahachi Trading Corp.	766
Paper Factory	615
Solvent Corporation	16
Stand Industries	13
Tallahassee Corporation	6003
Vanta Industries	506
Walter's Wonders	3132
Wonderjam Catering	390

Donna Jones
Re: Microprocessor Announcement 2-page...

Mark Rand
Re: Microprocessor Announcement 2-page...

Mark Rand
Re: Microprocessor Announcement 2-page...

Donna Jones
Notes from Discovery Presentation

Donna Jones
Re: Some archive images for Cyberspec site

Robert Davis
FW: Cyberspec logo: vector version

Robert Davis
Cyberspec interim site wireframes

Robert Davis
Some archive images for Cyberspec site

Sharing e-mail folders with your colleagues allows you to quickly get a sense of project progress, and double-check information you need reminders on.

to track client's change requests and confirm that these tasks were completed. (During meetings, I take notes and collect them in these folders too.) Of course, this centralized storage place is also useful for storing estimates, print quotations, and any other file you might need to refer to later. At smashLAB, we also maintain shared folders for Bookkeeping, Planning, Human Resources, and Sales, but for certain repositories only the appropriate parties have access.

All kinds of collaborative tools offer similar utility to shared e-mail folders; nevertheless, e-mail remains my preferred tool. Everyone uses it, moving e-mail between folders is a snap, and it's very easy to work with because it's adaptable to varying content and attachments. That being said, I encourage you to find whatever technology works for you and start storing all of your correspondence in one place. I haven't opened our filing cabinet in years, but I refer to shared e-mail folders on a regular basis.

STRUCTURING FOLDERS AND NUMBERING PROJECTS

Little frustrates me as much as having to dig my way through an unintelligible mess of digital files—particularly when I'm in a rush

(which makes me swear in a way that would make Snoop Dogg/Lion blush). The fact is, there's no reason for such wasted time.

Every job that comes through our studio uses the same folder structure on the file server. Within each main folder are subfolders organized so that staff members can easily locate files for any phase and step in the process. This system results in huge time-savings. If I need the content inventory, that's no problem. If I want to find the final vector version of a particular logo, it's right there. With one click, at the start of each new job we duplicate the same master folder hierarchy we've established and know exactly where to put our working files.

We also number projects using a unique identifier, which follows a project from the initial estimate through to the accounting system, and even accompanies each file associated with the project. It is advantageous to name your files in the same fashion each time and set up a system to ensure that everyone in your office does so the same way. Include version numbers in the filename to ensure you're always working on the most current document. (More about this in a moment.) This organization speeds up your design process because you'll know exactly where your files are supposed to go.

Creating taxonomy is exhausting work and not the kind of process you want to do any more than you have to. Establishing a clear structure once and then sticking to that system makes your workflow much easier throughout a project.

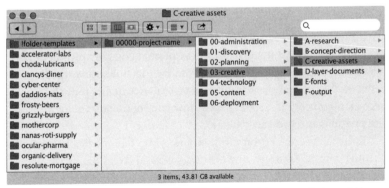

Having folder templates that you can quickly replicate for new jobs ensures that your folders and files are always structured consistently.

Good files are efficiently built, well organized, and intelligible to others who need to use them. This isn't unlike the output of other professionals. Craftspeople practice certain habits unilaterally. As the adage goes, they "measure twice and cut once." They make sure their cuts are at the right angle and sand down their work as necessary. They label parts to ensure they go together in the right order and build jigs to help make pieces uniform. By implementing such measures, a carpenter, for example, builds items of quality: tables that feel sturdy, chairs that don't squeak, and cabinetry that doesn't require filler and paint to hide its defects.

Effective habits are equally useful in the creation of solid design. If you've never spoken with someone who does prepress work at a print or copy shop, put this book aside and track one down. Buy him a cup of coffee and ask what part of working with designers is most frustrating. Find out which defects ruin print jobs. Let him carry on about the crummy files designers produce. Believe me, you'll get an ear full...and then some.

Your design is only as good as the files you produce. Files built carelessly will slow down websites, result in printing errors, and turn you into "that guy" whose files others dread working with. There's no reason for this sloppiness. From the beginning of a project, you must commit to building files that are well labeled, logically organized, and saved economically (e.g., compressed using appropriate settings). Putting this effort into the files you create helps your colleagues find what they need in your documents when you're away and reduces the possibility of print disasters and the associated costs for your company. You'll also prevent your IT people from having to upgrade servers regularly just to handle storing all of your massive files. (For the record, if you complain about how slow your computer is, your files are probably unnecessarily bloated.)

Label all the assets you produce and group them logically. Sort through your files for unused elements like old layers or errant vector points and delete these unnecessary bits. Check for full-size embedded images that you are using only a small part of, and reduce these images to just the parts you need. Make sure all the required fonts are included and that linked files are accessible. If necessary, create notes

in your files so others can learn how to use the file and replicate the same visual treatments you've developed.

Clean out your folders to avoid complexity. Scan for files that are too large and try to reduce the file size. Remove any unused files, and organize the remaining files sensibly. Compress any files that can be, and archive files you should hold on to but don't need for the current job. If a bus hits you, a coworker should be able to locate your most recent file, make sense of it, and continue working while you're busy feeding the worms.

NAMING AND VERSIONING FILES

The way you name your project files and the way you identify the iteration of each file can help you work better. Everyone has a pet peeve. Mine is in how some people name their files. My irritation with these matters hits a high when I see the term "FINAL." Typically, they write this word in uppercase, hoping this version *really* will be the last. They ready their file for press and title it brochure-FINAL.pdf.

A day passes and the client calls with a few more changes. The designer revises the file but is now at an impasse as to how to name it. Because the last file name was FINAL, he doubles up, resulting in brochure-FINAL-FINAL.pdf. The same happens the next day, so he changes the filename to brochure-FINAL-FINAL-FINAL.pdf. Over time, more changes are requested, but there is insufficient room to cram in that word again. So he starts adding version numbers of sorts, such as brochure-FINAL-FINAL-FINAL-1.pdf, brochure-FINAL-FINAL-FINAL-2.pdf, and brochure-FINAL-FINAL-FINAL-3-PRESS-READY.pdf (of course, what else would you call it?).

Then, on the day the file needs to go to press, the designer gets sick. A colleague filling in opens the job folder, selects brochure-FINAL.pdf (because the filename does read "final" after all), and sends the document to the printer. *Good times!*

Appropriate filenaming and versioning is critical to maintaining an efficient and orderly workflow. All staff must adhere to these naming systems. Our filenaming system at smashLAB succinctly identifies the project and its current state. The basic structure is *Job Number, Job Name, Revision Round, Version, Extension*. As a result, a filename

might look like this: 54298-sportco-race-poster-03-11.indd. The job number informs designers that they have the right project, and the name helps to identify the contents of the file. The second number represents the third round of client revisions. The third number indicates that this is the eleventh substantial modification of this iteration of the file (that is, this is the third version I've produced for the client, but I've internally versioned this specific file 11 times.) Versioning in this way allows you to roll back the file to an earlier state if necessary, which can afford a real sense of comfort.

Dating the file is largely unnecessary because this information is already stored in the file's metadata. The client name is not needed either because the file is stored in that client's folder on our file server. In the event that a file is misplaced, we can just search the entire server for a unique job number. We always know which file to use and where to find it, and can determine the project's progress just by the filename. Filenaming and versioning, as well as all other critical workflow systems new staff need to learn, are explained in our employee manual.

CREATE AN EMPLOYEE MANUAL

It's one thing to plan systems and standard procedures you might implement in your studio; it's quite another to educate your coworkers to utilize these methods. By creating an employee manual, you help ensure that you and your colleagues all share the same set of habits.

Some agencies prefer to use a printed manual that can be provided to new employees when they first join the firm. They can then add to this document and reprint it when substantial changes have been made. Others will use a wiki or intranet and make their manual a living document that can be augmented daily if need be. Whichever approach you take, locate your manual in a place that's easy for staff to access, whenever they need it.

A manual is useful in onboarding new staff. Therefore, you might want to include some information about your studio, including its history, mission, philosophy, and culture. Then identify the various policies you have in place, which might detail what's expected of staff, how to communicate with clients, and any guidelines you have for using the equipment in the studio.

Outlining your processes is also beneficial. Put some effort into discussing the methodology you employ and the procedures you adhere to, and explain the design resources that are available in the studio. Customizing this manual also allows you to review folder taxonomy, filenaming standards, and housekeeping tasks. Wrap up the document with all of the other human resources issues your staff will need to refer to, like review schedules and holidays, as well as health and other benefits you provide. Update the information regularly and get in the habit of having one place to keep all this information.

Training your coworkers to adopt good working habits, providing them with quality systems, and offering them a positive, friendly, and challenging place to create will help facilitate the growth of a successful business. But all your efforts will all be rather futile if you don't manage your cash flow well.

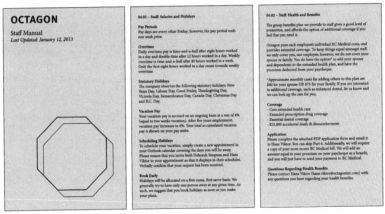

A staff manual—printed or digital—is the place to identify standard procedures, expectations, and any other details important to your studio.

PAY ATTENTION TO CASH FLOW

Few designers enjoy managing money and accounting tasks. Although this distaste for dry numbers and ledgers is completely understandable, if you fail to keep your finances in order, you risk the future health of your business. If you don't want to deal with these matters, hire a bookkeeper to help out. But, even if you do so, make sure you set aside time to review and understand your financials.

For the longest time, all I wanted to know was if the business was rich or bankrupt—I was uninterested in anything else. But this attitude was stupid and unfortunately hasn't changed all that much. Although I'm not interested in the small financial details related to the business—because others are better with such matters—there are a few documents I do need to review.

My business partner maintains a loose spreadsheet that projects substantial incoming and outgoing costs for the upcoming months. He also generates a statement from our accounting software that allows us to see exactly what's in the bank, how much we have in receivables, and if there's a cash crunch we need to prepare for. Additionally, he collects the hours currently worked on projects, so we can gauge billable efficiency and determine if we need to speed up certain jobs or look at whether scope changes are in order.

Reviewing these documents takes us only about 15 minutes, once per week, and from them we can evaluate the financial health of the company. From the results, I know whether we should make more sales calls, add staff, push a client for an outstanding payment, or make some kind of change in how we're operating the business.

You need to be willing to put in the time required to bill your clients regularly, pay bills on time, and prepare invoices or find someone who can. Those who ignore cash flow will lose their design business. Similarly, the clients you choose to work with will make all the difference in how successful you are.

VETTING PROSPECTIVE PROJECTS AND CLIENTS

It's a well-known fact that the ratio of calls you receive compared to the actual number of jobs you take on will likely be rather dismal. Don't take this low batting average as a sign that your work is not good enough. It's just a matter of finding the relationships that are right for you. Some budgets won't be sufficient given your operating costs; others might be bigger than you can handle. In addition, a lot of potential jobs just won't be a good match for what you offer.

Many variables impact whether or not prospective clients are a good fit. You can spend a great deal of effort chasing work you won't get or shouldn't take on. During your first years in business you'll be

so nervous about not having work that you'll chase gigs you shouldn't. However, this tenacity won't last. After spending three weeks preparing a response to a request for proposal (RFP) that gets cancelled or putting in months talking to a client, only to find that the client never had any funds available, you'll learn. There's nothing wrong with turning away work. In fact, selectiveness gives you power in that it helps you connect with the right groups, which will lead to more of the same to work with you. Additionally, when you say "no," you show that you aren't desperate for work.

Establish a process that helps you decisively choose which clients to work with by preparing a common set of questions for all incoming calls from prospective clients. Organize these questions into groups that help determine if you should stop at the questionnaire stage or proceed. Request some background information by having clients describe the project, the challenges they want to address, and their organization. Then start qualifying them. Ask how they found you and why they think you're a good fit. Ask what the budget is. Many clients won't answer this question, so probe them by requesting a ballpark figure: Is it under 25k, under 50k, under 100k? It won't take long for them to get worried as you increase your guesstimate, and you'll then gain an understanding of exactly what they have to work with. Then ask about the project timeline.

If all of the responses sound good, ask about the situation. Find out if they can provide a project brief or marketing plan for you to review. Learn about their audience, competition, and their position in the marketplace. Explore their goals for this project and how they'll measure success. You can also ask about existing brand assets, functional requirements, technology needs, and the availability of content. What you're trying to do is get a reasonable sense of what this project might entail.

At the end of your talk, ask any other pertinent questions that will help you better understand the potential project. Who are the project stakeholders and decision makers? What are they looking for in a design group? Have they worked with other agencies or designers? If so, why aren't they continuing with that relationship?

You must be as careful in choosing who you work with as your clients are. Your clients define your practice and output. Some will be a fit and others won't. By asking the suggested questions, you can find

out quickly whether to move to the next step or get out of the way so they can find a more appropriate designer. Regardless, do keep notes detailing these discussions and sort them in your client contacts or customer relationship management (CRM) software. It's best to keep these notes handy in case you need to review them in the future.

Keep "Shipping"

You need to ship the work you produce. Design is almost always constrained by time requirements and practical limitations. Early in my career, I blamed these limits for getting in the way of doing good work. With time, I accepted these parameters and came to appreciate them for two reasons: A hard timeline means our client needs to provide feedback faster, and we get paid sooner. In addition, limited budgets can sometimes test how innovative we are in making the most out of even scant resources.

The difference between design as a job and design as a hobby is that professionals don't let obstacles get in the way of completing a project. Clients depend on you to ship the work you commit to producing. Understand the limitations of your project, work within them, and find ways to deliver the design solution as needed.

Extra time on a project can lull you into a false sense of comfort. With a longer period to complete work within, you may put off the job, tinker with other (more fun) tasks, and find you're in a pinch when you realize how little time you have left. Another challenge is the crushing impact a long-running project has on morale. Almost all projects start with excitement and possibility, and those that never seem to finish are harder to be excited about. Also, work that lingers reduces billable efficiency. At a certain point, you need to ship the project and move on to the next.

Shipping your design requires a workback schedule. Although it can be a drag to prepare, it can also be illuminating. A workback schedule is developed by looking at the end product and tasks required, and scheduling time for each by working backward to the current time. Two or three months to complete a design project might seem like plenty of time when you don't consider all of the tasks, waiting for approval and sets of revisions, and unexpected slowdowns

like vacations, sick days, and other rush projects. A workback schedule shatters any such illusions and shows that there's no time to squander.

Once you've worked out the scheduled dates, print them and affix them to the wall beside your desk. Use a marker to cross out dates as you hit them, and use this schedule to move your project along. As tedious as planning and acting on these schedules can be, there's a satisfaction in realizing that you're making progress as a result of them. The faster you produce jobs, the happier your clients will be. And, the sooner you get their testimonials—and work samples in your book— the quicker you can attract new clients.

Achieving Mastery

Many have a craft, but only a few commit to mastering it. David Gelb's 2011 film, *Jiro Dreams of Sushi*, documents the life and work of 85-year-old Jiro Ono. The documentary shows the lifelong commitment and relentless practice Jiro and his apprentices undertake to master the creation of sushi. At one point in the film, his devoted apprentices are shown massaging octopus for 45 minutes to achieve a suitable tenderness. One cries when, after months of practicing, he finally gets his tamago (egg omelet) right. None of them seem concerned with titles or notoriety. Instead, they have chosen a profession and dedicated their lives to practicing their craft.

Watching the film is a humbling experience—particularly when you work in an industry in which designers want to be "directors" before they've even practiced for a decade. The practice of design isn't the domain of the young, no matter how talented some might be. Design is a lifelong journey that takes decades to master. Many find this notion off-putting, but the possibilities are invigorating. Regardless of what you learn or how many projects you complete, there will still be endless new opportunities to experiment and grow.

Everyone burns out at some point; when you do, take a moment to think about why you sought a career in design. My hunch is that you didn't choose design for a title, a list of accolades, or a director-level salary. Instead, you most likely chose design work for the challenge of a big problem, delving into possible solutions, and being able to create something with your own hands. Whenever you're in doubt, reflect on

those memories to inject the passion and enthusiasm that you started with many years ago.

Practice your craft diligently and deliberately. Ultimately, this practice involves a perpetual cycle of acting, refining, and repeating. Don't worry about perfection, what's exciting, or what your colleagues are doing. Concentrate on your clients, your skills and techniques, and the pursuit of mastery. This humble outlook will help you deliver good design and instill you with pride and satisfaction that no tacky trophy can ever afford.

At one time I thought I wanted to be an exciting designer who made work that turned heads. Now, I just want to be a good designer and practice my trade as best I can. In doing so, I believe that I come to deserve the trust my clients place in me. I hope you share this same commitment to your chosen path.

SUGGESTED READING

Following are some books you might enjoy. Although they're in no way critical to employing The Design Method in your work, I've found all of these books helpful. I think you'll likely get a lot out of them as well—even if they don't all seem immediately related to this book's subject and contents.

The 80/20 Principle by Richard Koch
Early in the formation of our agency I read Koch's book, and it shaped a great deal of how we treat our process. Understanding the 80/20 principle may not require you to read the entire book, but doing so does reinforce the key truth that there's a disproportionately high return on certain activities and that you can use this imbalance to your benefit. Grasping this notion can help you produce more design faster and easier by making smart decisions at the right time.

Content Strategy for the Web by Kristina Halvorson and Melissa Rach
I feel guilty about how much I talk about interaction design in *The Design Method*, but I recognize that this thinking is what most designers increasingly need to apply regardless of the kind of design they produce. Similarly, I'm convinced that we're evolving from seeing design and content as two distinct areas to recognizing them as intrinsically linked. Halvorson and Rach's tight, well-organized, and highly applicable book is a lovely introduction for designers who need to structure and produce content.

The Creative Business Guide to Running a Graphic Design Business by Cameron S. Foote
In perhaps the single most important book any design studio manager might read, Foote serves as a virtual coach to those without a mentor who can answer their questions. In his book, he outlines a number of strategies, approaches, and techniques to help designers gain control

of their businesses and make intelligent decisions surrounding growth, staffing, policies, and every matter in between. Smart designers will also subscribe to his newsletters and counsel at *creativebusiness.com*.

The Design of Everyday Things by Don Norman

Norman's book should be required reading for anyone who has anything at all to do with design. In his very approachable book he makes design tangible for even those with little knowledge on the topic. He provides good examples, sound thinking, and a cogent argument for functional design. You'll see your world differently after reading Norman's work and will recognize just how ever-present and necessary design is to all humans.

The Dip by Seth Godin

I don't have a good reason for suggesting *The Dip* instead of any of Godin's other—also great—books. I suppose for the struggling designer, though, this one is a nice kick in the pants. Frankly, all of his books are filled with insight that seems too simple to be true, which indicates just how good he is at recognizing important patterns and ideas relating to brand, advertising, and marketing matters. Alternately, you can just read his blog, which contains years of diligent writing and great thinking at *sethgodin.typepad.com*.

Don't Make Me Think: A Common Sense Approach to Web Usability by Steve Krug

Krug's writing on web design is among the most usable and accessible in existence. This book gets to the root of design by looking at users, usability, and the behaviors that shape the way most people make their way around the Web. He also employs simple, friendly visuals that make the book easy to skim and highly approachable. Ask your colleagues and clients to also read this book, because it will prime them to make smarter and more appropriate decisions.

The Elements of Typographic Style by Robert Bringhurst

I suspect that every first-year design student is asked to buy a copy of this book—and promptly places it on a bookshelf, never to give it a second look. This is a darned shame, because Bringhurst does a good job of making the rules for using type intelligibly and providing

a way to think about type. That is until he starts talking about weird notions (like musical measure linking to page composition), and then he loses me. My recommendation is to buy it today; study the first part diligently, and then pay little attention the less applicable passages.

Good to Great by Jim Collins
Collins' books work for designers on two levels. The first is in providing an understanding of leading companies' behaviors—so they can apply this insight when they do work for clients; the second is in recognizing the kind of disciplined actions and thinking they must apply in their own studios. Collins marries extensive data collection with compelling stories to make what might otherwise be very dry material both useful and interesting.

Hackers & Painters: Big Ideas from the Computer Age by Paul Graham
Graham is arguably the most visible partner in a start-up incubator of sorts called Y Combinator. I like reading his writing because he's so adept at finding patterns—whether in start-ups, ecosystems, or behaviors. In this book he discusses the kind of change we face today as a result of innovation. Although it's not specifically a book about design, the ideas within it are important to anyone who builds things in the digital era. You can also read his lengthy and remarkably good essays online at *paulgraham.com/articles.html*.

Hey, Whipple, Squeeze This: The Classic Guide to Creating Great Ads by Luke Sullivan and Sam Bennett
Sullivan is a funny guy. Well, he's a smart guy, but it seems that often goes hand-in-hand with being funny. In his book he provides an inside perspective on agency life and presents a number of concepts that produced results for the companies the agency represented. His thinking and wit are stellar, and I often found myself laughing out loud. Afterwards, I'd simply recount the stories within it to others, and tell them they had to read the book.

How to Be a Graphic Designer without Losing Your Soul by
Adrian Shaughnessy
Many who open design studios struggle with the practicalities surrounding operations along with the need to do work that is

fulfilling. Shaughnessy applies his—and others'—experiences in this book, producing a wealth of helpful ideas and tips. Highly applicable and practical, the book provides suggestions on issues important to designers ranging from setting up a studio to winning new work.

Positioning by Al Ries and Jack Trout

The problem that so many of today's designers face is that they can't extricate themselves from thinking in terms of visuals in order to see the bigger picture. One of the easiest ways to address this shortcoming is to start thinking about brands and what they need to accomplish, and how design is integral to making them work. In the book, Ries and Trout outline *positioning* one of the key tenets to branding. This is a great resource if you want to start strengthening your ability to produce effective brand strategy.

Whatever You Think, Think the Opposite by Paul Arden

I never knew Paul Arden, but I was saddened upon learning of his death a few years ago. Perhaps the reason is that his small books so efficiently achieved important insight. This book and *It's Not How Good You Are, It's How Good You Want to Be* are a couple of my favorites. You can skim either of them in less than a half hour, but you'll continually return to them for little bits of encouragement and new perspective. Buy two copies: one for the bookshelf and one for the bathroom—where you can quickly thumb through the short stories and smart visuals.

Zag by Marty Neumeier

In his books, Neumeier blends terse ideas with bold visuals and great examples to convey abstract concepts simply. Each of his books is a visual feast and prepares you to apply higher-level thinking to the design you produce. Better yet, his books are short and to the point, which means you're more likely to sit down, read them, and start putting his suggestions into use. This is another great book for those who want to improve their strategic capabilities.

ACKNOWLEDGMENTS

Writing a book is like training for a marathon—lots of long days, "rejuvenating" beverages, continued laboring, and asking one question that remains unanswered: "Why the hell am I doing this?" In addition to all these similarities there is one most notable—the support lent by those who put up with such foolish endeavors.

Without my mom and dad, Helina and Lauri, I'd never have managed to put anything like the studio, this book, or the systems within it together. They taught me how to work, organize, and build well. It's through their encouragement and financial support that I was able to attend art school. Similarly, their entrepreneurial spirit and well wishes led me to leave a safe job and go out on my own. I still look forward to our daily phone calls.

My partner at smashLAB (also named Eric) has kindly entertained my ramblings during roughly 5,000 morning coffees. Together, we've gone from being wide-eyed novices to establishing sound methods and producing some solid work. Very few get to collaborate with someone as smart, hard working, and dedicated. I'm grateful to have such a good friend and colleague.

Anne Marie Walker has contributed so very much in editing my rough drafts and pounding them into submission. It's through her keen eye and continued effort that this book avoids having *thing*, *it*, and *stuff* used as every second word. Additionally, Nikki McDonald, Becky Winter, Mimi Heft, Bethany Stough, James Minkin, and the team at New Riders have been delightful in helping to make the production of this book as pleasant an experience as possible.

My wife Amea winced only once when I discussed writing another book. She then patiently accepted my absence for several months while I spent evenings and weekends tapping at a keyboard, working to make this book all I could. I'm a lucky guy—few would be as forgiving as she is of such a distant spouse.

Most important are Oscar and Ari—two beautiful boys who

taught me that although design is a wonderful profession it is nothing compared to family. They can now stop asking how many chapters I have left, and we can get to work on building that model rocket.

All of the findings in this book are courtesy of those who've hired smashLAB over the years to help them with their design needs. You know who you are, and I speak for all of us at the studio when I say thanks for your continued patronage.

In addition, I owe a great deal to the many designers who've read my blog and past writing. Thank you for taking the time to review our thoughts and contribute feedback. Some have even sent a note saying they got something out of what they read. That sort of encouragement is incredibly valuable and appreciated. *Cheers!*

INDEX

80/20 Principle, The (Koch), 211

A

A/B testing, 164
about this book, xi–xiii
actions, flowcharting, 110–111
AdAge.com website, 11
advertisements, 24, 164
ambiguity, eschewing, 22–23
analyzing test results, 162–163
angry customers, 87
app development video, 47–48
Application stage, 62, 149–172
 analyzing test results in, 162–163
 building prototypes in, 152–153
 catching mistakes in, 170
 checklists used in, 169
 completion tasks in, 170–172
 creative brief referred to in, 166–167
 determining the design DNA in, 156–158
 iteration process in, 150–152
 logistics and details in, 167–168
 overcoming obstacles in, 153–154
 overview of processes in, 150
 placeholder vs. real content used in, 155–156
 producing your designs in, 164–166
 refining your work in, 163–164
 showing prototypes to clients in, 158–159
 testing your design work in, 159–161
 tracking issues in, 169
archetypes, personas as, 106
Arnell, Peter, 83
art, design distinguished from, 2–3
assumptions, inaccurate, 76–77
audience
 designers acting as, 10–11
 identifying in Discovery stage, 85–87

auditing
 content of websites, 113
 current state of clients, 92–93
awards, myth about, 11–12

B

ball in play workflow, 195–196
beliefs, challenging, 117–118
Beware Wet Paint (Fletcher), 127
blank page syndrome, 126
brainstorming, 134
brand design studios, 36
branding
 hipster, 40–41
 reckless decisions about, 38
brilliance, myth about, 6–7
broad strokes, 130
buckets, 53
Burger King, 11
business considerations, 189–210
 achieving mastery, 209–210
 defining procedural systems, 191–193
 essential tools and techniques, 196–208
 establishing a workflow, 195–196
 finding order in your work, 190–191
 replicating successful procedures, 193–194
 scheduling meeting and huddles, 194–195
 shipping your work, 208–209
 See also tools and techniques
"butterfly ballot" design, 20
buy-in from clients, 146–147

C

Canadian banknotes, 30
Canon cameras, 51
cash flow, 205–206
centralized storage, 198–199
chalkboards, 54

challenges
 to approaches/beliefs, 117–118
 experienced in Creative stage, 126–128
 explaining to colleagues, 137
checklists, 197
 presentation, 181, 182
 production, 169
choices, systems and, 46
client/designer relationship, 9–10
clients
 achieving buy-in from, 146–147
 building knowledge about, 74–75, 79–82
 communicating well with, 176–177
 defining roles with, 178–179
 discussion sessions with, 82–83
 documenting approvals by, 171
 editing designs for, 180
 fostering collaboration with, 145–146
 gaining the confidence of, 147
 managing interaction with, 174
 misunderstanding of design by, 35–36
 presenting work to, 173–188
 showing prototypes to, 158–159
 smartness of designers vs., 9–10
 surveying competition of, 90–91
 understanding the situation of, 175–176
 vetting prospective, 206–208
collaboration, fostering, 145–146
colleagues
 explaining challenges to, 137
 utilizing as editors, 129, 140
Comic Sans typeface, 42
communication design, 22, 61, 151
communicative process, 176–177
comparables, examining, 91–92
competition, surveying, 90–91
completion tasks, 170–172
computers
 desktop metaphor for using, 49–50
 interaction design and, 48–52
conference calls, 182
conflicts, irreconcilable, 38
confusing designs, 24
Connare, Vincent, 42
consistency, 178
content
 inventory of, 112–113
 organization of, 53–54
 strategy for, 115–116
Content Strategy for the Web (Halvorson and Rach), 211

contradictory messages, 26
conventions, establishing, 25, 44, 114
cooperating with others, 7
copycat approaches, 117
corporate identity design, 43
cost of reckless decisions, 38
CP+B agency, 11
Craigslist, 18, 161
creating order, 23–26
creative blocks
 creative conundrum and, 126–128
 techniques for breaking, 134–139
creative briefs
 crafting, 119–121
 recapping with clients, 123, 167
 referring back to, 166–167
Creative Business Guide to Running a Graphic Design Business, The (Foote), 211–212
creative concept
 documenting, 140–142
 evaluating, 142–143
Creative stage, 62, 125–148
 buy-in from clients in, 146–147
 collaborating with clients in, 145–146
 creative challenges experienced in, 126–128
 documenting creative concepts in, 140–142
 editing your ideas in, 139–140
 evaluating your concepts in, 142–143
 generating new ideas in, 134–139
 ideation process used in, 132–134
 key principles for working in, 129–130
 methodological design in, 128–129
 overview of processes in, 126
 style boards used in, 143–145
 tone considered in, 130–132
creativity
 funnel view of, 66
 measuring, 16–17
 myths about, 1–14
 and playing by the rules, 12–13
 problems generating, 126–128
 systems thinking and, 56–57
 utilitarian pursuit of, 16–17
cues, providing to users, 24–25, 26
cult of personality, 9
customer interviews, 87–88

D
deadlines, 136
decision makers, 177–178
decisions, reckless, 37–39

delegating work, 158
deliverables vs. outcomes, 30
design
 art distinguished from, 2–3
 communication, 22, 61
 informed by systems, 42–44
 interaction, 48–52
 making workable, 26–28
 measurement of, 17
 messiness of, 34–37
 myths about, 1–14
 pervasiveness of, 31–32
 planning related to, 98–99
 style utilized in, 39–40
 systems thinking and good, 57–58
 utilitarian pursuit of, 16–17
design DNA, 43–44, 156–158
The Design Method, 59–72
 Application stage of, 149–172
 Creative stage of, 125–148
 Discovery stage of, 73–96
 effectiveness of, 69–70
 fundamental stages of, 61–64
 funneling process in, 65–67
 introduction to, 60–61
 one concept approach in, 67–69
 origins and development of, 64–65
 Planning stage of, 97–124
 variety of uses for, 71–72
 working phases in, 63
Design of Everyday Things, The (Norman), 212
design process, 60
design thinking, 71
designers
 facilitator role of, 9, 21
 role definition for, 20–22
 smartness of clients vs., 9–10
 stereotypes about, 13
 subjective responses of, 10–11
 trusted advisor role of, 31
desktop metaphor, 49–50
details, clarifying, 93–94, 168
diagnostic design, 31
"different is good" myth, 4–6
Dip, The (Godin), 212
Discovery stage, 62, 73–96
 asking questions in, 78–79, 90
 auditing the current state in, 92–93
 clarifying the details in, 93–94
 discussion sessions held in, 82–83
 examining parallel offerings in, 91–92

expanding your observations in, 94–95
finding underlying problems in, 83–85
getting firsthand knowledge in, 80–82
grasping the basics of clients in, 79–80
identifying the audience in, 85–87
inaccurate assumptions made in, 76–77
interviewing customers/users in, 87–88
journeying into the unknown in, 75–76
knowledge building process in, 74–75
recognizing discrepancies in, 89–90
seeking out opportunity in, 94–95
surveying the competition in, 90–91
using time allotted to, 96
discrepancies, recognizing, 89–90
discussion sessions, 82–83
Disney theme parks, 85–86
DNA, design, 43–44, 156–158
documents, 198
 creative brief, 119–121
 creative concept, 140–142
 preparing for clients, 121–123
 presentation, 186–188
Don't Make Me Think (Krug), 212
Dropbox, 20

E
edge cases, 106
editing
 generated ideas, 139–140
 separating brainstorming and, 134
 simplifying designs by, 27
editors, working with, 129, 140
Elements of Typographic Style, The
 (Bringhurst), 212–213
e-mail folders, 199–200
empathy, 10–11, 175
employee manual, 204–205
environment, changing, 135
erickarjaluoto.com website, xi
ethnographers, 82
evaluation, creative, 142–143
exploration, structured, 16

F
Facebook, 25
facilitator role, 9, 21
feedback loops, 87
files
 building good, 202–203
 naming and versioning, 203
financials, 205–206

firsthand knowledge, 80–82
flowcharting actions, 110–111
focus groups, 161
focused questions, 85
folder structure, 200–201
fonts. See typefaces
form follows function, 17–18
Frankensteining process, 68
function
 form as following, 17–18
 visual treatments and, 55
funneling process, 65–67

G

game environments, 24
Gelb, David, 209
genius thoughts, 3–4
goals
 establishing in Planning stage, 100–101
 objectives distinguished from, 101
 regularly checking, 123–124
good design
 characteristics of, 57
 systems thinking and, 57–58
 trends transcended by, 41
Good to Great (Collins), 213
Goodby Silverstein and Partners (GS&P), 29
"Got Milk?" campaign, 29–30
graphical user interface (GUI), 29, 49
greatness, search for, 6
Greeking text, 114, 155
groupings
 audience, 86–87
 idea, 139–140
 information, 53–54
 task, 198

H

Hackers & Painters (Graham), 213
Hey, Whipple, Squeeze This (Sullivan and
 Bennett), 213
hierarchy, typographic, 25
hijacking projects, 11–12
hipster branding, 40–41
hobbyists vs. professionals, 190
holographic images, 27
hotel analogy, 66
"house style" designs, 57
Houston, Drew, 20
*How to Be a Graphic Designer without Losing
 Your Soul* (Shaughnessy), 213–214

huddles, informal, 195
hunches, playing, 102–103

I

iA Writer text editor, 27
IA/UX plan, 121–122
ideas
 aiming for abundance of, 137
 editing your own, 139–140
 process for developing, 132–134
 techniques for generating, 134–139
ideasonideas.com website, xi
ideation process, 132–134
identity projects, 165
IKEA brand, 43, 45
impulse control, 18–19
inconsistent messages, 26
information, organization of, 53–54
innovative design
 organizational impact of, 31
 unusual solutions vs., 28
inspiration, myth about, 6, 7
Instagram look, 41
interaction design
 planning process and, 104–105
 systems related to, 48–52
interaction design tools, 104–116
 content inventories, 112–113
 content strategy, 115–116
 flowcharts, 110–111
 personas, 105–108
 scenarios, 108
 sitemaps, 111–112
 user stories and use cases, 109
 wireframes, 114–115
interactive elements, 24, 50, 51
interface design, 5, 24, 28
interviews
 conducting customer/user, 87–88
 recognizing discrepancies in, 89
inventory, content, 112–113
irreconcilable conflicts, 38
iteration process, 150–152

J

jellybean buttons, 42
Jiro Dreams of Sushi (film), 209

K

Kalman, Tibor, 127
Kastner & Partners agency, 22

key performance indicators (KPIs), 163–164
Kickstarter, 24
knowledge
 building, 74–75, 79–80
 getting firsthand, 80–82

L

labeling categories, 53
language, organizing content using, 53
large organizations, 185–186
liberating yourself, 56–57
lifestyle, myth about design as, 8
limits, value of creating, 138
links, designing, 51
logistics, 167–168
logos
 discount services for, 38
 trends related to, 40

M

Mad Men (TV show), 183
Made You Look (Sagmeister), 127
magazine design, 52
management tools. *See tools and techniques*
mastery, achieving, 209–210
Matrix, The (film), 28
McDonald's, 11, 90–91
meetings, 194–195
messiness of design, 34–37
methodological design, 128–129
Metro design language, 29
Microsoft
 design approach of, 28–29
 Word for Mac problems, 50
micro-type trend, 41
milk advertising campaign, 29–30
"Miscellaneous" classification, 54
mistakes, catching, 170
mixed messages, 26
mock-ups, 153, 155
Modern UI language, 29
mood boards, 131–132
movies
 creating characters for, 44–45
 rule breaking in, 55
MUJI products, 41, 42
multivariate testing, 164
myths about design, 1–14
 awards count, 11–12
 brilliance matters, 6–7
 design is a lifestyle, 8

design is art's cousin, 2–3
designers are smarter than their clients, 9–10
designers are the audience, 10–11
different is good, 4–6
inspiration must be sought, 6, 7
originality exists, 3–4
personal voice is key, 8–9
rules aren't for creative people, 12–13

N

naming files, 203–204
navigation bars, 54
nebulous projects, 23
Nikon cameras, 51
numbering projects, 201

O

objectives
 establishing in Planning stage, 101
 regularly checking goals and, 123–124
observations, 78, 94–95
one concept approach, 67–69
One Laptop per Child program, 71
Ono, Jiro, 209
operational efficiencies, 70
opportunities, uncovering, 94–95
order
 creating, 23–26
 finding, 190–191
organizations
 touchpoints of, 38
 tug-of-war within, 54
organizing information, 53–54
originality, myth about, 3–4
"Other" classification, 54
outcomes vs. deliverables, 30
ownership, fostering, 83

P

pain points, 16, 84
parallel offerings, 91–92
persona development, 105–108
personal voice, myth about, 8–9
perspective, regaining, 154
Perverse Optimist (Hall and Bierut), 127
Photoshop, 155, 158, 166
placeholder content, 114, 155
planning
 design as a form of, 98–99
 sitemaps for websites, 111–112
 systems thinking and, 43

Planning stage, 62, 97–124
 challenging approaches/beliefs in, 117–118
 content inventories used in, 112–113
 content strategy determined in, 115–116
 crafting creative briefs in, 119–121
 creating sensible plans in, 99–100
 design process and importance of, 98–99
 developing strategies in, 101–102
 establishing goals/objectives in, 100–101
 flowcharting actions in, 110–111
 interaction design used in, 104–105
 keeping your project moving in, 123–124
 making recommendations in, 118–119
 persona development in, 105–108
 playing hunches in, 102–103
 preparing documentation in, 121–123
 scenarios used in, 108
 shaping your plan in, 103–104
 sitemap planning in, 111–112
 traps of shadow planning in, 117
 user stories and use cases in, 109
 wireframes built in, 114–115
popular styles, 40
portfolios
 hijacking projects for, 11–12
 representative samples in, 21
positioning matrix, 91
Positioning (Ries and Trout), 214
possibility, uncovering, 29–31
practical questions, 94
praise from others, 6
preflighting checklists, 169
presenting work to clients, 173–188
 communications in, 176–177
 defining roles in, 178–179
 documentation for, 186–188
 editing designs before, 180
 general guidelines for, 184
 importance of preparing for, 180–182
 involving decision makers in, 177–178
 large organizations and, 185–186
 remote presentations and, 182, 185
 showing your prototypes, 158–159
 skipping the thrilling unveil in, 182–184
 stemming prejudgments in, 184–185
print dialogs, 52
print jobs, 165, 171
probing questions, 84
problems
 finding underlying, 83–85
 identifying and solving, 19–20, 21, 30–31

procedures
 defining systems for, 191–193
 replicating successful, 193–194
process stages, 63
product design, 22
production process, 164–166
 catching mistakes in, 170
 checklists used in, 169
 completion tasks in, 170–172
 design brief and, 166–167
 logistics and details in, 167–168
 tracking issues in, 169
professionals vs. hobbyists, 190
prototypes
 building, 152–153
 showing to clients, 158–159
 testing, 159–161, 170
purposeful design, 15–32
 achieving suitability in, 28–29
 creating order in, 23–26
 defining your role in, 20–22
 eschewing ambiguity in, 22–23
 form following function in, 17–18
 identifying problems in, 19–20
 making design that works, 26–28
 pervasiveness of, 31–32
 restraint exercised in, 18–19
 uncovering possibility in, 29–31
 utilitarian pursuit of, 16–17

Q
QR codes, 55
quality assurance (QA) checklists, 169
questions
 asking in Discovery stage, 78–79, 90
 clarifying details through, 94
 identifying the audience using, 85, 86–87
 organizing for discussion sessions, 83
 probing underlying problems with, 84
 systems thinking and, 44–45

R
randomness, applying, 138
real content in designs, 155–156
reckless decisions, 37–39
recommendations
 making in Planning stage, 118–119
 presenting your findings and, 122–123
Red Bull, 22
refinement process, 66, 163–164
reframing discussions, 84

relationships
 client/designer, 9–10
 design systems and, 46–48
remote presentations, 182, 185
replicating procedures, 193–194
restraint, importance of, 18–19
restroom symbols, 24
Return/Enter key, 25
road sign designs, 25
role of designers, 20–22
 client role and, 178–179
 facilitator role, 9, 21
 trusted advisor role, 31
rules
 creating order through, 25
 establishing for visuals, 55–56
 myth on not playing by, 12–13
 problem with breaking, 55
Russian Constructivist posters, 40
Russian nesting dolls, 46, 47

S

scenarios, 108
schedules, workback, 208–209
screen sharing services, 182
search engines, 28
shadow planning, 117
shared e-mail folders, 199–200
shipping your work, 208–209
shortest path exercise, 135
sitemaps, planning, 111–112
situations, describing, 136
skeuomorphs, 27
Sleep (Warhol), 27
slide presentations, 122, 187
smashLAB, xi, 61, 63, 67, 123, 182,
 195, 200
social media
 campaigns utilizing, 165
 planning to use, 103
software, beta versions of, 18
spreadsheets, 54, 206
staff manual, 204–205
stakeholder discussions, 82–83
Starbucks, 46–47
starting over, 139
stereotypes about designers, 13
storage, centralized, 198–199
strategy
 determining for content, 115–116
 developing in Planning stage, 101–102

structure
 establishing, 25, 53
 systems thinking and, 53, 58
style
 explanation of, 39
 problems with, 40
style boards, 143–145
style sheets, 166
suggested reading, 211–214
suitability, achieving, 28–29
surveying the competition, 90–91
SWOT analysis, 94
syntax, visual, 44, 55
systems thinking, 33–58
 designs informed by, 42–44
 explanation of, 34
 good design based on, 57–58
 information organization and, 53–54
 interaction design and, 48–52
 liberating yourself through, 56–57
 messiness of design vs., 34–37
 questions related to, 44–46
 reckless decisions vs., 37–39
 relationships and, 46–48
 trends and, 39–42
 visuals and, 55–56

T

tangential process, 66
task lists, 65
taxonomies, 201
technology
 ambiguity related to, 22
 proliferation of, 24
templates, folder, 201
testing designs
 analyzing results of, 162–163
 catching mistakes by, 170
 overview of process of, 159–161
text
 placeholder, 114, 155
 typefaces for, 42, 45
three option approach, 67, 68, 69
thumbnails, 114
time
 placing limits on, 136
 valuing, 129–130
tone
 considering in Creative stage, 130–132
 defining in creative brief, 120
 documenting in creative concept, 141

tools and techniques, 196–208
 centralized storage, 198–199
 checklists, 197
 documents, 198
 employee manual, 204–205
 file building, 202–203
 file naming/versioning, 203–204
 folder structure, 200–201
 grouping tasks, 198
 numbering projects, 201
 reviewing financials, 205–206
 sharing e-mail folders, 199–200
 vetting clients, 206–208
 See also interaction design tools
touchpoints, organizational, 38
tracking issues, 169
trends
 good design vs., 41
 problems with, 39–42
 styles and, 39–40
trophies, 12
Tropicana, 83
trusted advisor role, 31
tug-of-war in organizations, 54
typefaces
 function of specific, 42
 tone related to, 45
typographic hierarchy, 25

U

underlying problems, 83–85
uniqueness, myth about, 4–6
unveil moment, 182–184
use cases, 109
user flows, 110
user stories, 109
user testing, 160
users
 interviewing, 87–88
 telling stories about, 109
utility of design, 16–17

V

Vancouver Aquarium website, 53, 165
variations, visual system, 56
versioning files, 203–204
vetting projects/clients, 206–208
visual syntax, 44, 55
visuals
 style boards for determining, 143–145
 systems thinking about, 55–56

W

Warhol, Andy, 27
websites
 completion tasks for, 171
 content inventory for, 112–113
 content strategy for, 115–116
 design of early, 5, 28
 interaction design for, 51–52
 key performance indicators for, 163–164
 menu item design on, 26
 production process for, 165
 sitemaps for, 111–112
 testing the design of, 160, 161
 trends in designing, 41–42
 wireframes for, 114–115
Whatever You Think, Think the Opposite
 (Arden), 214
wireframes, building, 114–115
workback schedules, 208–209
workflow, 195–196
working phases, 63
worst-case scenarios, 168

Z

Zag (Neumeier), 214

ABOUT THE AUTHOR

Eric Karjaluoto is creative director and a founding partner of the creative agency smashLAB. He has helped a broad range of clients, including CN, The Vancouver Aquarium, The Nature Conservancy, Canadian Heritage, ThoughtFarmer, lululemon athletica, Crescent Spur, WWF Canada, BC Film + Media, Tourism Vancouver, and the University of Minnesota's Institute on the Environment with their strategic, design, and communication challenges. This work has been recognized by The Adrian Awards, *TIME*, *Communication Arts*, The Advertising & Design Club of Canada, The Lotus Awards, *Applied Arts*, *Graphis*, Icograda, and others. In 2007, he spearheaded Design Can Change to unite designers and address climate change. Eric writes about design at ideasonideas and his new blog: erickarjaluoto.com. He also speaks about design and has done so at events for groups including AIGA, SEGD, and GDC. In addition to this book, he is the author of *Speak Human: Outmarket the Big Guys by Getting Personal* (smashLAB, 2009). Eric lives in Vancouver with his lovely wife and two curious and delightful little boys.